Christmas 2007

Chris and Roxana

Hope this helps you
find new places
to explore right in
your own backyard!

Dad and Mom

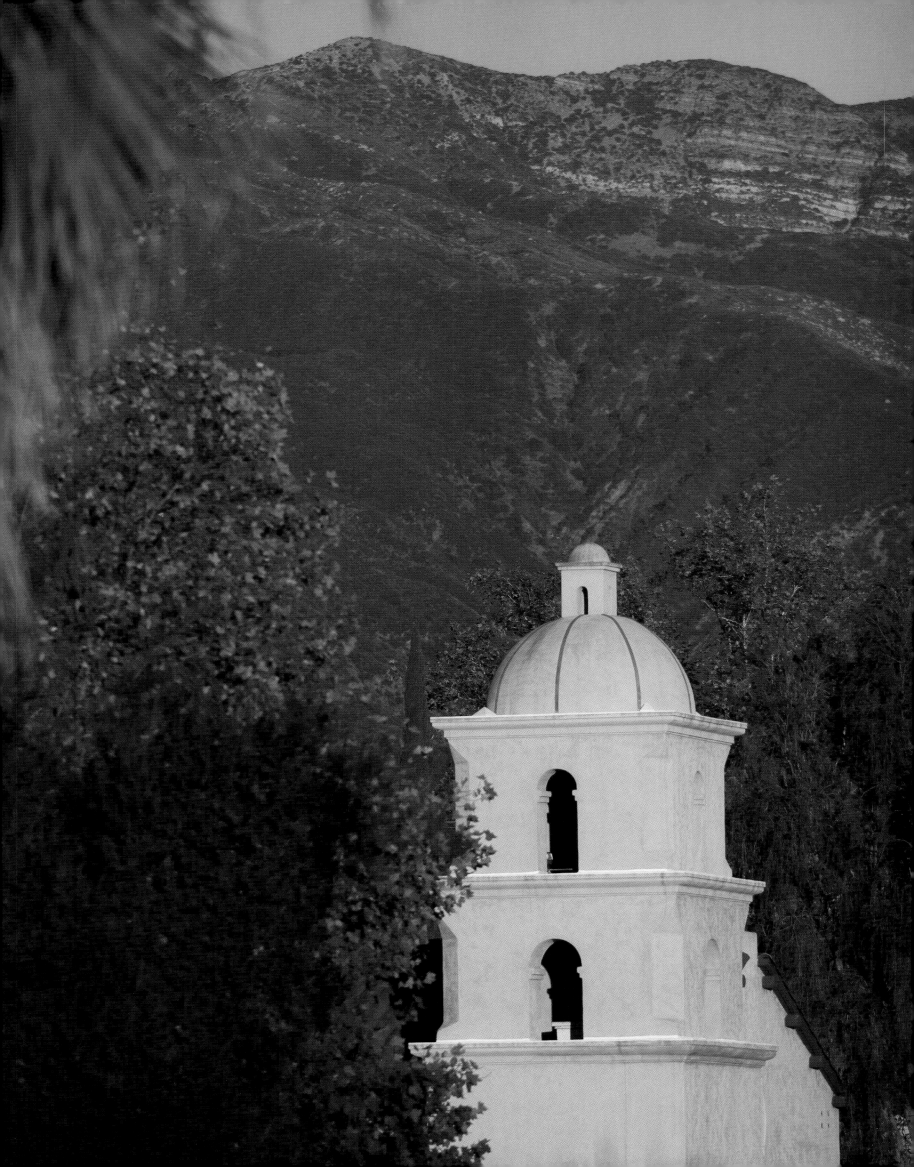

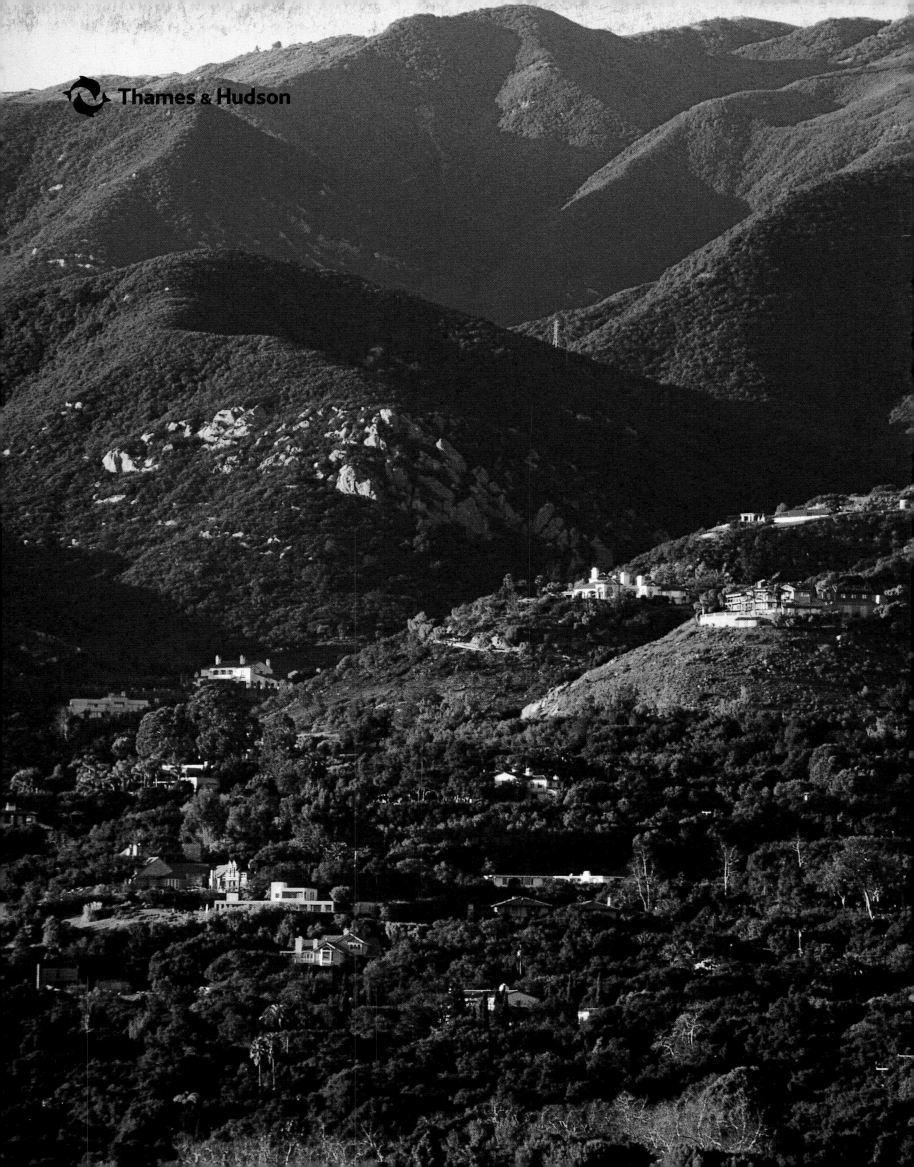

The Most Beautiful Villages and Towns of California

JOAN TAPPER

PHOTOGRAPHS BY NIK WHEELER

with 323 color illustrations

HALF-TITLE PAGE: *The bell tower of the Ojai Valley Museum.*

TITLE PAGES: *Montecito and the Santa Ynez Mountains.*

OPPOSITE: *Sonoma mission bell* (above); *a wall fountain in Avalon* (center); *fish traps in Eureka* (below).

Designed by Liz Rudderham

© 2007 Thames & Hudson Ltd, London
Text © 2007 Joan Tapper
Photographs © 2007 Nik Wheeler

First published in 2007 in hardcover in the United States of America by Thames & Hudson Inc., 500 Fifth Avenue, New York, New York 10110

thamesandhudsonusa.com

Library of Congress Catalog Card Number 2007900610

ISBN 978-0-500-51368-2

Printed and bound in Singapore by C.S. Graphics

Contents

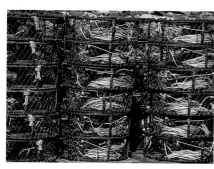

Introduction

California beckons with a golden sheen, the color of its hillsides in late summer, of its poppies and its veins of ore, even its aura of tantalizing celebrity. In response, visitors arrive from all over the world to tour the state's cities and explore its natural wonders, sometimes to imagine themselves living the California lifestyle. And why not? It's fun to picture oneself in a swimming-pool under the palms or sipping a local wine on a terrace overlooking rows of grape-vines. Movies and television add to the illusion that we already know California well, that there are no surprises in its fantasy geography.

This book, however, introduces the quirky corners, small towns and villages with charm, history, and their own individual characters. What makes them beautiful? It could be a cluster of Queen Anne Victorians with wrap-around porches and witch's-hat turrets. Or perhaps there's an old Spanish mission where locals still stage traditional Christmas pageants. It might be endless vineyards dotted by stone wine-cellars, or half a dozen antique stores in a row of Western false-front façades. In the vast, varied landscape of California, all these things are possible.

In sheer size the state equals eight or so of its East Coast counterparts. California's Pacific shore extends for 1,200 miles, from Oregon to Mexico, and it is 250 miles from the ocean to the Nevada and Arizona borders. Within those outlines are low mountain ranges flanking the coast and the majestic Sierra Nevada Mountains, whose 14,000-foot peaks virtually wall in the state on the east. And because this is a relatively young terrain, with mountains continuing to inch toward the sky, there are fault lines that generate frequent earthquakes, which realign geographic features in radical ways.

The climate has its own unexpected aspects; the weather is affected not just by distance north to south and by altitude, or lack of it – Death Valley lies several hundred feet below sea-level – but also by the moderating influence of the ocean and blankets of fog. Thus little Julian, in the hills east of San Diego, might be as chilly as bucolic Ferndale, some 300 miles north of San Francisco. And Montecito and Summerland could lie under a cool fog bank, while Los Olivos, Ballard, and Santa Ynez, just over the mountains, are basking in the sun's heat.

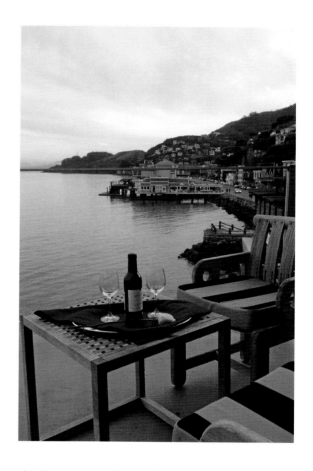

The tradition of hospitality extends back a century at Brothers Restaurant at Mattei's Tavern (opposite), which grew out of a 19th-century stagecoach stop in the Santa Ynez Valley. An old water tower stands nearby, though for many, it's the local wines that draw the visitors here. Farther north, in Sausalito (above), a balcony at The Inn Above Tide is a scenic spot to toast sunset.

A Moorish-style fountain adds grace notes to the Mediterranean flora in the garden of Montecito's Casa del Herrero (opposite). Built in 1925, the estate re-creates an Andalucian farmhouse in architecture and interior details (top). Among the actual legacies of the Spanish era is Carmel's Mission San Carlos Borromeo (above), founded by Father Junípero Serra.

In many ways this is a state of abundance, with fertile valleys suited to agriculture, towering redwood forests, and mountains laced with veins of precious minerals, especially gold. The flora and fauna here nurtured hundreds of tribes of Native Americans for thousands of years. Yet in parts of Southern California no rains fall from April to November and no rivers flow. The landscape was daunting enough to discourage active settlement by the Spanish for several centuries after the conquistadors' initial forays along the coast in the 1500s. Only the threat of Russians, British, and Americans encroaching on the claim prompted the expedition that established missions, presidios, and a few pueblos, and even those did not extend too far from the Pacific.

After that, other momentous events shaped the history of the state: Mexican independence, the Gold Rush, the spread of railroads and the management of water resources, the founding and reinvention of great cities — and the nurturing of many dreams. The small towns and villages celebrated in this book, however, are largely the places that lost out in the sweepstakes. Many boomed and then went bust. Mission communities were disbanded. Former seats of Mexican authority lost their importance as settlers poured into other parts of the state. The gold mines petered out; the lumber industry failed. County seats were built somewhere else, or railway lines followed other routes. Again and again these settlements were forgotten as they lost the battle for people, energy, influence. Of course, some might say they won out in the end.

For these places have also sidestepped the problems of California's larger cities: the freeways with paralyzing traffic, the high-rise apartments and ticky-tacky housing developments. Decades of quiescence have left much of their architecture or their natural surroundings undisturbed, to be rediscovered and embraced by new generations over the last 30 or 40 years. The residents have fought to establish historic districts and historical parks to protect enclaves of one- and two-story adobes, lively plazas, Victorian residences, and turn-of-the-century commercial blocks. In other places the quaint old buildings have been turned into restaurants, shops, and bed-and-breakfast inns, and in turn have attracted a new wave of visitors and residents. Even California's emphasis on lifestyle has had an

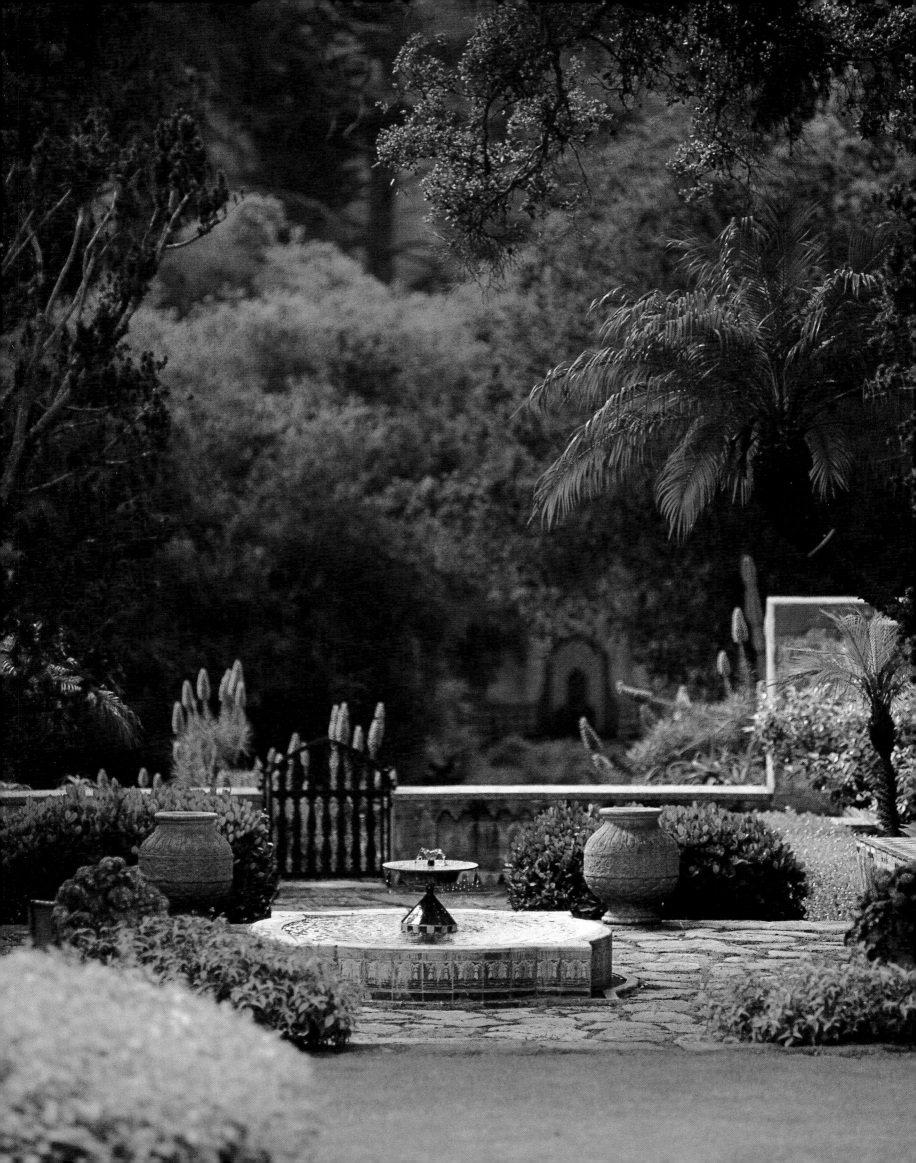

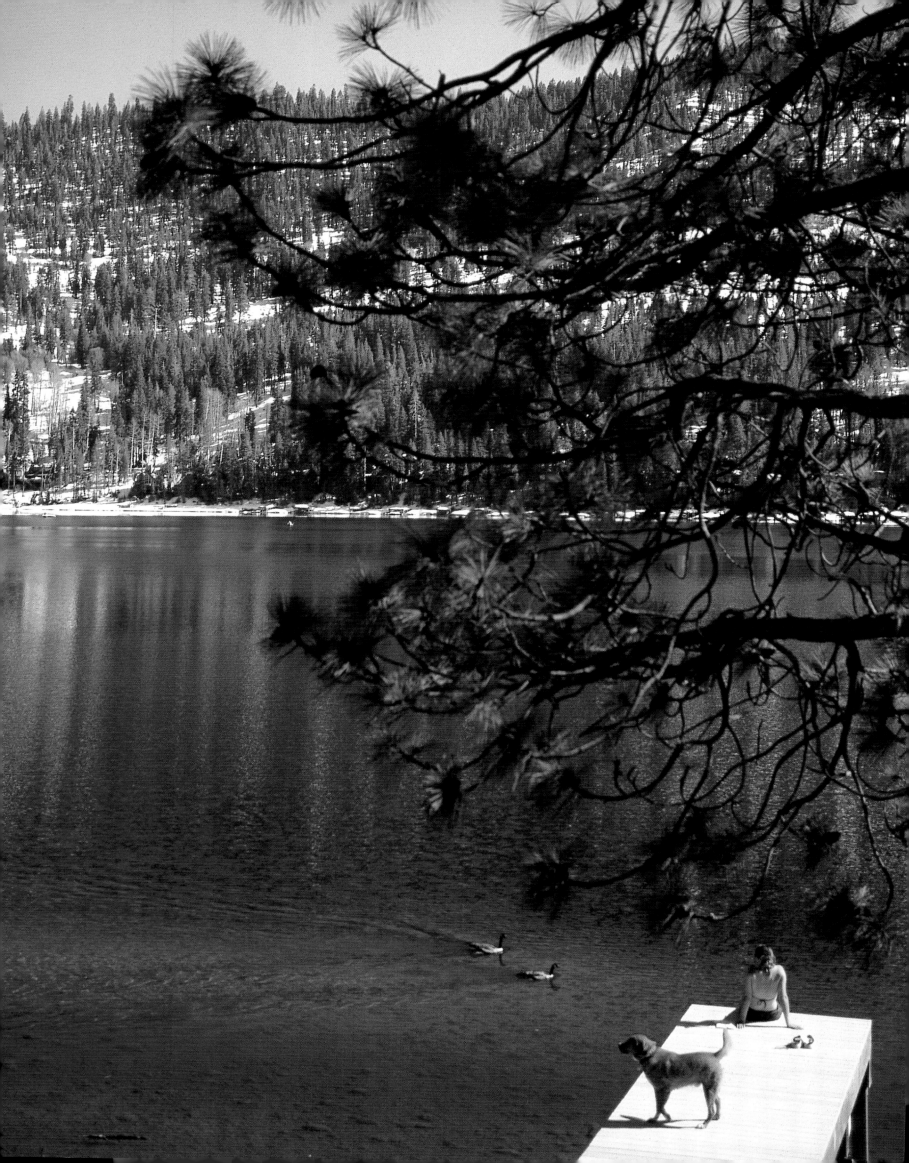

effect, helping to promote wine-country towns and centers of spiritual renewal that have similarly grown into travelers' destinations.

Choosing the small towns and villages for this volume was not an easy task. We began by setting a rough limit of 40,000 for population (though there are villages here with just a few hundred people, too). Dividing the book roughly into quadrants – coast versus inland valleys and mountains, and Northern California versus the Central and Southern parts of the state – we relied on past experiences, research, friends' recommendations, and a desire to present as much variety as possible. We also tried to highlight different historic periods. Elements of the mission era are visible in San Juan Capistrano, San Juan Bautista, Carmel, Monterey, and Sonoma. Truckee was an entry point for early settlers. The Gold Rush is present in Downieville, Nevada City, Sutter Creek, and Sonora, Columbia, and Jamestown; Julian also had a mining history. The Victorian age shines in Eureka and Arcata, and Ferndale. Wine country is represented by St. Helena, Sonoma, and also Los Olivos, Ballard, and Santa Ynez. Several towns blend highlights of a few eras with an emphasis on arts and antiques and other aspects of fine living: Mendocino, Sausalito, Carmel, Cambria, and Montecito and Summerland all have unique and unmistakable appeal. Ojai is famous for its aura of spirituality, while Avalon is a one-of-a-kind island village.

Three towns here are gateway communities to spectacular natural environments: Joshua Tree is at the edge of a stark, awesome desert; Point Reyes Station is at the entrance to a coastal preserve, and Bishop is flanked by two ranks of magnificent mountains. And we added to the mix three photo essays – on wine country, ghost towns, and missions – to tell stories that connected several towns…and also to share a trove of visual riches.

We couldn't include every place we wanted. Santa Barbara – a home-town favorite – was too large. Sweet Pacific Grove bridges Monterey and Carmel; the coastal settlement of Trinidad was only a few miles from Arcata and Eureka. Other gems also will have to await another volume.

What is notable about the small towns and villages in this book, though, is that they are active communities, with passionate residents who organize and support historical societies, offbeat museums – virtual town

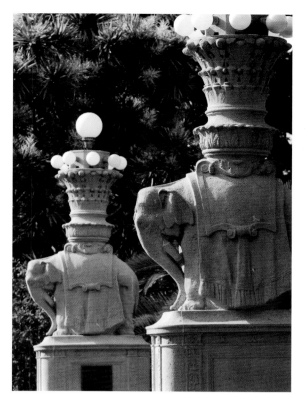

Winter lingers in the pine-covered mountains around Donner Lake (opposite), near Truckee, even as visitors embrace more summery pleasures. California's varied landscapes reach from the Sierras to balmy island towns like Avalon (above), where a canine resident catches a golf-cart ride. The stone pachyderms in Sausalito's Plaza Viña del Mar (top) were first on display in San Francisco's 1915 Panama-Pacific Exposition.

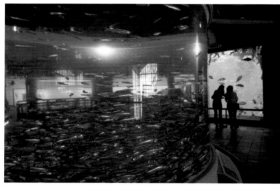

*T*ule elk graze a hillside in Point Reyes National
Seashore (opposite), where a wild herd was
reintroduced after more than a century of absence.
Denizens of the sea attract young and old to the
innovative Monterey Bay Aquarium (above). At the
historic Buena Vista winery in Sonoma (top), visitors
line up for a taste of the grape.

'attics' – and architectural and garden tours. The 'small' is important. In these places bureaucracy gives way to personal connections and address books. During research for this book such obstacles as a closed museum in Downieville, a locked office in Bishop, a hard-to-get behind-the-scenes peek in Ojai simply disappeared. After all, in a place where everyone knows who has the keys, access is often just a phone call away.

And almost everyone has a story to tell. Sometimes the narrator is a longtime resident, like the local historian in Sutter Creek who still remembered when an antique store was a colorful bar. Sometimes the story-teller has a lifelong hobby, like the printer in Sonora who had an incredible collection of photos and memorabilia. Occasionally, a newcomer embraces local history with a passion; one of Ferndale's civic leaders left a career in the movie industry for an entirely different way of life, and in Ojai a visiting curator passed along racy tales of an important artist's life.

Of course, the renewed interest in these places carries a mixed ledger as local economies increasingly rely only on tourism. Who keeps the tally when a community's hardware store becomes another antique shop? How do you balance the painted façades of century-old homes with declining grade school enrollments, because the restorers are retired, with no small children in school? Which is better? An empty old house that might someday welcome a full-time resident or a preserved architectural masterpiece that's a weekend getaway for a couple in San Francisco or Los Angeles? The balance-sheet is not yet complete.

Yet for all the questions and uncertainties, these towns and villages are unforgettable, repositories of the state's colorful heritage and full of promise for the future. They are wonderful places to visit for a day or a lifetime, good places to ask the kind of questions that California has prompted for 150 years. Where should I live? How can I prosper? Where can I go to find myself and fulfill my dreams? These towns and villages provided answers then. They continue to do so today, and their names are more precious than ever.

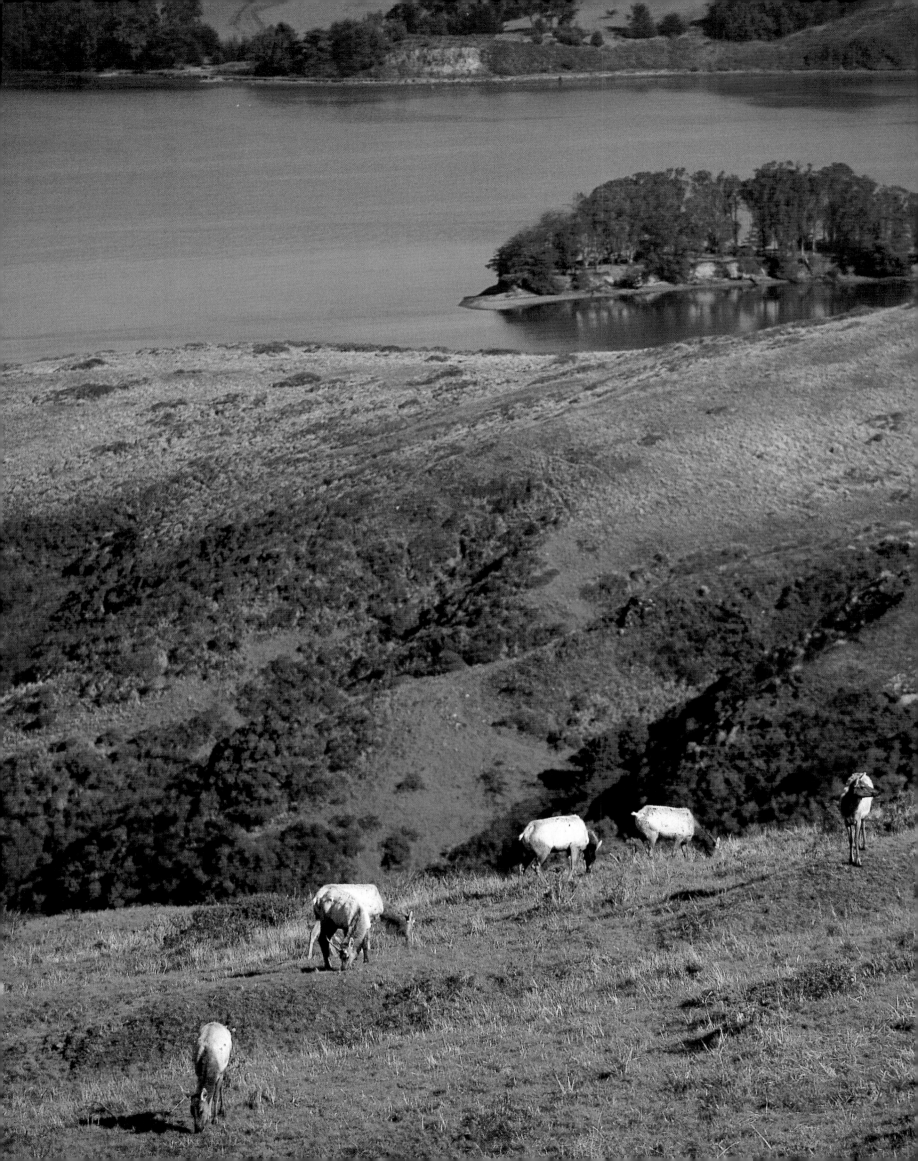

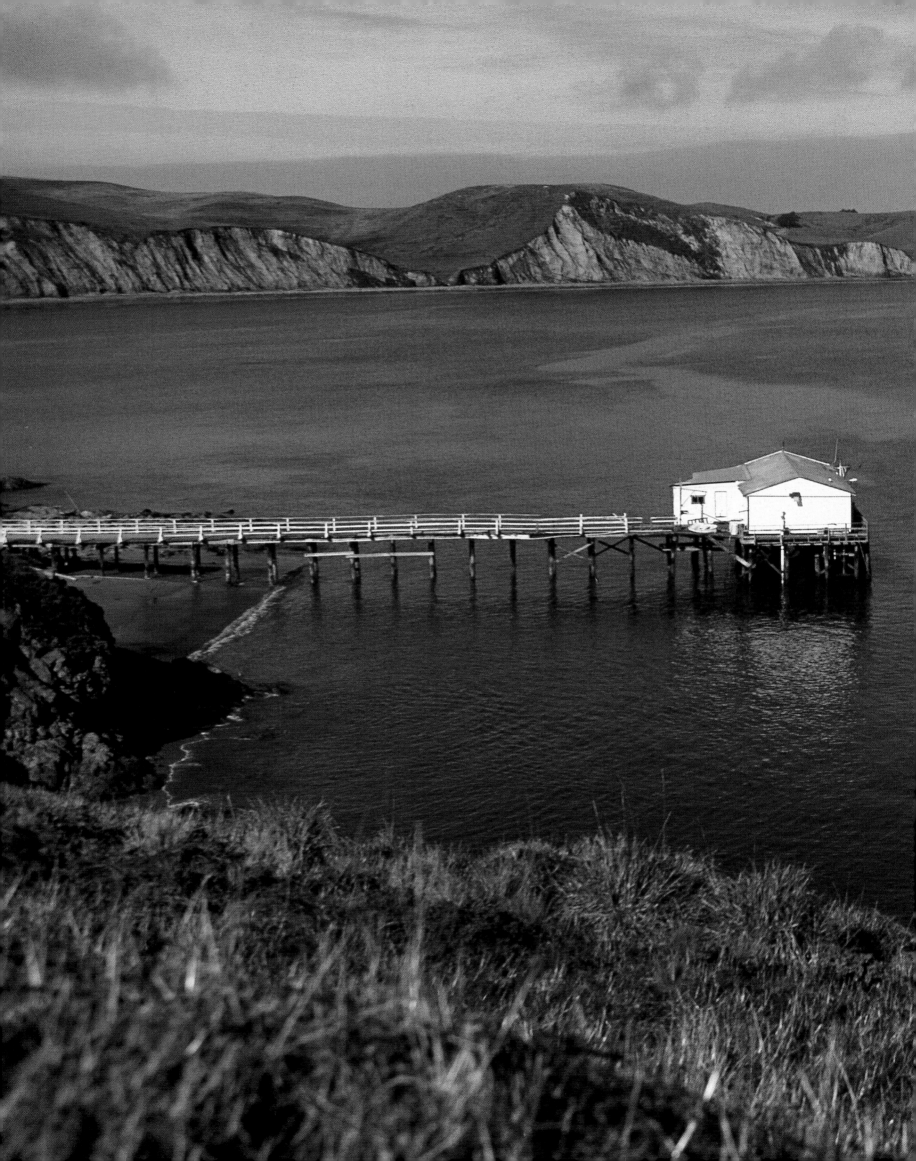

NORTHERN
CALIFORNIA COAST

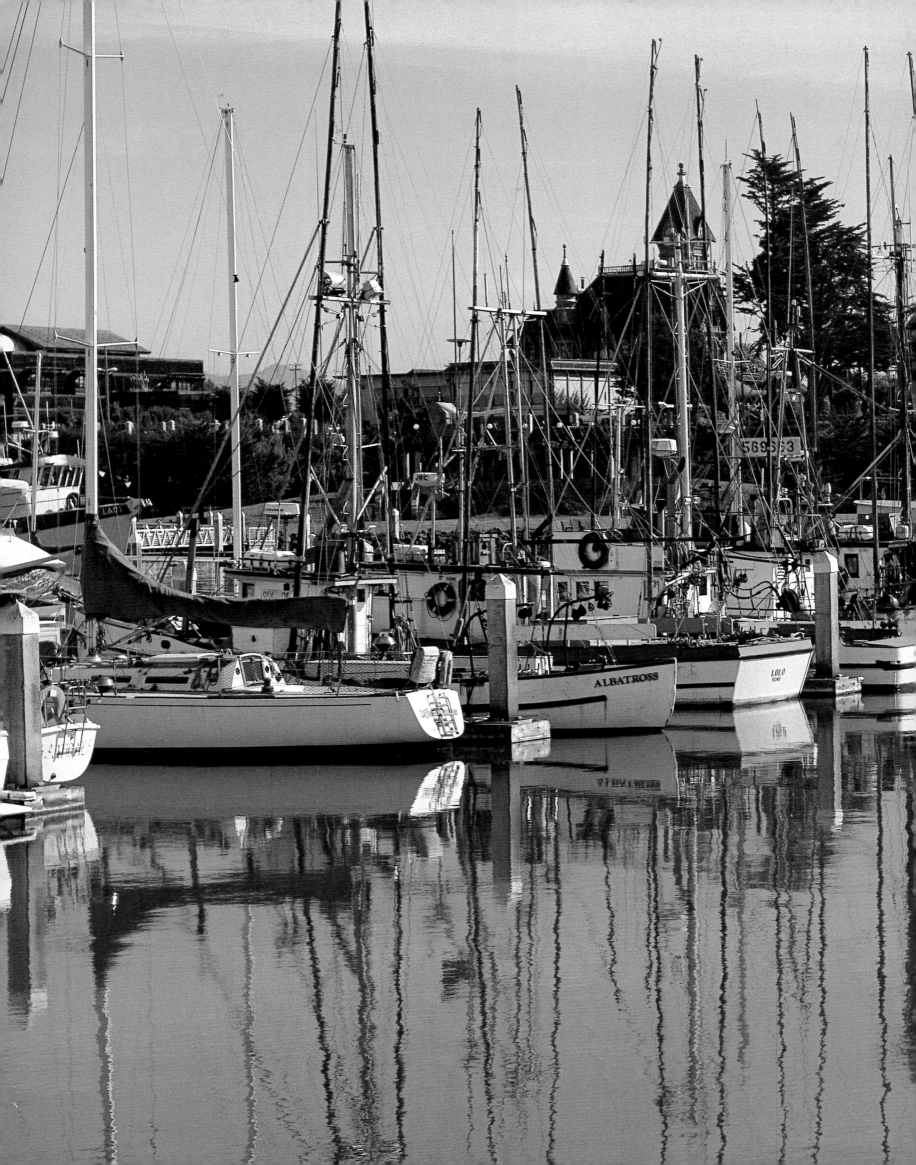

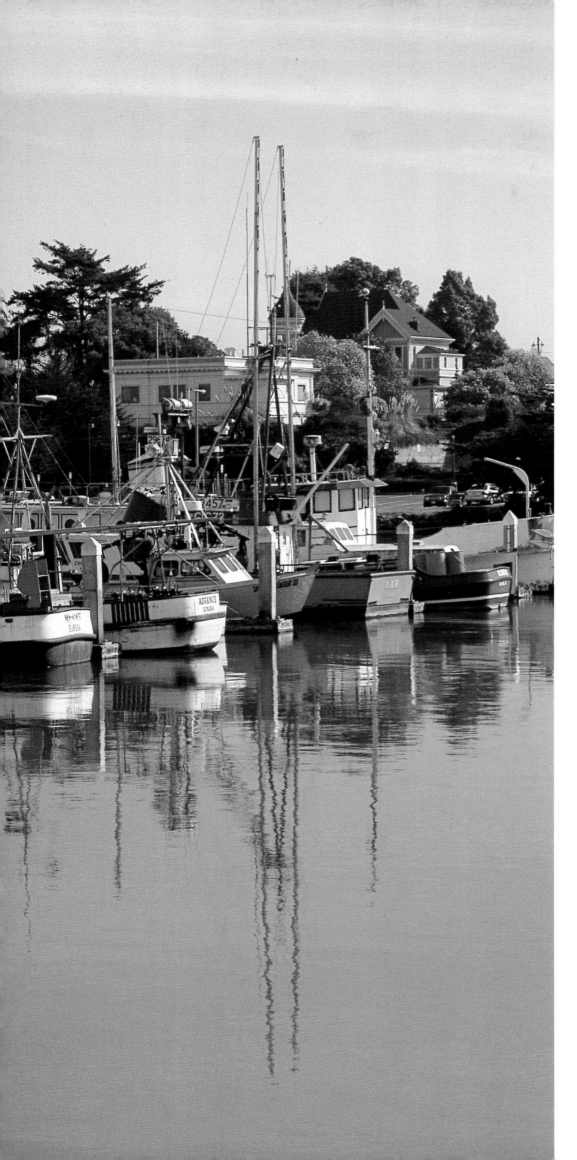

Eureka and Arcata

WITH ITS TOWERS, gables, verandas, and ornately carved pillars, the William Carson Mansion is a Victorian fantasy in overdrive, designed by Newsom and Newsom, noted San Francisco architects. Painted spruce and olive green, the gingerbread-trimmed redwood home was built from 1884 to 1886 by a 100-man crew for one of Eureka's lumber magnates, not far from the mills and docks that sustained his fortune. Across the street Carson also built his eldest son a Queen Anne-style home known as the Pink Lady. Those houses are just two of the architectural riches of a National Registered Historic District at

*D*rakes Bay in Point Reyes National Seashore recalls the arrival of Sir Francis Drake, who sailed here in 1579 (preceding pages).

*B*ehind a stockade of sailboat masts , the William Carson Mansion (left *and* below) stands as the most elaborate of Eureka's many Victorian residences.

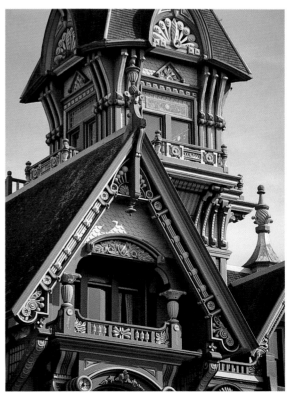

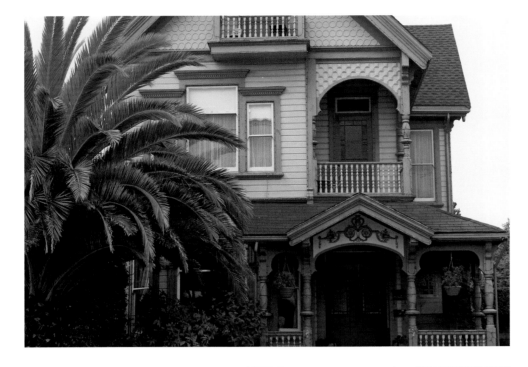

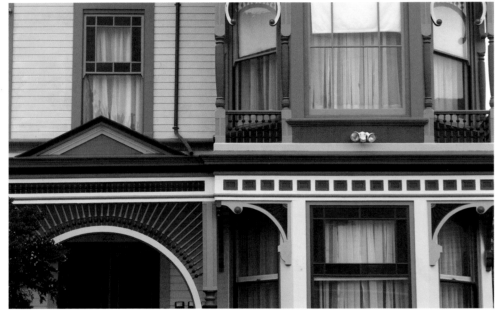

the edge of Humboldt Bay, more than 300 miles north of San Francisco.

Overlooked by most seagoing explorers because of its sheltered entrance, the bay was the ancestral home of Wiyot Indians, and they still are a strong presence in the area. Their heritage – including spectacular examples of basketry and clothing – is a highlight of the Clarke Historical Museum. In 1849 mine company workers arriving over land rediscovered Humboldt Bay. Within the decade, prospectors and merchants had swarmed in, and the town became a supply center for the gold fields. Its real wealth, though, was inland, in the groves of towering redwoods. By the late 1850s sawmills, shipyards, and carpentry shops abounded, and fishing-boats and coastal schooners filled the waterfront. Historic Eureka's Second and Third Streets are lined with richly detailed commercial buildings that date to the booming late 1800s: the Hotel Vance, built in 1873 with wood siding that was fashioned to resemble stone; the cast-iron Buhne Building from 1884, and the Carson Block office building from 1892, whose original directory board announces modern tenants. A drive through the town's alphabetical residential streets reveals dozens of homes with porticoes and patterned shingles, gables and turrets, painted in 19th-century color combinations that range from restrained to rainbow.

Rowdy sailors and lumberjacks gradually turned Eureka's waterfront into a rough tenderloin district, with legendary saloons and bordellos. Jack London was said to have come looking for material; he found a fist-fight instead. Even after the area had become a dreadful skid row, the buildings were never razed. When the city began to restore its downtown in the early 1970s, more than 200 historic structures remained, along with residents passionate about their architectural heritage. The Restoration Hardware firm

*A*t *the Blue Ox Millworks Historic Park a contemporary artisan* (right) *demonstrates old woodworking techniques, like those that produced Eureka's many memorable examples of the carpenter's craft* (above *and* top).

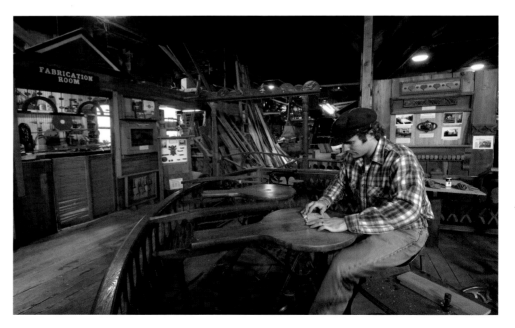

*F*lat, curved, scalloped, and peaked, the roof lines
along Old Town's Second Street (above) *display the
earmarks of varied 19th-century styles. Eureka, which
thrived on lumber and shipping in the late 1800s, had
faded by the 1960s, though many old buildings survived.
A strong preservation movement over the last three
decades has saved and restored more than 200 structures
in the National Registered Historic District, bringing
residents back and attracting visitors to restaurants like
the Café Waterfront* (right).

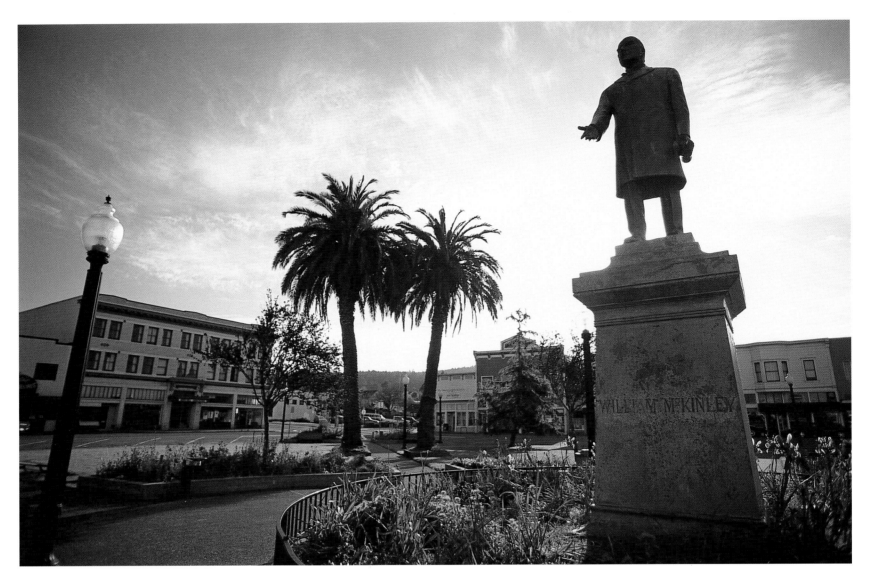

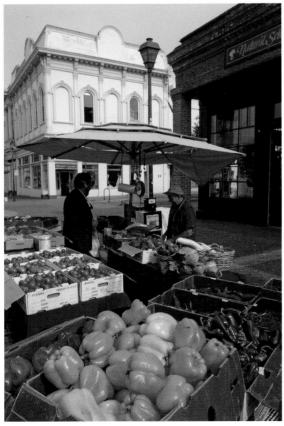

was founded here by a local trying to find antique fittings. An emerging colony of artists also found the old buildings useful for studios and galleries, a tradition that continues in the Morris Graves Museum of Art, which opened in 2000 in the spectacularly renovated Carnegie Library from 1902.

At the north end of Humboldt Bay, the town of Arcata shares an early history with Eureka and has its own notable houses, from simple 1850s cottages to ornate Victorians clustered on a low hill. After 1913, however, Arcata became a university town and took on its own personality. Students congregate around the Plaza that has been the center of Arcata's Old Town for more than a century. Of the coffee shops, bars, bookshops, and other businesses that face the square, Jacoby's Storehouse is the oldest, begun in 1857. And in the center, where Gold Rush pack trains once assembled on a dusty lot, a popular organic market is now the important weekly event.

A casual hiker follows the curving trail through Arcata Redwood Park (opposite). The towering trees were a source of the area's economic wealth; now the grove provides spiritual enrichment. Since 1906 a statue of William McKinley (above) has presided over the Plaza in Old Town Arcata, where a colorful farmers' market, like that in Eureka (left), takes place weekly.

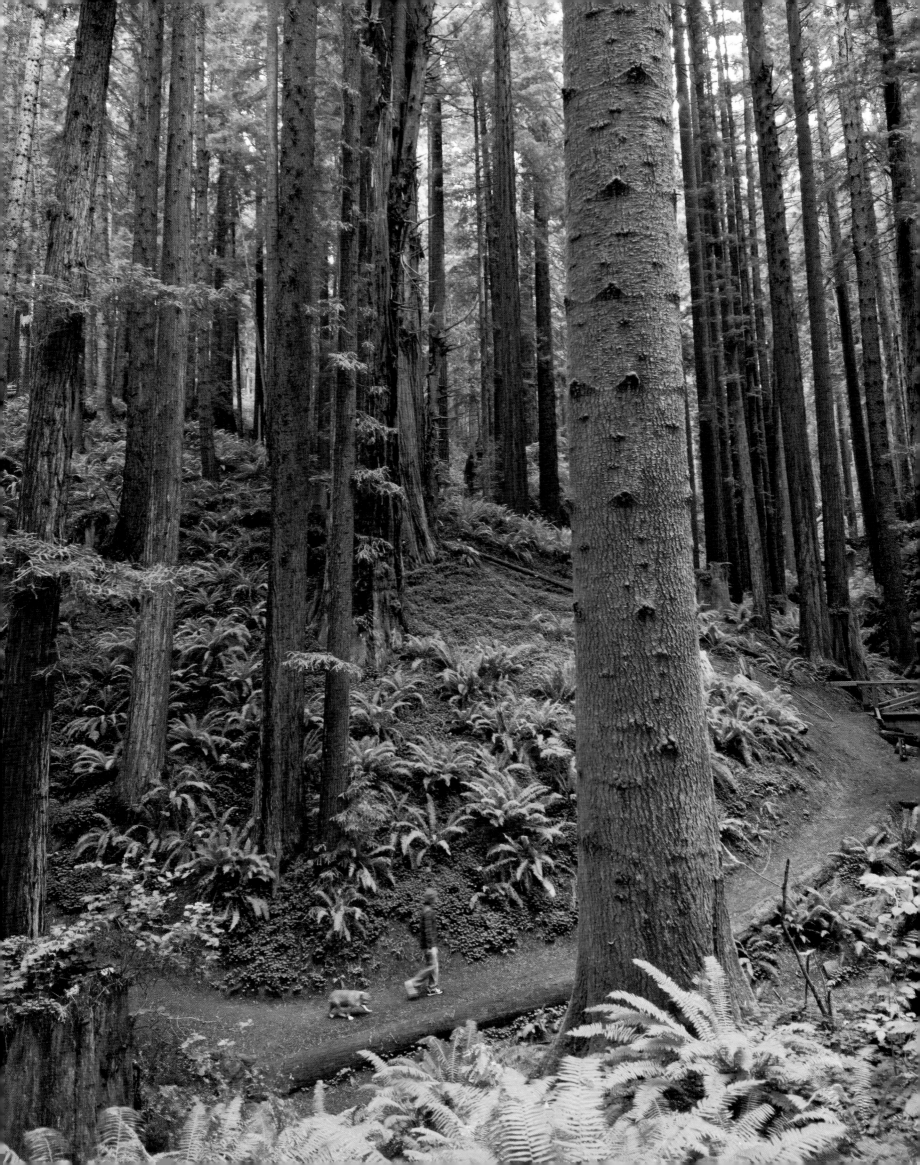

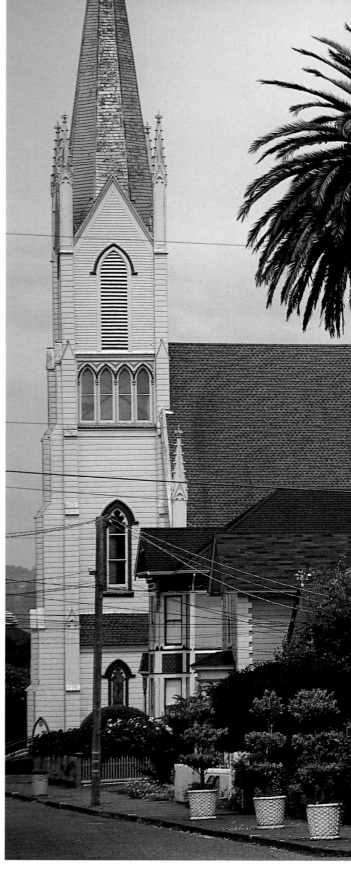

Ferndale

IN THE AISLES of Golden Gait Mercantile, on Ferndale's Main Street, old cracker tins and containers of Williams Mug Shaving Soap jostle preserves made just last week and trendy cooking utensils. Upstairs, alcoves re-create a Chinese herbalist's store-front, an old-style apparel shop, and a toy boutique from decades ago. This is part museum, part modern general store, combining a light-hearted appreciation for the past with contemporary commerce and lifestyle. In a sense that's what this entire village is doing.

Here, about ten miles south of Eureka and just inland from the coast, the Eel River borders mostly flat pasture-land that seems a universe away from the redwoods that define most of Humboldt County. In 1852, when east-erners Seth Shaw and his brother, Stephen, arrived by canoe, they had to push their way through dense fern

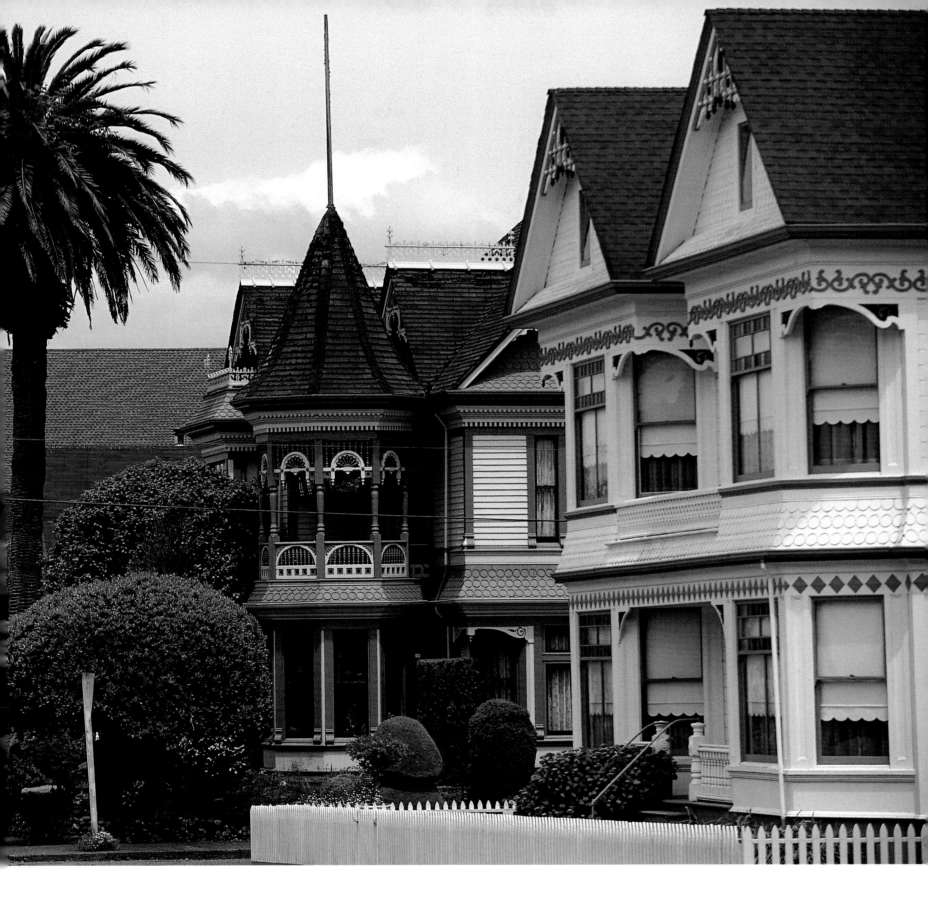

thickets. They put up a cabin, cleared the land, and commenced farming. Stephen eventually sold his claim, but Seth remained and two years later built a residence he modeled on Nathaniel Hawthorne's *House of Seven Gables*. Today his classic Carpenter Gothic-style home is a bed-and-breakfast inn, still showing some of the ceiling paint Shaw's bride, Isabella, picked out and the marble fireplace she ordered from Gump's in San Francisco.

Another farmhouse from that early era, Fern Cottage, was built in 1866 for the Russ family, who gradually expanded it to accommodate their 13 children. Its well-tended gardens are a frequent wedding site.

By the 1870s, Danish immigrants had begun to establish dairies around town; their creameries, carried on first by Italian-Swiss settlers, and then by Portuguese newcomers from the Azores, continue to dominate

Architectural treasures from the late 1880s edge Berding Street (above), buttressing Ferndale's claim to the title of Victorian Village. Sculptured greenery showcases the intricate woodwork of a 19th-century home (opposite).

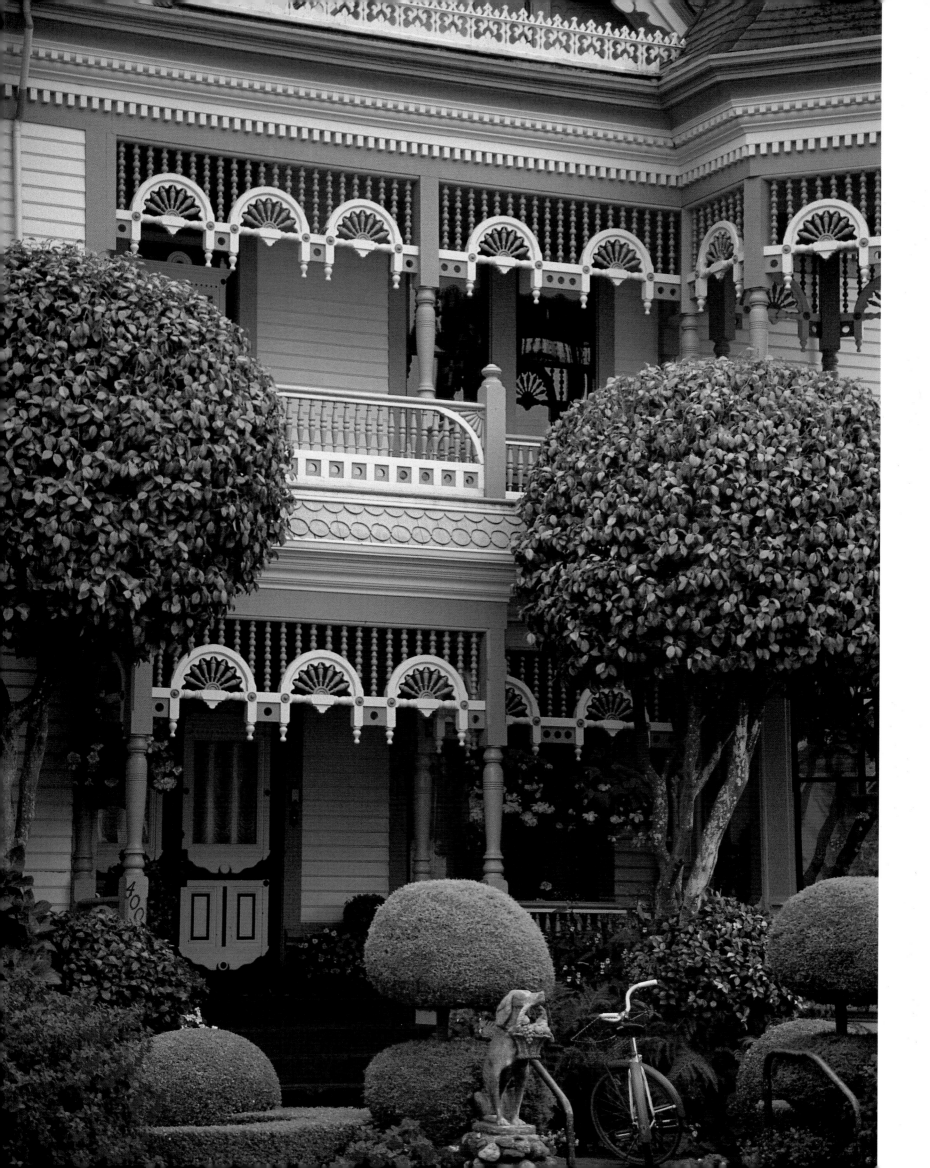

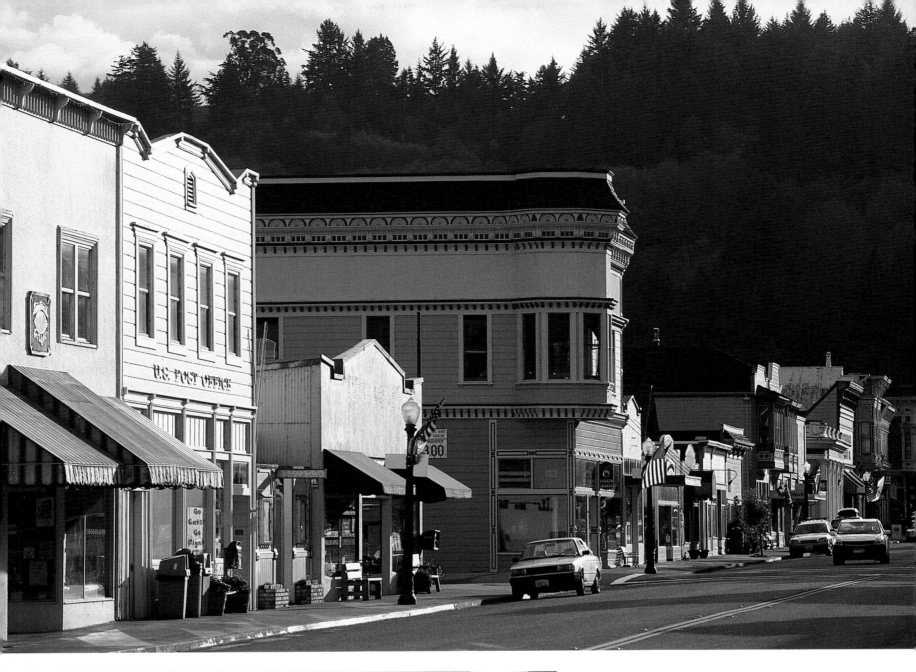

The unmistakable Gingerbread Inn Mansion (opposite), built in a combination of Queen Anne and Eastlake styles, started out as a doctor's residence just a block off all-American Main Street (above). Ferndale's first settler constructed the Shaw House (left) by hand; now an inn, its cozy parlor still welcomes guests with some of the original décor.

Ferndale's economy. As the dairymen prospered, they built their own 'butterfat mansions'; more than a dozen of those elaborate homes survive on the town's side streets, along with other examples of 19th-century buildings.

The prettily painted façades along Main Street, part of the National Registered Historic District, are an appealing jumble of one- and two-story Victorian styles, housing everything from hotels, clothing boutiques, and gift shops to a meat market, candy store, and grocery. The picturesque streetscape made a perfect location for the movie *The Majestic*. A blacksmith shop and wrought-iron gallery recall the days when horses and livery stables were part of daily life here. And the

Ferndale Museum not only exhibits individual artifacts in Victorian room-like settings but also displays an entire old-time barbershop.

In the mid-1900s the town faced hard times: a devastating flood in 1955 killed off huge numbers of livestock, nearly putting an end to the community; in 1964 an even worse flood drove many remaining businesses away. Viola Russ McBride, granddaughter of a pioneer family and an artist herself, responded by buying up empty houses for $500 each and inviting other artists to come and use them. Eventually the economy improved. The local dairy cooperative is now one of the largest ice-cream producers in the United States, and in the last few years organic fruit and berry growers have found a niche here as well. And the artistic spirit lives on, too, not only in painting but also in kooky pedal-powered constructions – on display at the Kinetic Sculpture Museum – that take part in the annual three-day race that finishes with a flourish on Ferndale's Main Street.

Centerville Road passes bucolic farms (left) on the way to a rarely visited stretch of Pacific coast. Such pastoral scenes surround the compact historic district of Ferndale, where the bay window of a Victorian building from 1901 offers a view of varied turn-of-the-century architecture (below).

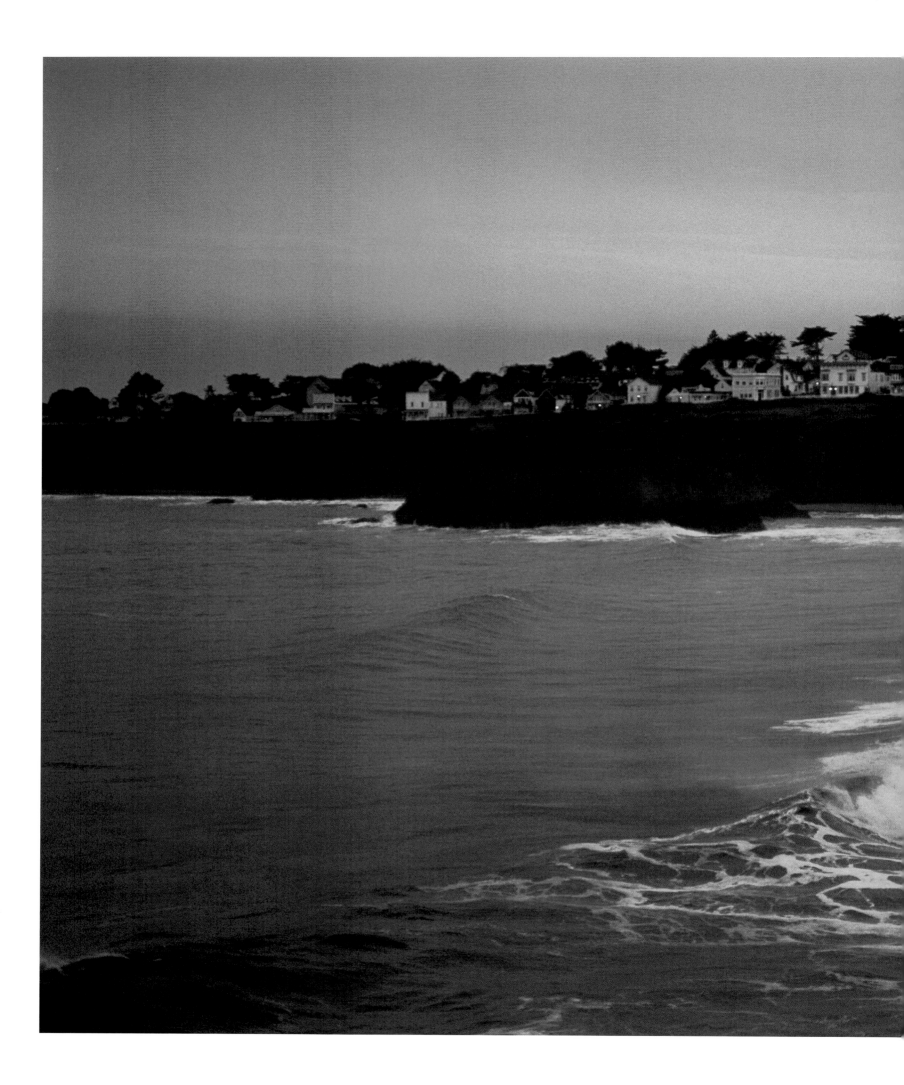

Mendocino

BENEATH THE BRAMBLE-COVERED headlands that are Mendocino's front yard, crashing waves sculpt low sandstone cliffs, and migrating gray whales 'blow' offshore. Inland, peaked-roof shops and Western false-front façades, New England-style cottages, and a tall-steepled church line up to face the sunset. The village panorama resembles a quaint 19th-century streetscape, thanks to the restrictions of a historic district set up in 1971. In the 1860s, however, the scene would have been blocked by the messy jumble of a lumber port, where logs were dropped down chutes from the bluffs to schooners anchored in the cove.

The story of Mendocino's transformation from wild coast to timber town to picturesque getaway begins with a shipwreck. In the summer of 1850 the clipper *Frolic*, laden with valuable trade goods, went down at nearby Point Cabrillo. The crew piled into small boats and made their way to San Francisco, where they caught the attention of entrepreneur Henry Meiggs, who dispatched an employee to try to salvage the wreck. By the time Jerome Ford arrived, the *Frolic*'s cargo had long since disappeared. What he found

*S*unrise casts a pink glow over Mendocino's Main Street (left), where century-old façades are edged by now undeveloped headlands. In the mid-1800s this was a busy lumber port, with ships waiting in the bay for their cargo of redwood logs. Early morning light adds definition to the façade of the Mendocino Hotel (above).

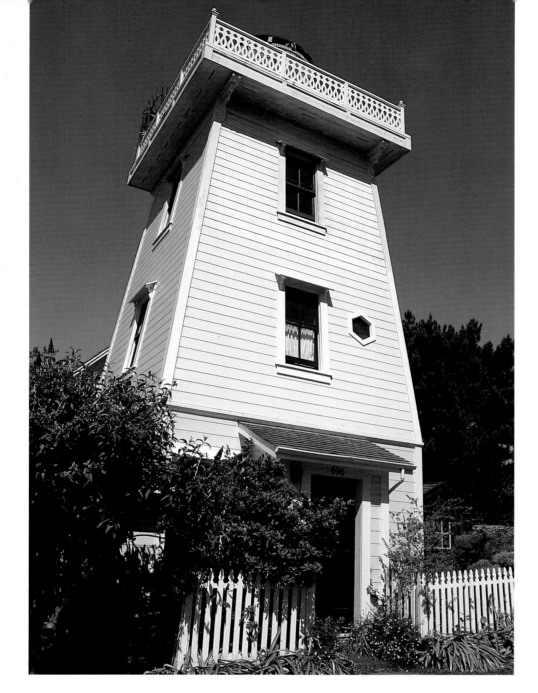

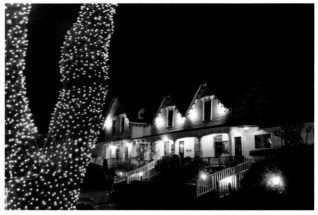

instead proved far more lucrative. Ford described groves of majestic redwoods and received a new assignment: find a spot for a sawmill that Meiggs obtained in New York, disassembled, and had shipped around Cape Horn.

The mill arrived in San Francisco in 1852, when sailors were abandoning their ships for the gold fields. Meiggs bought a vessel, hired a captain, and signed on 40 lumbermen, including a carpenter named William Kelly, who would become a prosperous merchant in the burgeoning settlement. As Meiggs expanded his logging business, however, his finances crumbled, and he fled to South America. Ford and other partners regrouped and carried on. He traveled back to Connecticut and returned with his bride, Martha, in 1854. Their blue-gray cottage, the second house in the village, had been built in their absence with the kitchen/dining-room in the basement. That was soon remedied. And today the bright dwelling welcomes visitors to Mendocino Headlands State Park. Across the street stands William Kelly's

sunny yellow residence, constructed in 1861. It's now the Kelley House Museum – a strong-willed daughter, Daisy Kelley MacCallum, added the second 'e'– which re-creates Mendocino's 19th-century lifestyle.

The quiet streets are lined with dozens of trim cottages and more ornate Victorians from those days, along with the characteristic tank towers that still pump the town's water. The Presbyterian Church, with its patterned redwood-shingle exterior and imposing bell tower, dates to 1859. The village's Chinese community gathered at the diminutive green-and-red Kwan Tai Taoist temple, from the same era. For less righteous townspeople there were 19 bars, as well as numerous houses of ill repute. Since 1866, a symbolic sculpture of *Time and the Maiden*, carved from a single redwood trunk, has presided over it all from atop the old Masonic building.

The mills kept working until 1938, but then Mendocino's fortunes plummeted, along with the

Cream-colored siding encloses a restored water tower (above left) that has been converted to lodgings. These characteristic structures, which dot the area, are more than decoration. They still pump Mendocino's water. Stronger drinks are on offer in the lobby lounge of the Mendocino Hotel (above), from 1878, a favorite spot for cocktails. Another local gathering place, the Little River Inn (top) was built around the 1853 home of lumberman Silas Coombs; it has been open to guests since 1939.

*M*any of Mendocino's homes have been turned into inns. Daisy Kelley MacCallum's gracious house (right) was a wedding present from her parents in 1882. Now a hotel and restaurant, it serves breakfast on the veranda in sunny weather. The Mendocino Presbyterian Church, however, has retained its original function (above). The white-painted redwood building, with its tall, narrow steeple, went up in 1859, but the windows are contemporary, the work of an area artist.

The sandy beach along the Big River (opposite) offers a quiet spot for a couple to stroll. In recent years Mendocino has become a popular romantic getaway, aided by the appeal of New England-style houses like those of 'Bankers' Row' (right). The renovated Kelley House Museum (above right), built in 1861, re-creates the lifestyle of the 19th century. Meanwhile, the moral message of the Time and the Maiden *sculpture (above) may simply go over modern heads. The view from Mendocino Headlands State Park shows off rocky outcrops and a Pacific Ocean that is anything but (overleaf).*

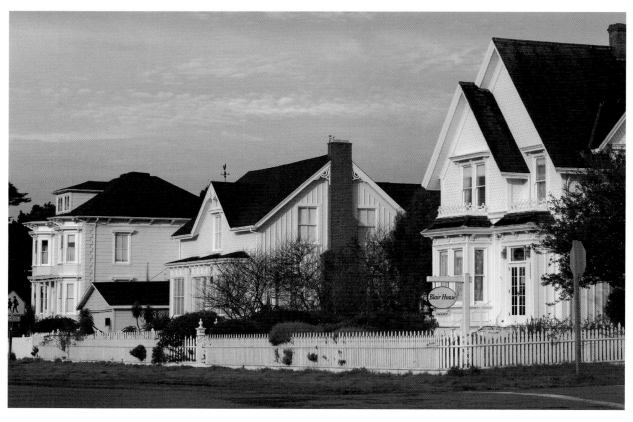

population. Still, the area's dramatic scenery and evocative architecture made it an attractive movie location. *Johnny Belinda* and *East of Eden* were shot here, and more recently, the town stood in for Cabot Cove, Maine, in the TV series *Murder She Wrote*. In 1957 art teacher Bill Zacha moved to Mendocino and began inviting San Francisco artists, writers, and musicians to help him set up a local arts center. The cultural explosion that followed sparked the town's rebirth and a vibrant preservation movement. A lively art colony and a favorite romantic destination, contemporary Mendocino is a kinder, gentler version of itself a century and a half ago.

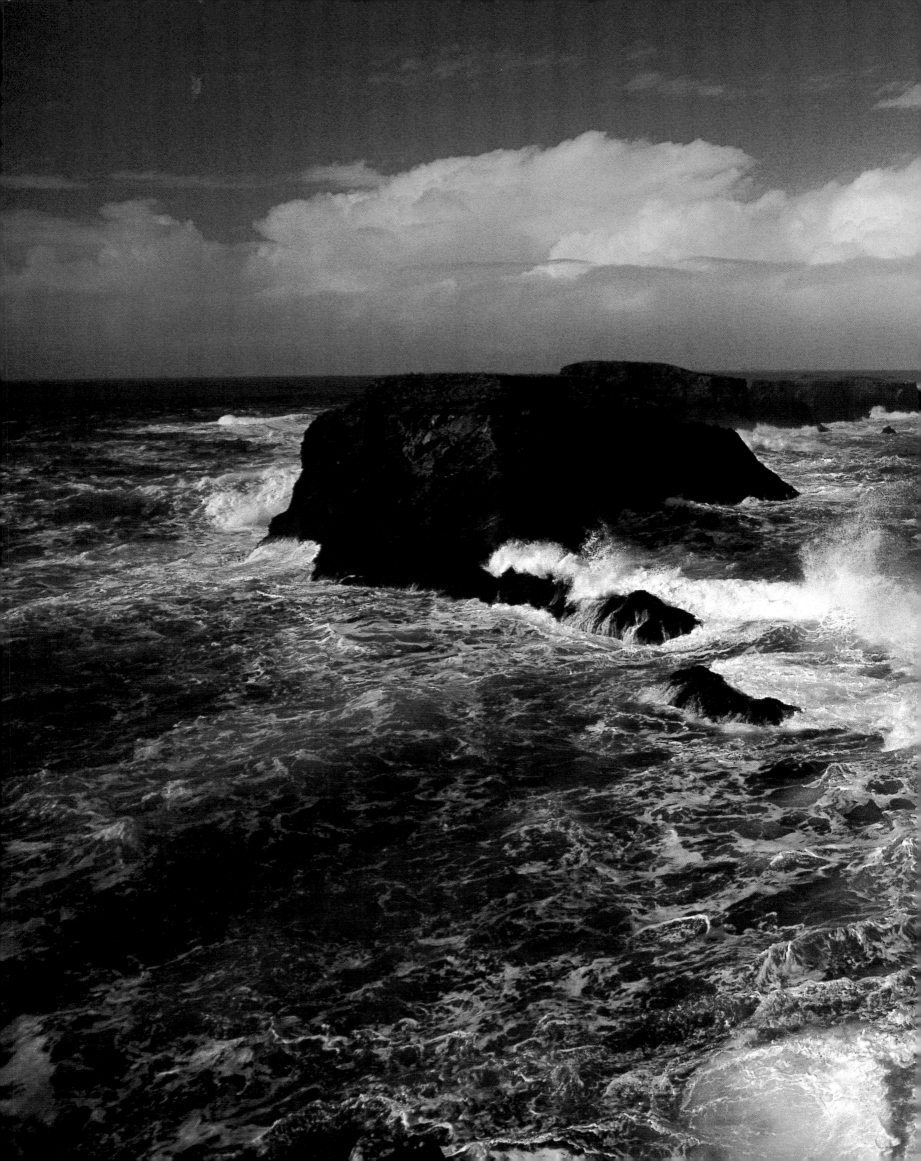

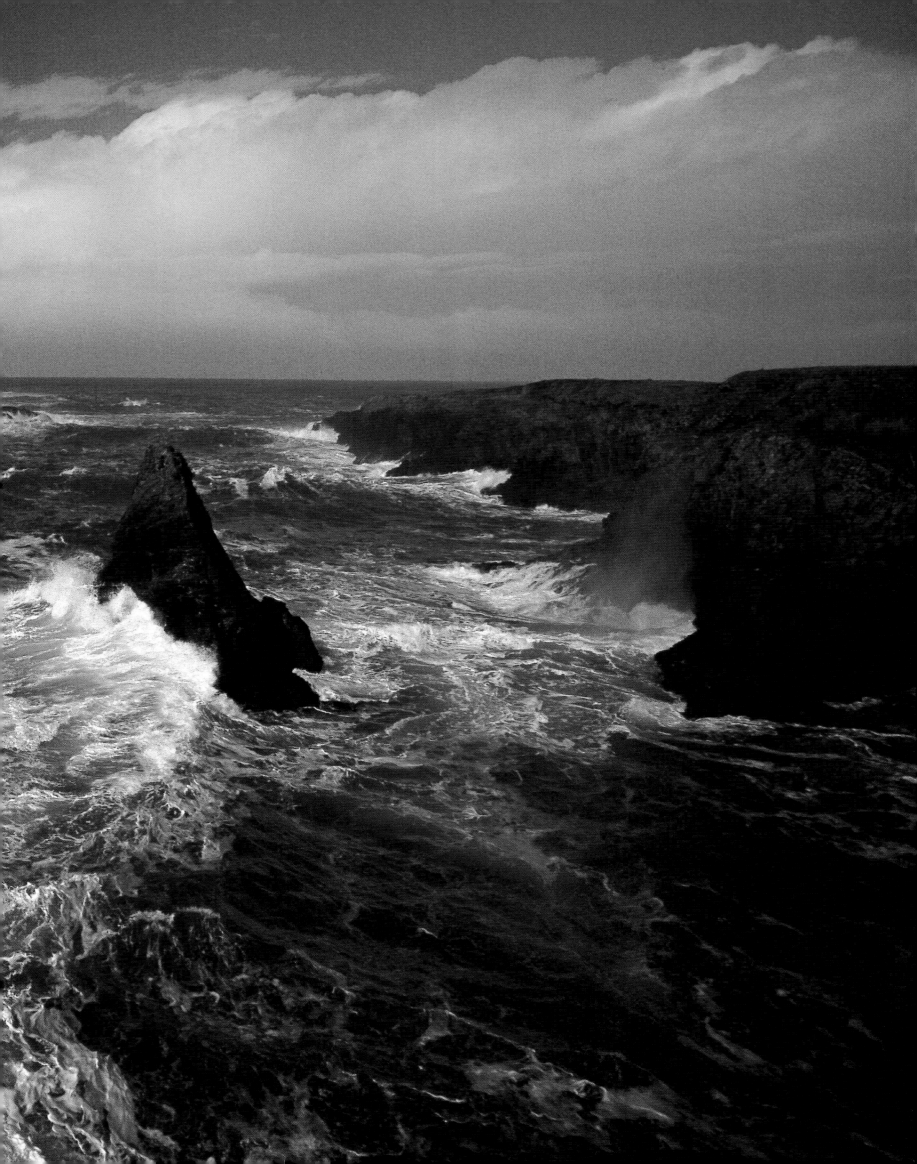

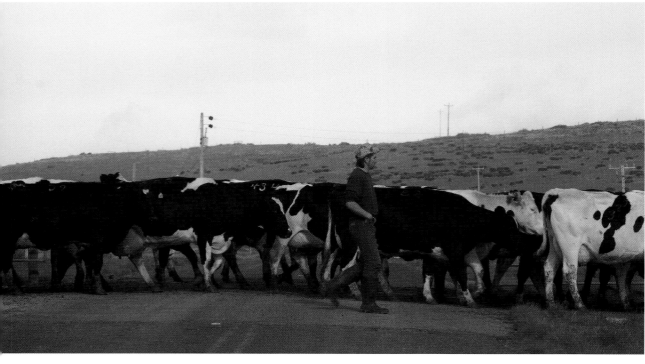

Point Reyes Station

IN THE CENTER of the three blocks that make up Point Reyes Station's main street, the Bovine Bakery displays its butter-rich pastries, muffins, and scones. A wooden barn nearby offers Cowgirl Creamery's renowned artisanal cheeses, made from locally produced organic milk. And against the surrounding hilly green pastures it's easy to make out the shapes of contented cows.

Roughly 150 years ago two determined San Francisco lawyers, Oscar and James Shafter, and Oscar's son-in-law, set up a dairy empire on the fertile Point Reyes peninsula, which juts like a fish-hook into the Pacific north-west of San Francisco. Nowadays the area evokes those 19th-century roots by embracing progressive

Why do the cows cross the road? Around Point Reyes Station, it's to get to the rich pastureland on the other side (above left and top). There have been dairies in the region since the mid-1800s, when they sent butter to the citizens of a growing San Francisco. Some of the historic farms still exist within Point Reyes National Seashore. Others more recently established produce organic dairy products and meat.

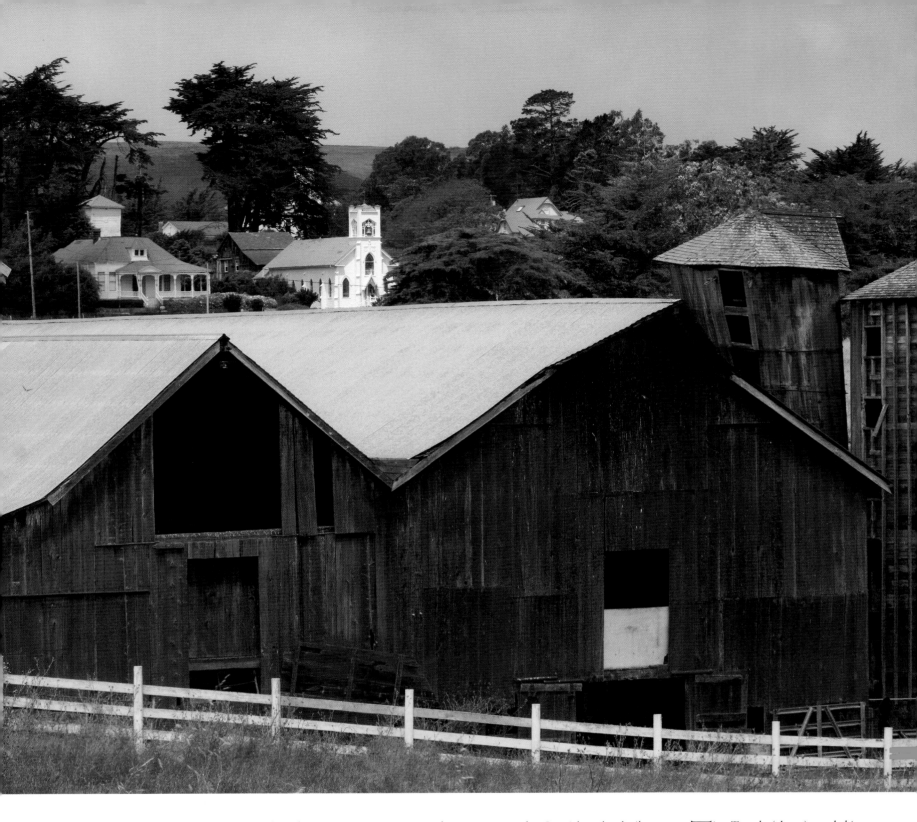

agriculture and promoting organic produce, hormone-free beef and poultry, and natural dairy products.

The region has an unusual geological history: the San Andreas Fault runs past the peninsula's eastern edge, south of long, thin Tomales Bay. Violent earthquakes have radically reshaped this land, leaving lowlands that give way to chaparral ridges and laurel valleys, pastoral meadowlands, fog-bound headlands, and golden-sand beaches. At one stunning cove in 1579 – today's Drakes Bay, according to some legends – British privateer Sir Francis Drake careened the *Golden Hind* to make repairs while claiming 'Nova Albion' for England. The first Europeans to really make

an impact, however, were the Spanish, who built a mission at San Rafael in 1817 and tried to convert the area's Coast Miwok Indians. Within a few years, Mexican independence had ended the mission system, and then the Native American way of life disappeared as well. Mexicans with political connections received valuable land grants, but sales, foreclosures, land swaps, and a casual attitude to boundaries led to decades of complicated litigation that continued after the United States gained possession of California. Finally in 1858, the Shafters' law firm acquired most of the land, and the family set up 31 dairies run by tenant farmers.

Tiny Tomales (above), settled in 1850, retains the look of a 19th-century country town. Once it was a major stop on the region's narrow-gauge railroad, but the massive 1906 earthquake and a later fire destroyed many buildings, and the community never recovered its importance.

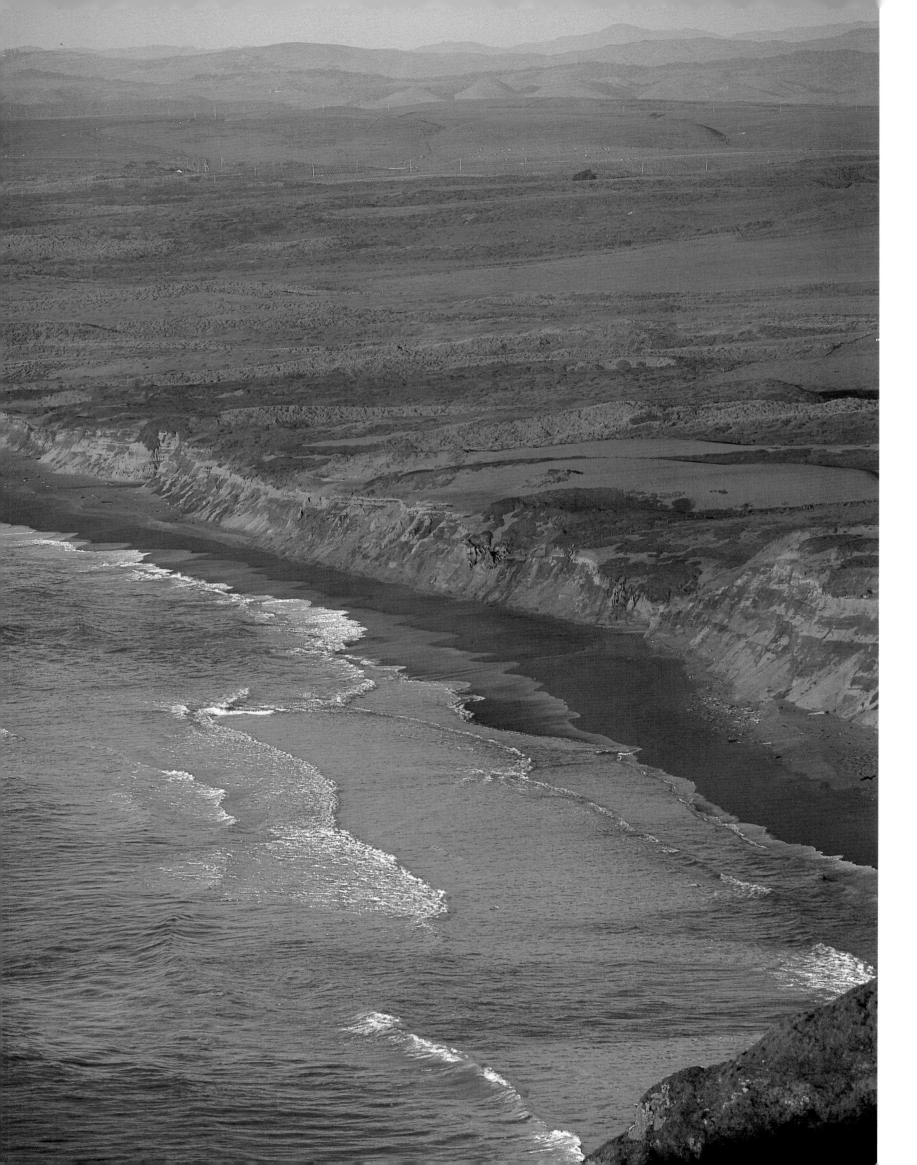

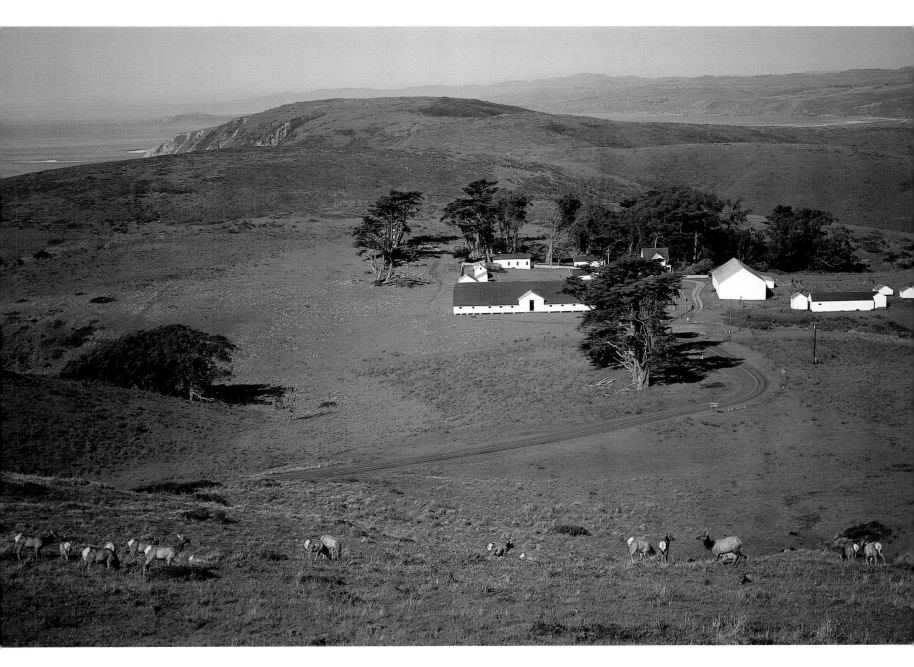

Red cliffs add drama to Point Reyes Beach South (opposite), along the western edge of a peninsula that encompasses chaparral ridges and laurel valleys as well as meadows and ocean-side headlands. One park road passes through a cathedral-like avenue of trees (right). The varied environments nurture myriad birds and mammals, including tule elk, which were reintroduced to a reserve near Pierce Point Ranch (above). The tidy buildings there now shelter interpretative displays instead of cows.

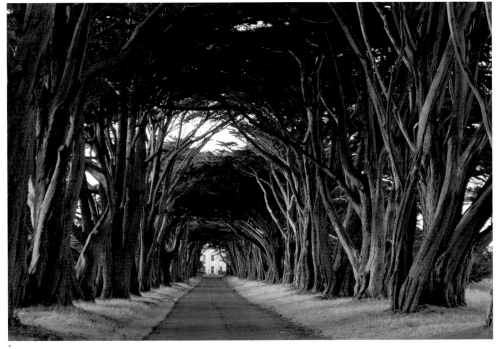

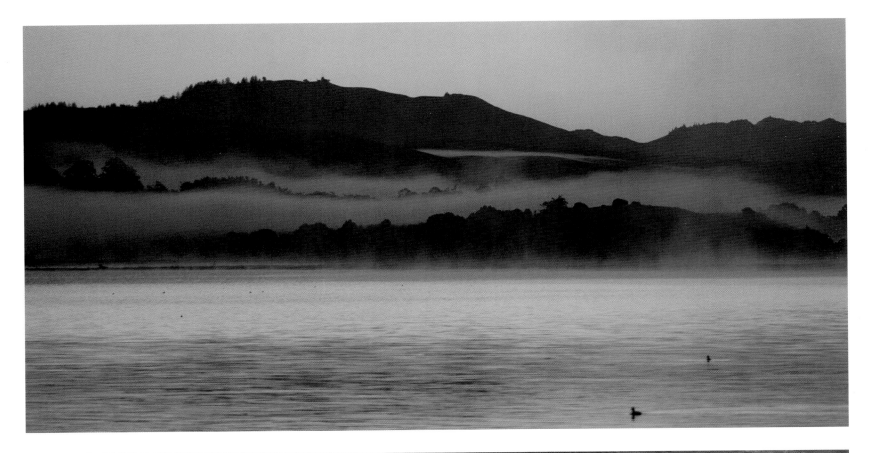

*F*ingers *of fog caress the land along the quiet waters of Tomales Bay* (opposite above), *which separates the peninsula from the mainland. More turbulent seas rage off Point Reyes Beach* (opposite below), *which extends north from the point that juts ten miles into the Pacific. For centuries shipping here was a hazardous business, till the lighthouse beacon* (left) *began shining in 1870. Five year later Point Reyes Station grew up around a railway depot. Cafés, clothes stores, and craft shops now line its quaint main street* (above).

In the 1860s and '70s San Franciscans were hungry for fresh, high-grade butter, and the Point Reyes farms loaded their wares on to schooners and steamers for the trip to the city. The village of Olema became a busy crossroads, with a post-office, hotels, grocery, and saloons, but by 1875 the coming of the railroad had shifted the energy to the station at Point Reyes, which soon was divided into new town lots.

Point Reyes Station still has a slight turn-of-the-century look. The old depot houses the post-office, and a livery stable has become a gym. Behind one gingerbread-trimmed façade is a trendy emporium; an imposing brick bank has become a floral décor shop. There are also galleries and crafts stores, a legacy of the cottage industries begun by hippies who moved here in the 1970s.

Most important, Point Reyes is a gateway to the national seashore, which began in 1962 with the authorization to buy 53,000 peninsula acres and culminated with the establishment of the park a decade later. Point Reyes National Seashore now encompasses working cattle ranches and dairy farms – some of the original Shafter properties. But it's a haven for other wildlife, too. There's a reserve for once-rare tule elk; more than 400 species of birds shelter in marshes, mud-flats, and bays; and sea-lions haul out beneath the 1870 lighthouse, where every winter and spring the ocean reveals gray whales passing offshore.

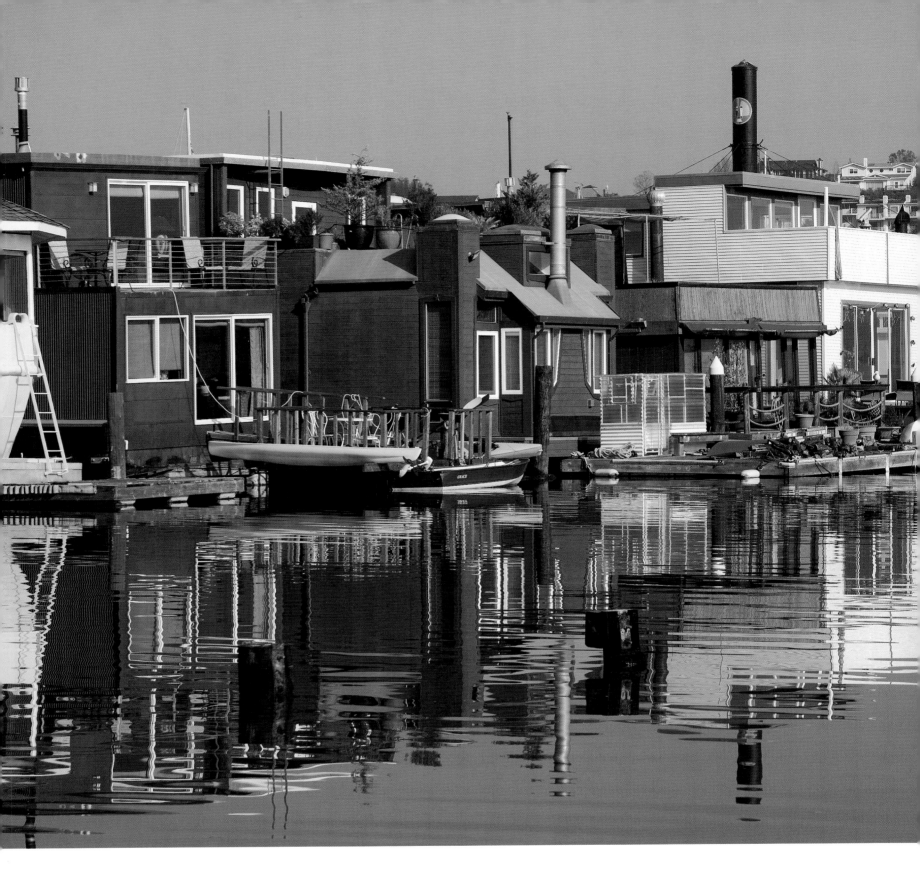

Sausalito

THE HOUSE-BOATS MOORED in Richardson's Bay are as colorful as the characters who have shaped Sausalito's history. There's a white tugboat from 1912 with spiffy red trim; an unforgettable 'train wreck,' constructed out of a railway dining-car that seems to have run into a house; and a memorable replica of the Taj Mahal.

Sausalito's house-boat scene really took off after World War II, when the departing shipyards left surplus watercraft behind. Artists and other free spirits built homes on old lifeboats, and cooperative communities sprang up, the site of poetry readings and raucous parties in the 1960s. The authorities considered the unruly residents a problem, but over time the controversy died down. Recent house-boat rents and sales prices attest to their sky-rocketing value.

The first boats here were the canoes of the Coast Miwok Indians, local inhabitants for some 3,000 years. The Spanish also explored the bay in 1775. But in

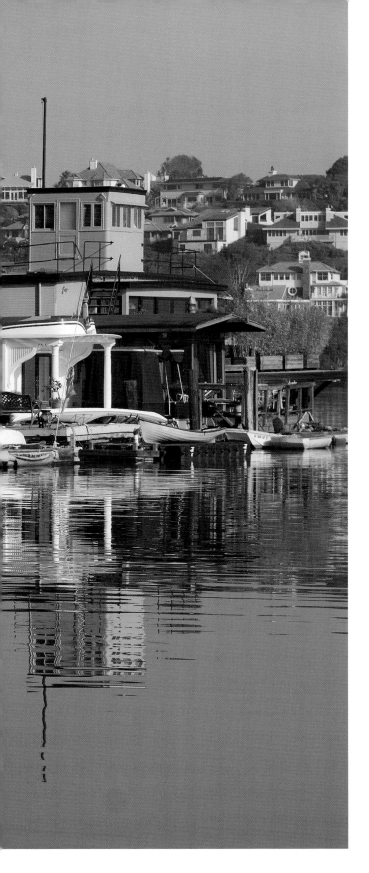

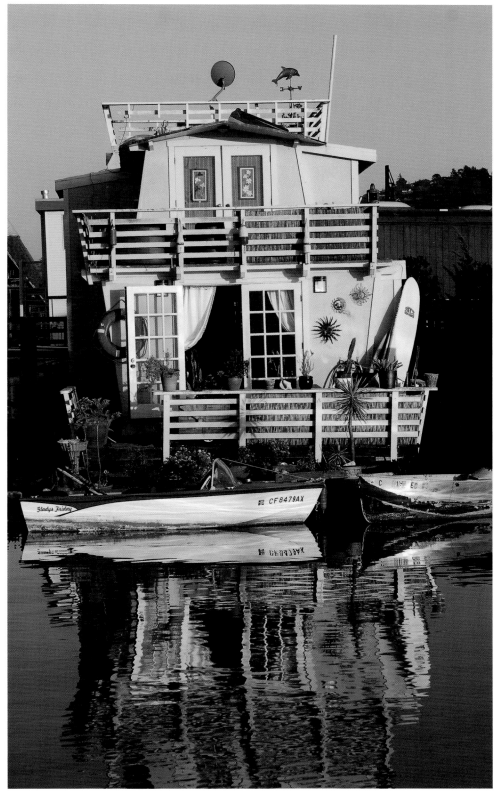

1838 Englishman William Richardson, son-in-law of the commandant of San Francisco's presidio, came to stay. With a land grant for much of Marin County, he built a hacienda and began selling spring water to the whaling ships that anchored here.

Unfortunately the Gold Rush overturned Richardson's dreams of wealth; gold seekers encroached on his property and business deals went bad. By 1868 the Sausalito Land and Ferry Company had taken over his estate and plotted out a town that extended from the mudflats to the panoramic hillsides. The firm also set up a ferry service to San Francisco across the bay. When the railroad was completed, linking northern towns to Sausalito, the waterside town finally began to boom.

The winding terraced streets above the harbor–called the Banana Belt for its semi-tropical microclimate – attracted British society figures and wealthy San Franciscans. Meanwhile immigrants from Italy, China,

*P*roducts of the creative spirit – and often salvaged materials – Sausalito's renowned house-boats (above left) *form entire communities in Richardson's Bay. The space may be small but there's still room for potted plants, a satellite dish, and a surfboard,* (above).

and Greece moved into the lowlands and the Caledonia Street neighborhood. Portuguese settlers began a wooden-boat-building tradition that continues to this day. And though the hill people and the 'water rats' rarely saw eye to eye, the town's personality came to embrace both groups.

Over the years many larger-than-life characters also found a welcome here. Writer Jack London was a frequent visitor early in the 1900s, and during Prohibition, Baby Face Nelson's bootleg whiskey route added to Sausalito's raffish reputation for bars and gambling. Things began to change when the Golden Gate Bridge

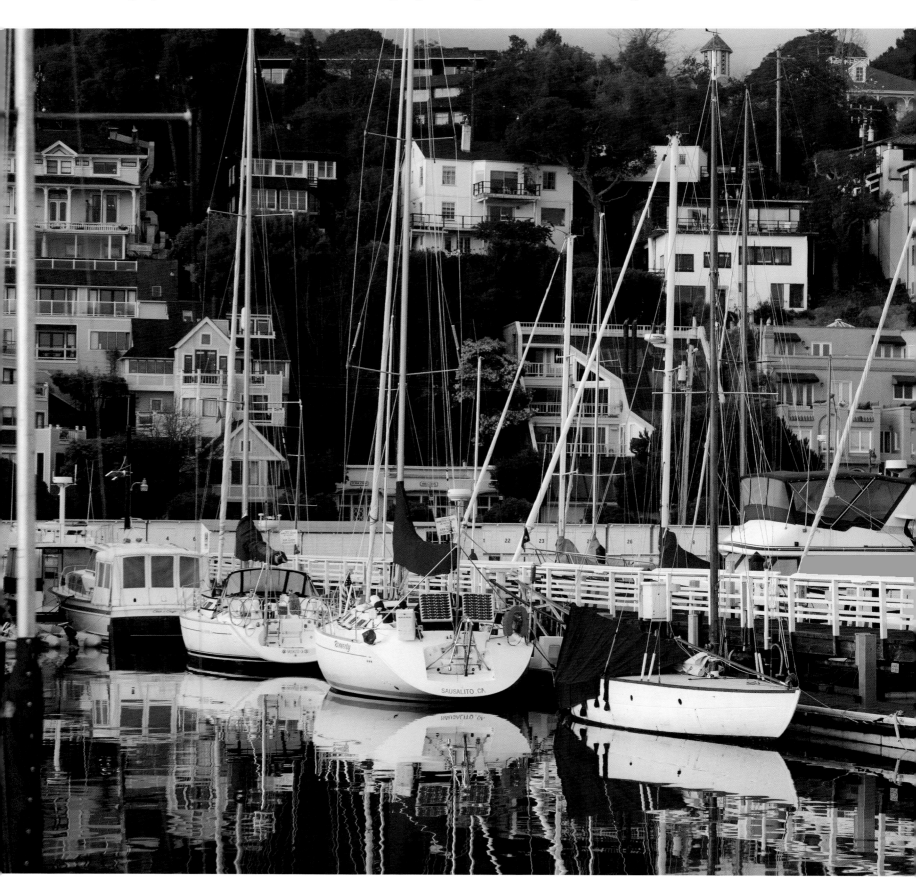

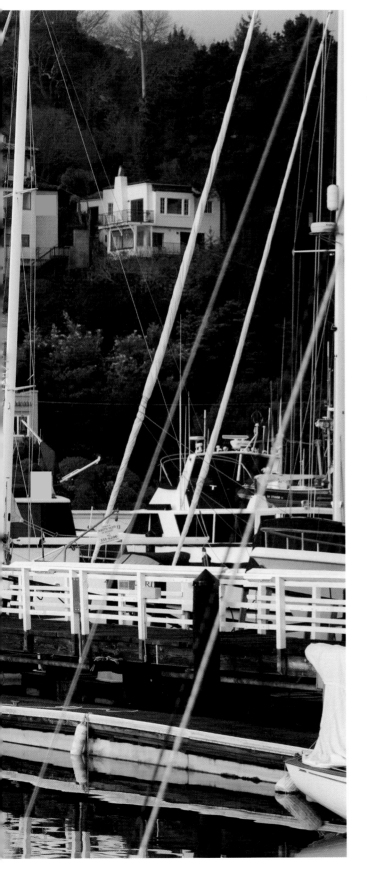

*Y*achts and sailboats line a marina pier (left), *hinting at popular leisure activities in the bay. A prized water view has spurred construction on the densely built hillsides of Sausalito's balmy Banana Belt* (above) *for a century. An unmistakable landmark is visible above Fort Baker* (top), *part of the Golden Gate National Recreation Area.*

*O*ld buildings and new ones line Bridgeway, the town's main thoroughfare (far right *and* below), *which boasts numerous shops, restaurants, and watering holes, including one with no name. A second commercial center has sprung up on Caledonia Street, where Studio 333 (bottom) showcases local artists. Other painters display their work on utilitarian objects* (right).

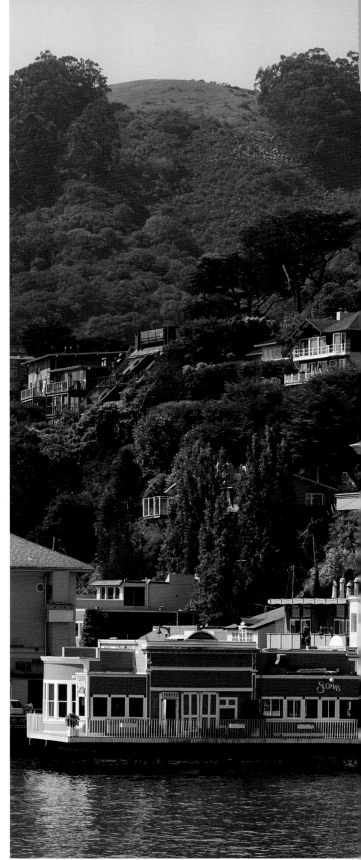

was finished in 1937, then World War II finished the transformation. In the huge Marinship yard, built over hastily filled-in waterfront land, some 70,000 workers turned out 93 Liberty ships and tankers before 1945.

After peace returned, artists and writers rediscovered Sausalito. The bohemians gathered at the now-closed Tides Bookstore on Bridgeway Street and drank at the

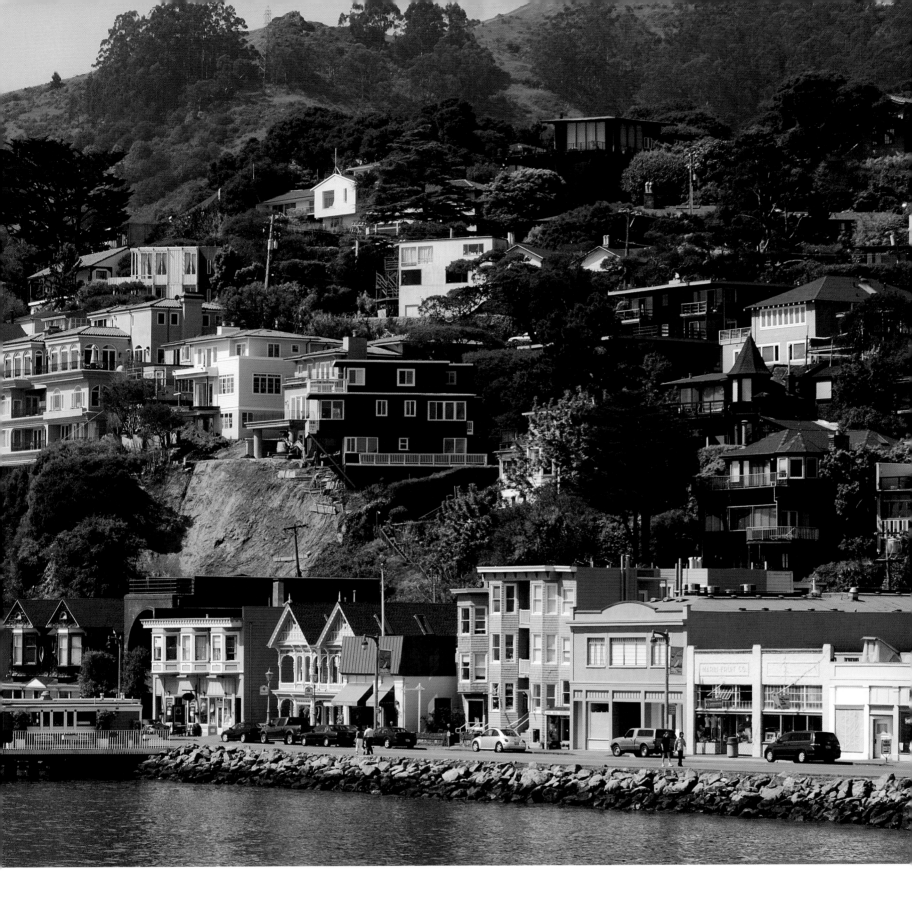

No Name Bar, which still serves cocktails a few doors down. Sally Stanford, a former San Francisco madam, came to town in 1949, and turned the Walhalla saloon into the famed Valhalla restaurant, and after six runs for office was elected mayor in 1972.

Today's Sausalito is as mixed as the chockablock Victorian façades and newer buildings that house attractive boutiques, galleries, restaurants, and cafés and give the town its European air. Extensive marinas have been added to the old yacht club and the houseboat wharves, and the Marinship area is home to artists' studios, multimedia and software companies, and boat builders and restorers whose creations hark back to Sausalito's past.

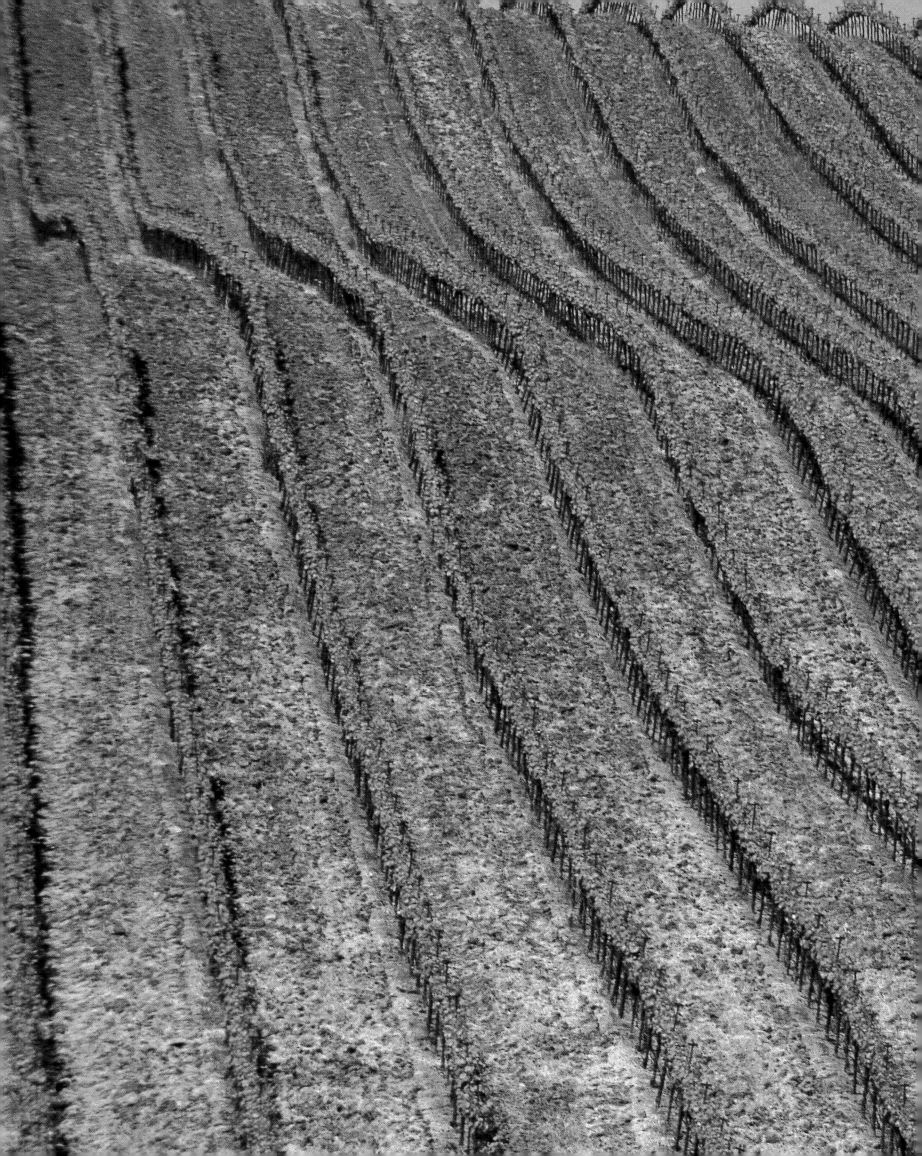

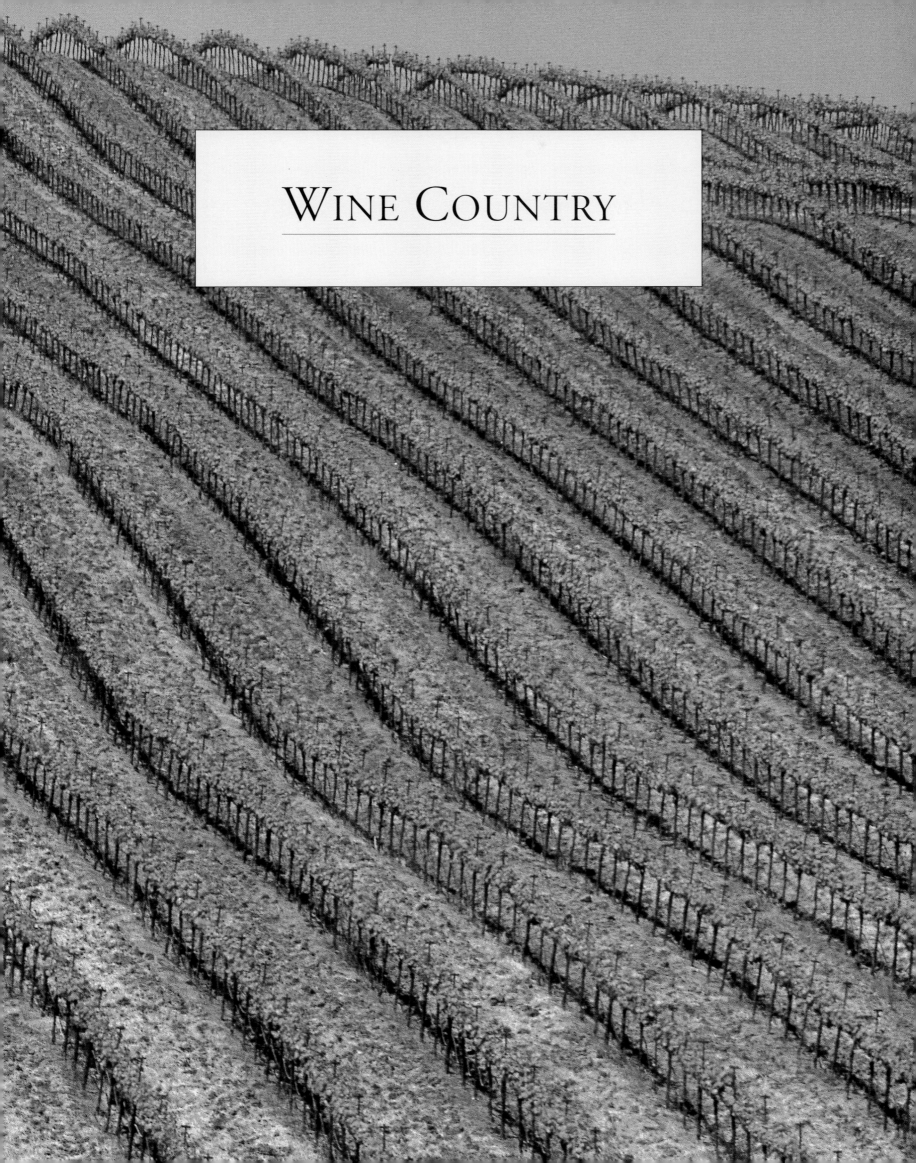

Wine Country

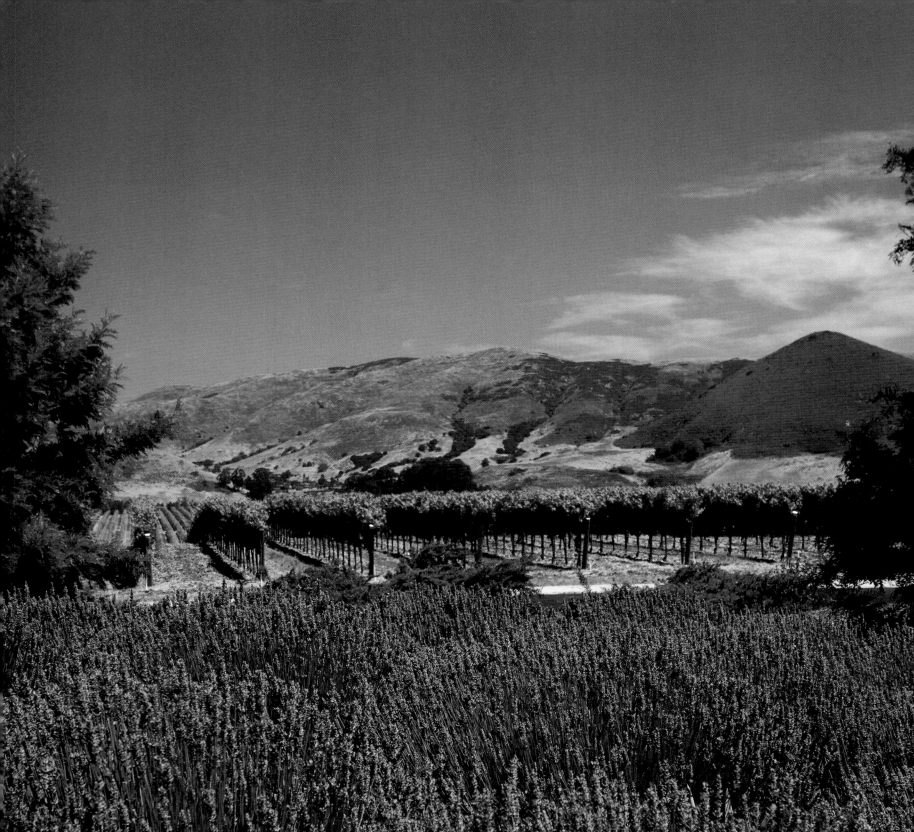

Tilt a glass of Cabernet Sauvignon. Examine the color. Savor the aroma. Then take a sip, and reflect on the romance of California's wine country. In the Napa and Sonoma Valleys, the Sierra foothills, and on the Central Coast, wine-tasting has gone beyond merely drinking a beverage to embrace an entire lifestyle. Movie-maker Francis Ford Coppola, comedian Robin Williams, and race-car driver Mario Andretti are just a few of the celebrities to buy a country estate, plant grapes, and bottle their prized vintages. Even ordinary mortals now seek out weekends in wine-country inns, grapeseed-based spa treatments, elegant wine and food pairings, and home décor that evokes a vineyard villa.

California's love affair with the grape had a far more sober beginning – going back to the first vines planted by Father Junípero Serra for sacramental wine. One of the museum rooms at Mission San Juan Capistrano still has the sunken vat where Indian boys stomped the grapes to crush out the juice. In Sonoma the friars passed vines along to one of their carpenters: George Yount later planted his cuttings on his rancho over the mountains, in the Napa Valley. And when the Sonoma Mission was secularized in 1834, General Mariano Vallejo, the commander of Alta California's north-western frontier, took some of the grape-vines to make his own wine and brandy.

By then grapes were grown in many parts of California. Santa Barbara's De La Vina Street recalls the vineyards in that presidio. And neighboring Montecito's most famous landmark may have been La Parra Grande, a staggeringly huge grape-vine supposedly planted around 1780 as a love token. The legendary vine produced four tons of grapes each year and lived on till 1876, when it was cut down and hauled off to the Philadelphia Exposition. In Los Angeles, a French immigrant aptly named Jean-Louis Vignes imported cuttings from France and set up California's first commercial winery. The Gold Rush, however, changed the wine industry as radically as it affected every other aspect of life in the burgeoning state. Among the immigrants pouring in, Italians and Croatians drew on wine-making traditions to plant grapes in the Sierra foothills. Most of the action, though, took place closer to San Francisco.

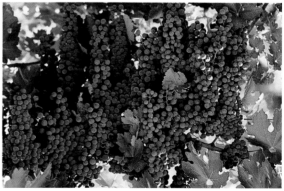

*G*rape-vines ridge a hill in Sonoma County (preceding pages).

*F*ields of lavender add their own shades of purple to vines in the Edna Valley (opposite), *in Central California. The state's grape-growing regions draw throngs of visitors every year who enjoy the sight of ripening fruit* (above) *but undoubtedly savor the aroma and taste of the wine* (top) *even more.*

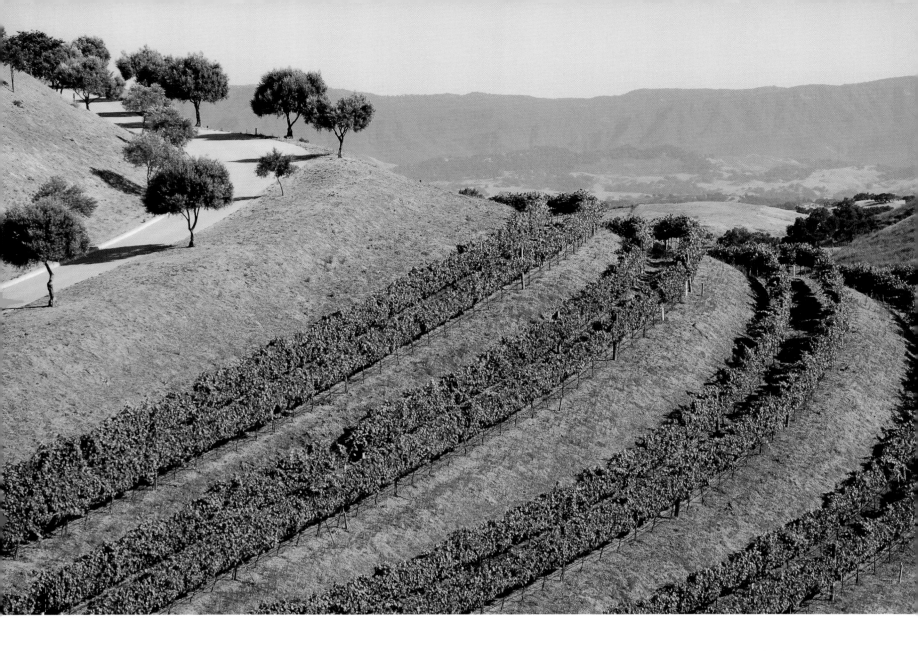

Varied soils and microclimates contribute to the distinctive characteristics of each vineyard, whether it curves around a Los Olivos hillside in Santa Barbara County (above) *or shoots straight across the Napa Valley floor* (opposite above). *The resulting* terroir, *or expression of the earth, is embodied in the grapes themselves at harvest time* (both opposite below).

Energetic, imaginative Count Agoston Haraszthy had fled his Hungarian grape-growing estate in 1842. Settling first in New York and Wisconsin, he tried businesses that ranged from a brickyard and sawmill to a general store, then made his way to San Diego, where he was elected state assemblyman. In 1854 he wangled an appointment as an administrator of the federal mint in San Francisco, but his tenure was clouded by the disappearance of $151,000 in bullion. Undaunted, Haraszthy bought more than 800 acres of Sonoma land from General Vallejo, and in 1857, the Hungarian established the Buena Vista winery. He planted thousands of vines, dug storage tunnels into the limestone hillsides, built an impressive stone press house, and eventually canvassed European vineyards to find the best grapes to improve his stock. A tireless promoter of California wines, he sent back more than 100,000 cuttings, sharing them with other growers.

Meanwhile, Prussian immigrant Charles Krug had begun to turn out wine in the Napa Valley for another entrepreneur, using a cider press to crush the grapes. When Krug married in 1860, his wife's dowry included land near St. Helena, and he immediately put in acres of vines, becoming

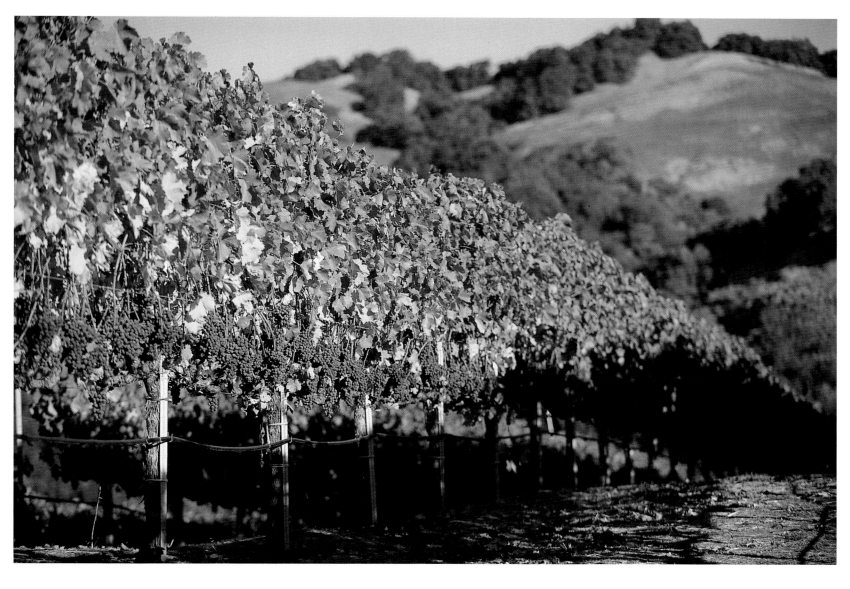

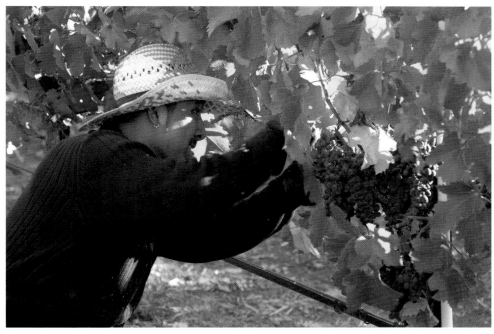

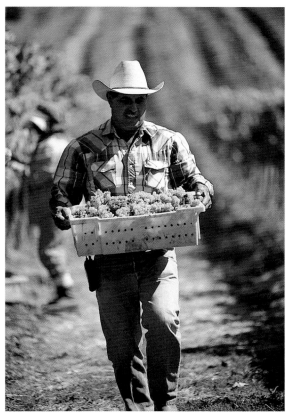

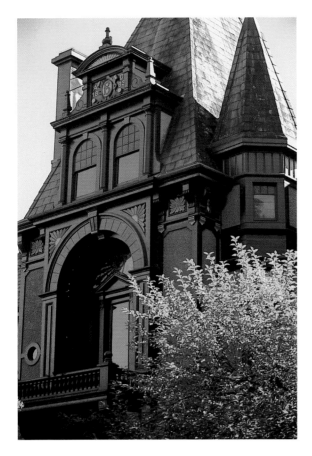

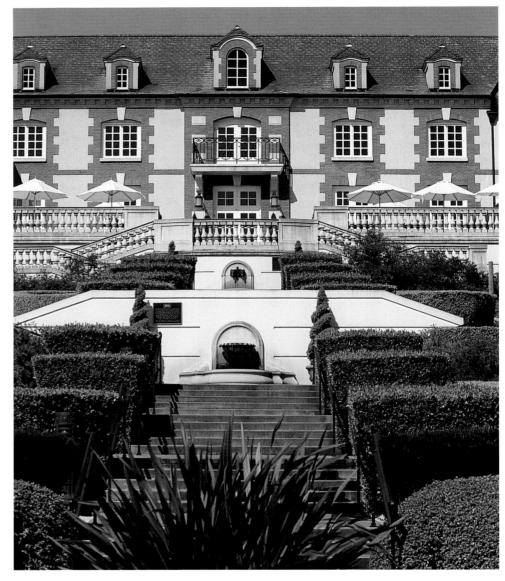

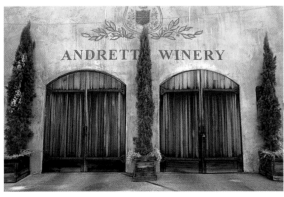

Winery architecture often evokes foreign lands, like the French château at the Napa Valley's Domaine Carneros (above right) or the Mediterranean-inspired Andretti Winery (above) near Yountville. Pioneering wine-maker Frederick Beringer named his ornate Victorian mansion in St. Helena (top) the Rhine House.

one of the valley's most prominent vintners. Other talented wine-makers joined in, including Frederick and Jacob Beringer, from Mainz, Germany; Rhineland native Jacob Schram; and Gustave Niebaum, born in Finland. Their wines became famous for high quality, and their building projects attracted equal attention. Behind the monumental press houses, miles of tunnels were pickaxed out of the mountains by Chinese laborers who had finished laying track for the transcontinental railroad, and Frederick Beringer's Rhine House and Niebaum's Inglenook château rivaled Old World mansions in their luxe appointments.

The vintners prospered when phylloxera devastated vineyards in France in the late 1870s, eliminating the competition. Unfortunately, the root-eating louse spread to California, too, compounding the effects of a nationwide depression; more than one winery failed before the wine-makers discovered the secret of grafting varietal vines on to resistant rootstock. Then, on January 17, 1920, came Prohibition. Though the Beringers had a rare license to produce sacramental wine, and some growers stayed afloat by shipping grapes across the country – home wine-

makers were exempted from the Eighteenth Amendment – most wineries closed. By the time the legislation was repealed in 1933, the Depression had eliminated the market for fine wines.

Fast forward a few decades: by the end of World War II, some of the old wineries had regrouped and reopened, and new vintners had entered the scene, particularly in the Napa Valley, where in the 1960s thousands of tourists tried a new pastime called wine-tasting. Finally, in 1976, a Stag's Leap Cabernet Sauvignon surpassed French wines in a blind tasting in Paris. California wines were back on center-stage.

The state's varied terrain attracted vintners interested in different varieties of *vitis vinifera*. Fog-cooled climes outside Monterey and in Santa Barbara County suited Pinot Noir and Chardonnay. Amador County's Sierra foothills attained a reputation for jammy Zinfandels. Today, California wines are prized around the globe, holding 25 of the top hundred spots in a 2005 *Wine Spectator* ranking – including five of the ten best.

Automobiles, limousine tours, and buses filled with wine aficionados throng the roads of Napa and Sonoma, the Central Coast, and Gold Country; in response, the wineries have welcomed them with re-created castles, Tuscan-style villas, Victorian schoolhouses, and oak-shaded picnic grounds. At Clos Pegase, near Calistoga, architect Michael Graves has even created a 'temple of wine and art' that includes exhibition space for the owner's collection of paintings and sculpture.

Wherever highway signs point the way to wine-cellars, inns and restaurants are sure to follow. For many visitors, day-long tasting excursions turn into weekend jaunts; single meals lead to intensive culinary courses; overnight stays give birth to the desire for full-time wine-country living.

Along with the grapes there are olive groves, lavender fields, and organic gardens whose produce commands premium prices. World-renowned restaurants offer California cuisine – matched with the proper California wine, of course. For those who crave the wine-country experience at home, boutiques sell grape-themed coasters and napkins, gourmet mustards and fig tapenades, lavender soaps and even purple garden hoses. They can cap it all off by screening *Sideways*, the award-winning movie that added satire and romance to a heartfelt celebration of California wine.

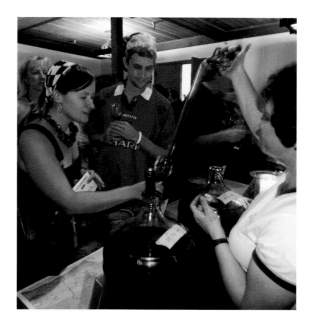

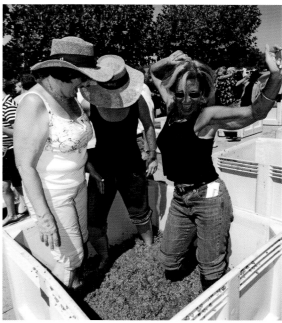

Fruit on the vine inspires grape expectations (top left), *and wineries often respond with special events. At The Gainey Vineyard in the Santa Ynez Valley visitors may be invited to preview a vintage* (top) *or get into the spirit of a stomp* (above).

NORTHERN CALIFORNIA
MOUNTAINS AND VALLEYS

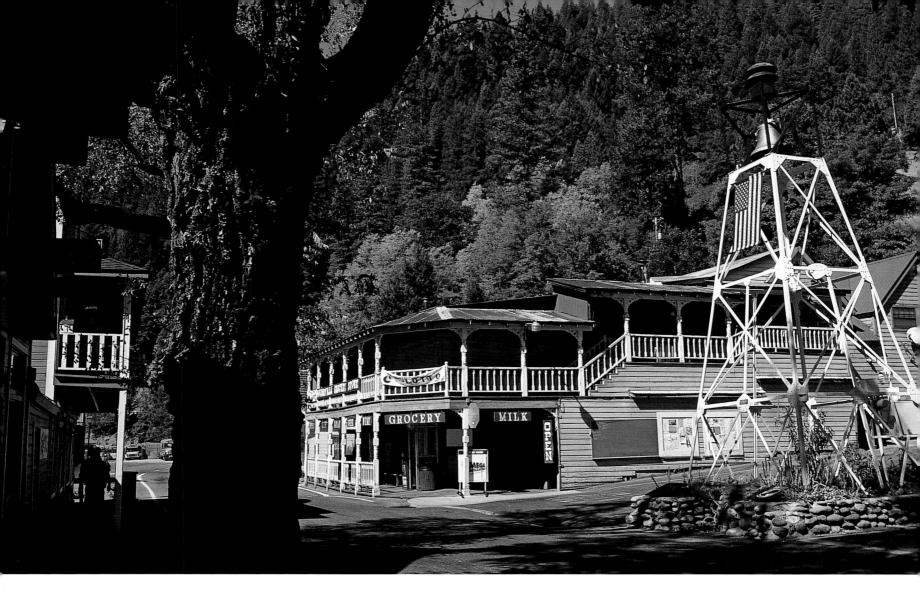

Downieville

TWO RIVERS MEET in the center of Downieville, flowing together beneath the pine-forested slopes of the Sierra foothills. The North Yuba and the Downie have shaped the history of this town for more than 150 years, creating both boom times and disasters. In September 1848, gold that had washed out of the hills was discovered at the river fork. Winter put an end to the first season of prospecting, but the following spring hordes of miners arrived, hoping to strike it rich. Some of them did. Eventually 30 million dollars of gold came out of the county's ground.

By 1852 there were 4,855 inhabitants in Downieville, mostly under 35, and just 106 of them women. The times were colorful: the town was christened, legend has it, after James Downie offered to throw a pan of gold-dust into the street if the residents named the community after him. But the times were also rough: an angry mob actually hanged a woman, a Mexican called Juanita, after she stabbed a miner who had insulted her.

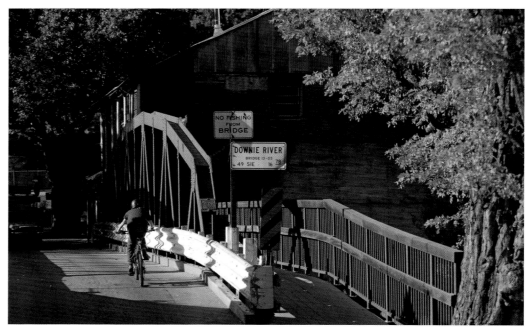

The 8,000-foot Sierra Buttes dominate their corner of northern Gold Country (preceding pages).

Downieville's stunning river-and-pines setting (opposite) increasingly attracts residents who want an alternative to big-city living. A single-lane bridge spans the Downie River (above). The first fire-proof building (top), has survived since 1852.

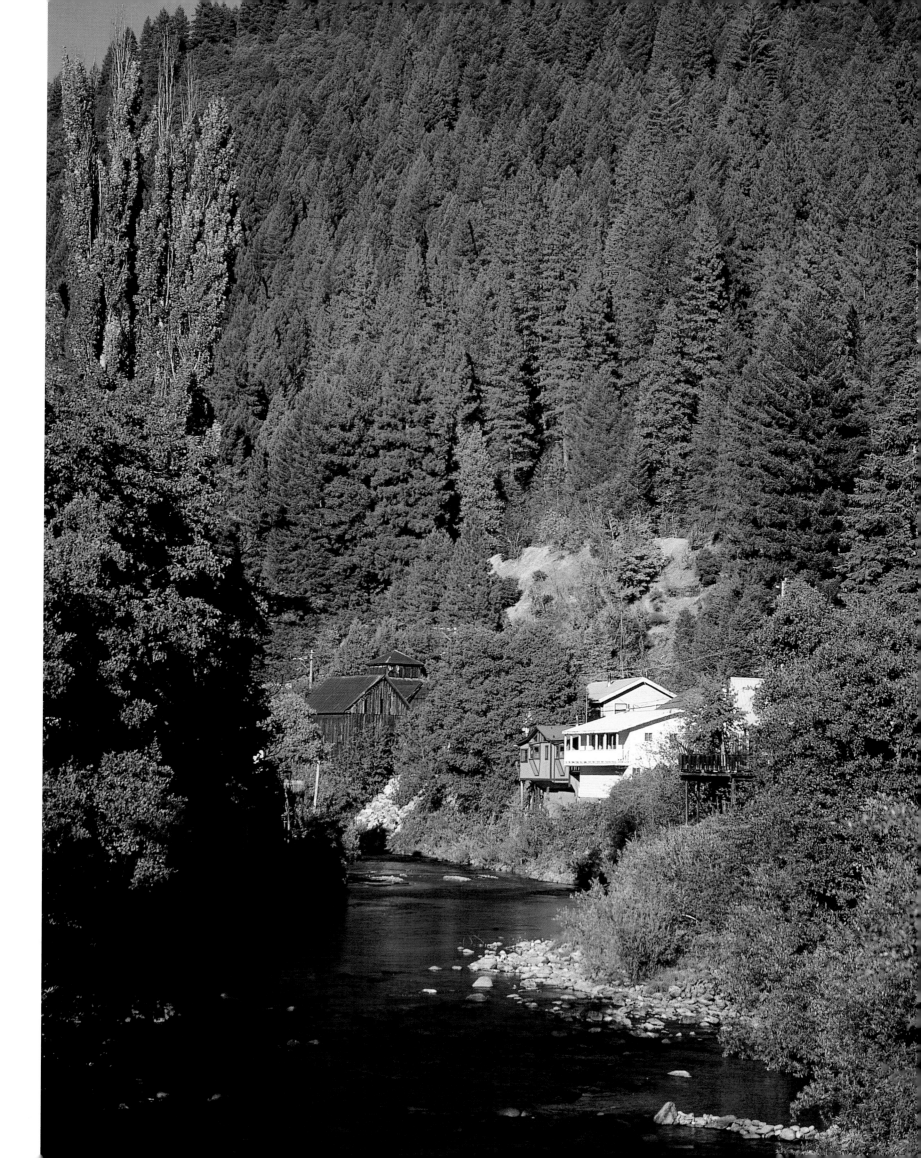

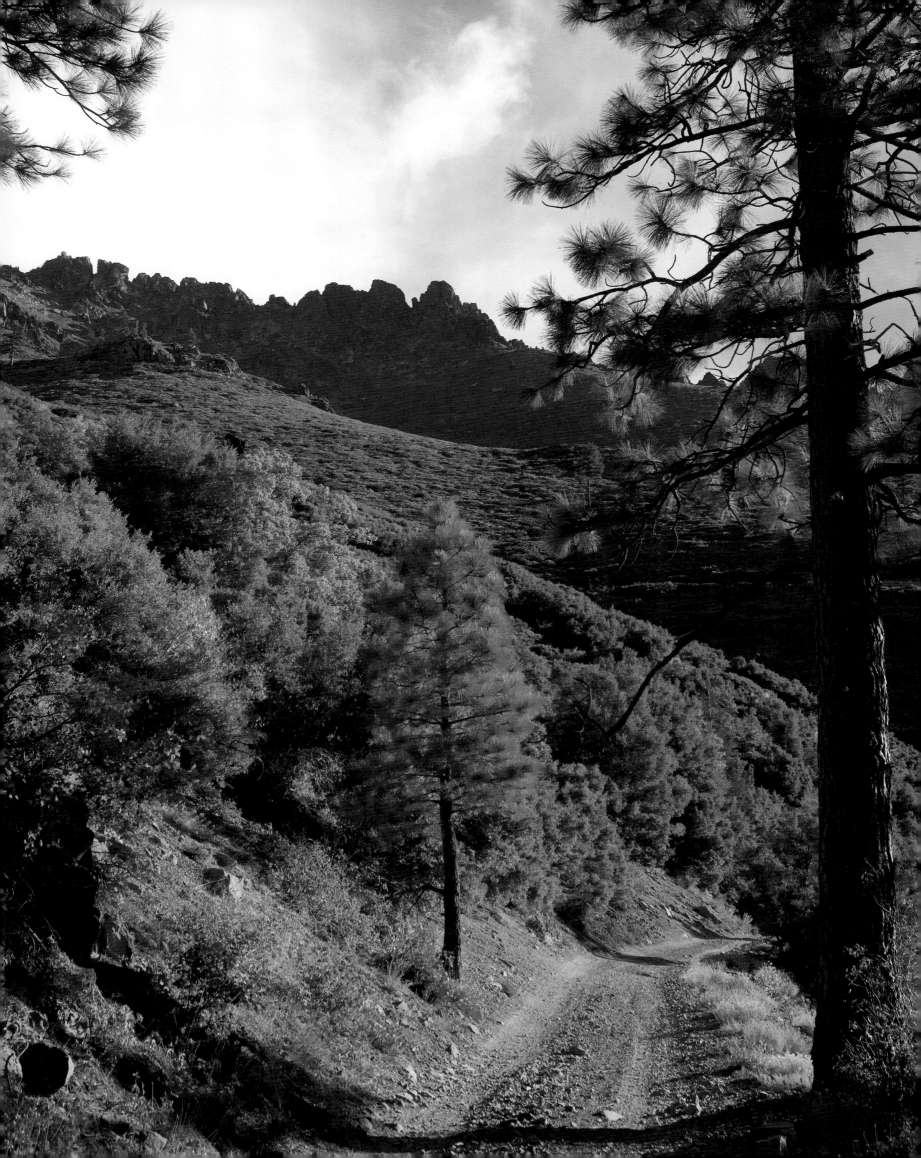

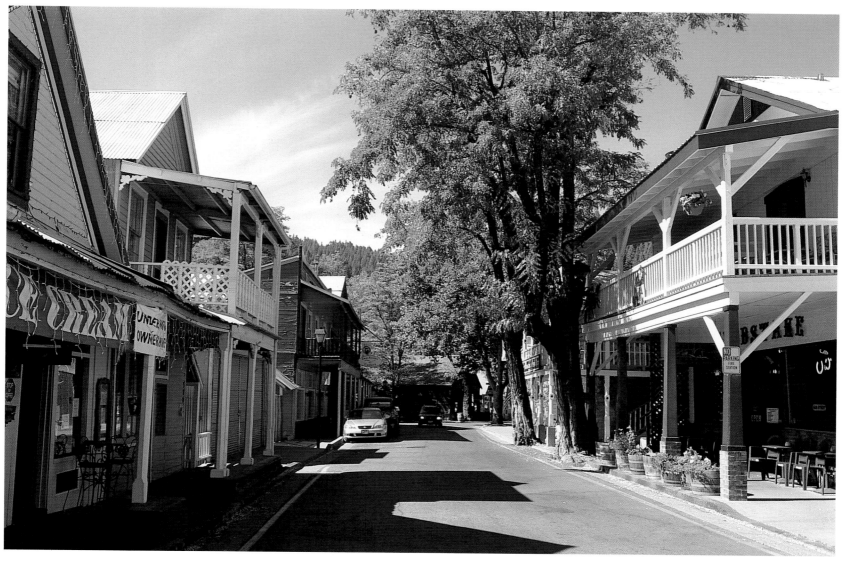

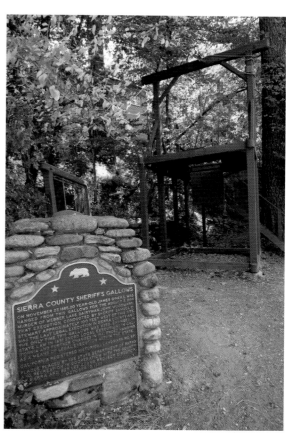

An unpaved road outside Sierra City points the way to the saw-toothed Buttes (opposite). A plethora of old mining trails makes the region a mountain bicyclists' mecca; the river attracts campers and anglers as well. For less active visitors, there are crafts shops, bars, and restaurants in the Western-style buildings (above) along Downieville's raised wooden sidewalks. The town's gallows (right) is authentic. Used only once, to hang murderer James O'Neal in 1885, it was disassembled in 1888 and packed away for a century, then restored in the present spot near the court-house.

Though Downieville's population has dwindled to less than a tenth of what it was in the early 1850s, much of Main Street still looks as it did then, with wooden sidewalks and low brick façades that enclose restaurants and bars, boutiques, antique stores, and wine shops. Floods and fires swept away many structures over the years, but four buildings from 1852 survive: the Claycroft Building, the saloon where Juanita sought refuge from her attackers; the grocery, in Downieville's first fire-proof building; the offices of the *Mountain Messenger*, which boasted Mark Twain as a contributor; and an old Chinese store. There, in a brick-and-shale building, the Downieville Museum displays an odd assortment of artifacts and memorabilia – from maps and clothes to a valuable assayer's case and an unusual Aeolian organ, a breadbox-shaped instrument that uses punched-paper music rolls to pump out 'In the Sweet By-and-By.'

Across the one-lane Jersey Bridge that spans the Downie River, another museum, in an 1855 foundry, stands as a monument to the toolmakers who labored here till the turn of the century. Inside there are displays on local history, miners' apparatus, a huge annealing oven, and a replica entrance to the Ruby Mine, as well

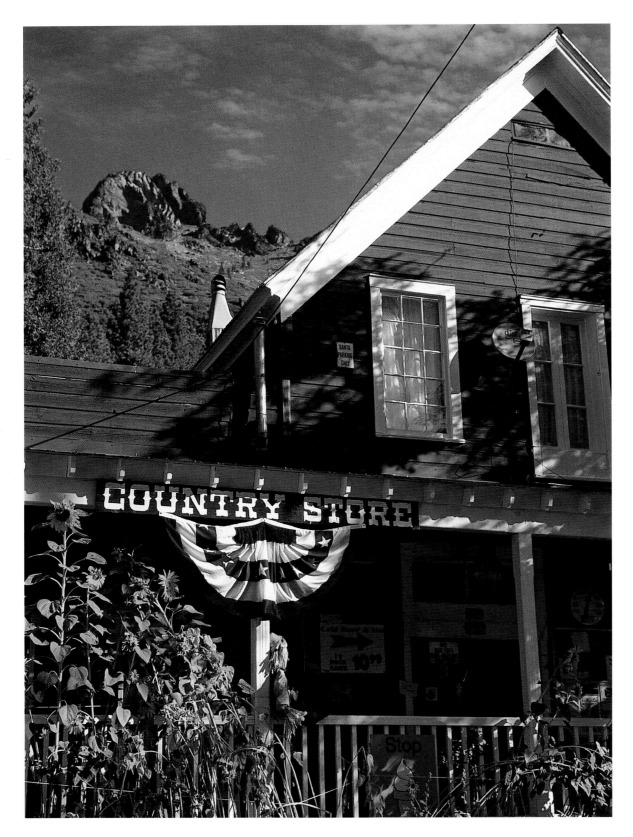

Dwarfed by the Sierra Buttes, a fisherman tries his luck on shimmering Sardine Lake (opposite). *Nearby Sierra City's Country Store* (left) *epitomizes the town's rustic redwood look. In Downieville an old Chinese emporium, built in 1852, now houses the local museum, with a wealth of clothes, signs, household objects, tools, and other curiosities of life in a historic Gold Country settlement* (below).

as an exact model of Downieville in 1860. The town's lost-in-time atmosphere increasingly attracts big-city residents interested in moving to a mountain town without stoplights, franchise restaurants, or even cell-phone service. Others come for a shorter getaway of fishing, hunting, hiking, camping, and kayaking. The pack trails that once supplied the miners have found new life as mountain bike paths. Downieville's annual Mountain Bike Festival attracts a thousand racers to the competitions, including the 'river jump,' which ends with a plunge into the water, bike and all.

About 10 miles east – and 1,300 feet higher– is tiny Sierra City, which also boomed during the Gold Rush as miners tunneled into veins in the Sierra Buttes that loom more than 8,000 feet high behind the town. The crags form an alpine backdrop for pristine lakes bordered by campgrounds, and the most precious gold now is the sunlight that illuminates the bare pale peaks.

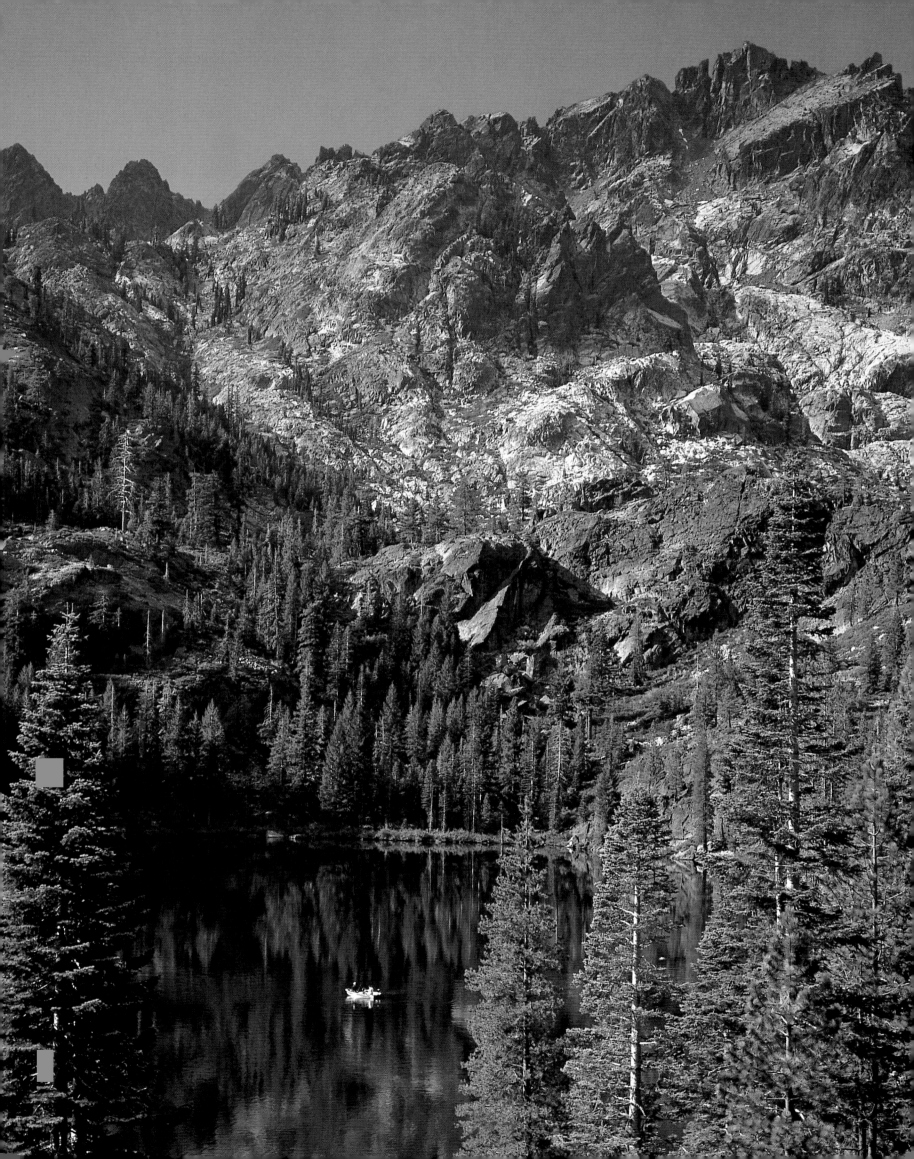

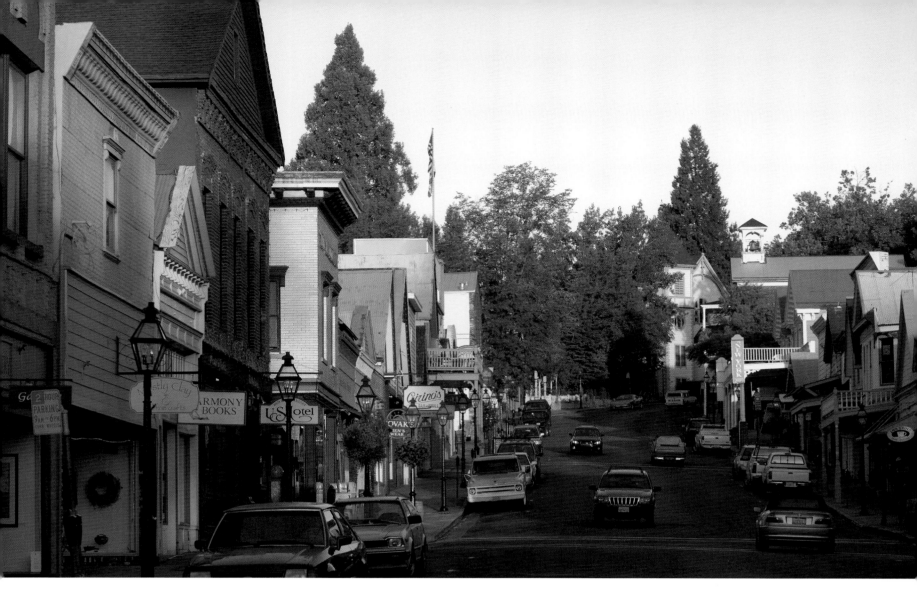

Nevada City

The gaslights along Broad Street, Nevada City's main thoroughfare, are real, adding to the impression that this town of Victorian houses, shops, churches, and hotels sits in a time warp in the mid-1800s, instead of on the boulder-lined banks of pretty Deer Creek, 60 miles north-east of Sacramento.

Like many of the settlements in the Sierra foothills, the town – whose name means 'snow-covered' in Spanish – exploded into being in the first flush of the Gold Rush. By 1850 there were 10,000 people here – more than three times the current population – mostly miners panning, sluicing, and dredging gold along the creek and raising a ruckus in town. But Nevada City does not lie along the mother lode, and the easy diggings soon vanished, replaced by underground hard-rock mines that persisted until the 1950s. Two nearby state historic parks, the Empire Mine and Malakoff Diggins, showcase the mines, methods, and equipment that brought the precious mineral to the surface, and allow visitors to hike and enjoy the Gold Country landscape. In Nevada City

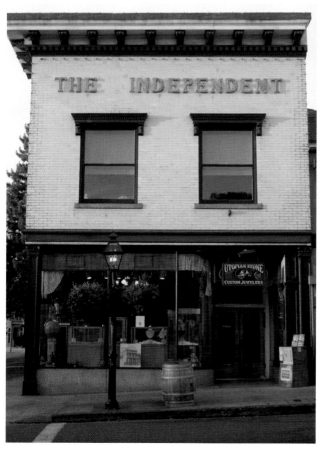

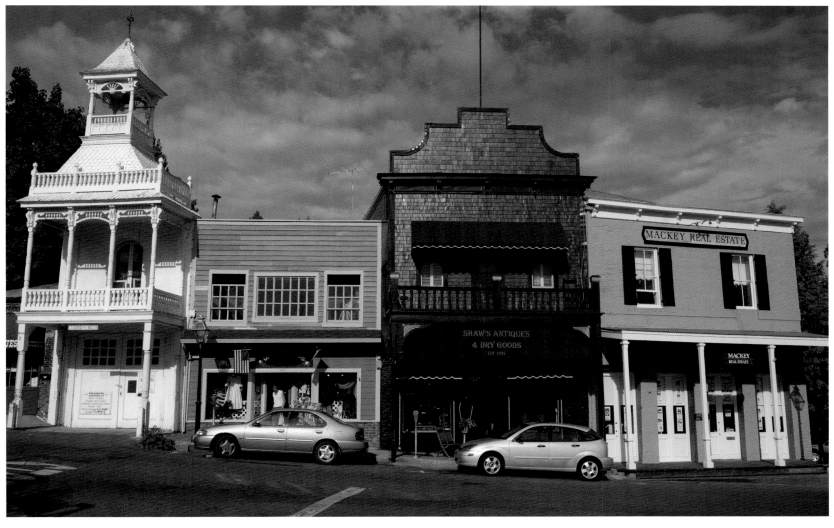

*W*ith its entire downtown listed on the National Register of Historic Places, Nevada City presents a fascinating array of 19th-century façades along Broad Street (opposite above). After fire destroyed many of the earliest houses and businesses, residents put up two brick firehouses in 1861. On Main Street, Number 1, painted white with carved balustrades (above) is now a museum; Number 2 (right) on Broad, is only slightly plainer. In the old Independent building (opposite below), the glittery touches are inside, in the form of gold-and-quartz jewelry.

itself, the Miners Foundry, in a cavernous stone-walled building now a cultural center, supplied ore cars, tools, and stamp-mills to the region, and also built the 'Pelton wheels' that revolutionized hydroelectric power production after they were invented in this county in 1879.

With so many rowdy souls and a lot of wooden houses, it wasn't surprising that the city burned down several times; a fire in 1856 destroyed 400 homes and businesses, causing the settlers to rebuild mostly in brick, often with decorative touches. Even the two firehouses dating to 1861 are picturesquely elaborate – tall, narrow structures with balconies and bell towers.

Nevada City's Historic District includes almost a hundred 19th-century buildings. The National Hotel, from 1856, preserves its Victorian look with painted green and white columns and wrought-iron banisters; inside the lobby, settees flank a venerable square grand piano. And a showpiece of the atmospheric lounge is the carved wooden back bar, which once served as the buffet in the Spreckels mansion in San Francisco.

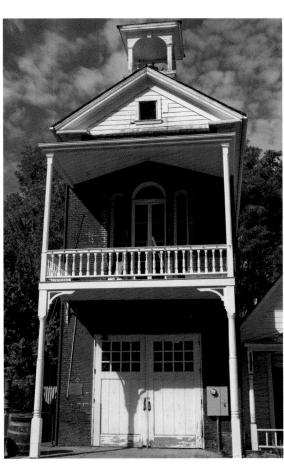

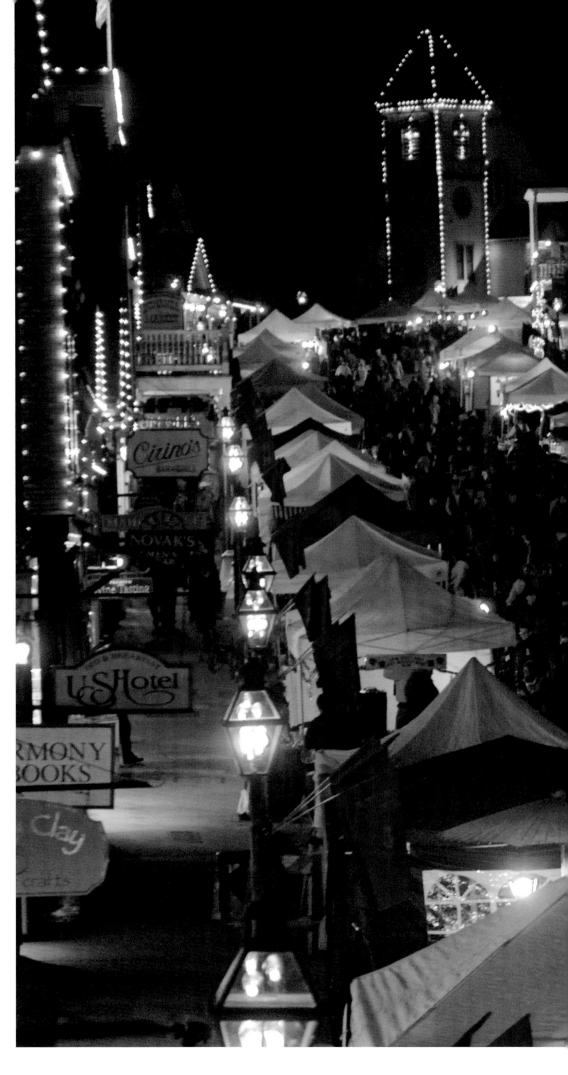

*N*evada City's working gaslights come on every night, but during the annual Victorian Christmas (right), the illumination receives an added boost. Costumed residents welcome visitors with libations (top) and song (center). Often the party continues indoors, at the Mine Shaft Saloon (above).

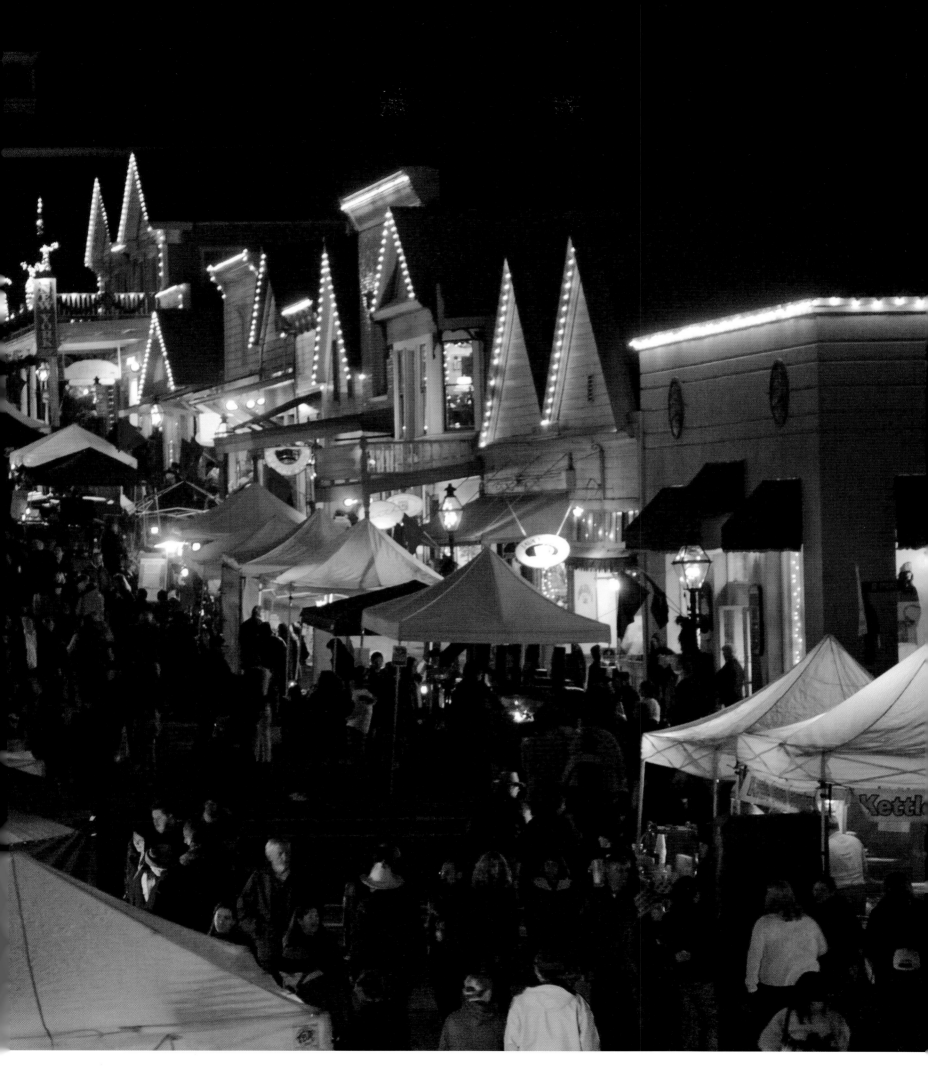

Another landmark, the Nevada Theater, opened in 1865. It would welcome to its stage such luminaries as story-teller Mark Twain, novelist Jack London, and opera singer Emma Nevada (whose family home is now a charmingly renovated inn). At the far end of Broad Street stands the home of A.A.Sargeant, who owned the county's first newspaper and later left his law career to become a U.S. Representative and Senator. His gracious white mansion was later converted to a bed-and-breakfast but is once again a private residence in a park-like setting.

Other historic sites include the Searls Historical Library, a yellow-brick cottage that was a law office for three generations of attorneys, and the town's public library, with its original cornices, ceiling decoration, wood, and stained glass from 1907.

Behind the historic façades are a host of contemporary establishments that range from art galleries and clothing boutiques to bookstores and chic restaurants. And, of course, there are jewelry shops whose elegant gold-and-quartz creations make a glittering memento of Nevada City's past.

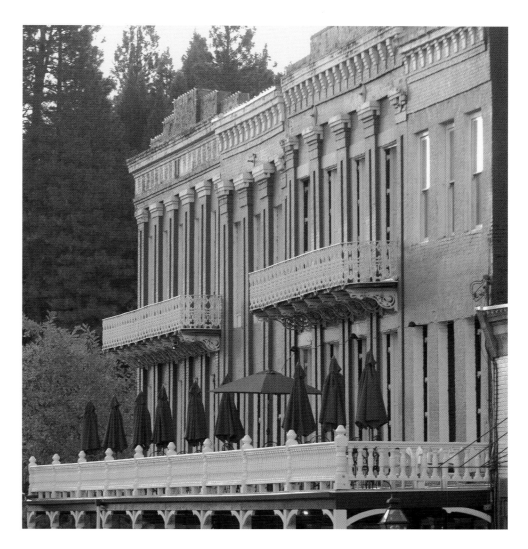

Victorian touches are beautifully preserved in a gracious bay-windowed clapboard house (opposite). The National Hotel is composed of four stylish brick buildings (right) from 1854–57. On Main Street are the town's earliest commercial structures (below). The South Yuba Canal Building, on the left, dates to 1855; Otts, from 1857, was an assay office.

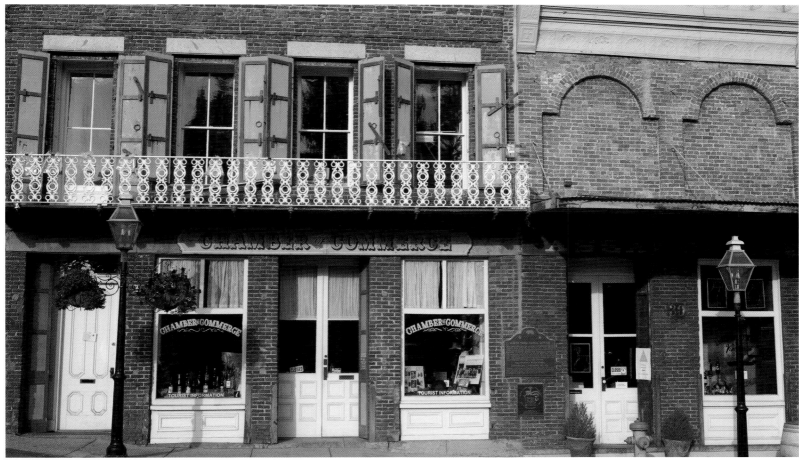

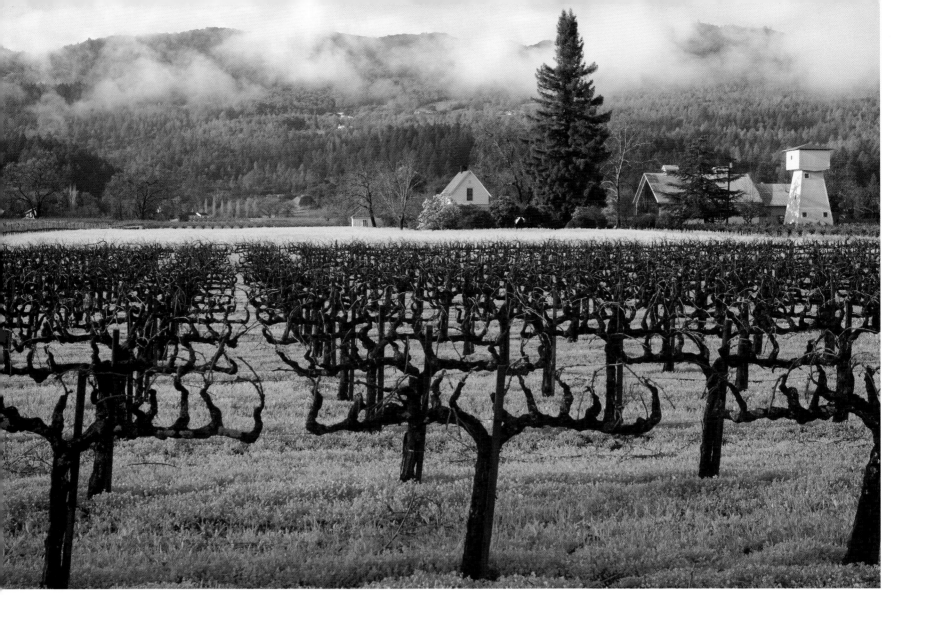

St. Helena

Cabernet grapes ripen in the sun (opposite) on Mt. Veeder, in the Mayacamas Mountains. Morning mist shrouds the Napa Valley in early spring, when mustard's gold adds color to vineyards whose old vines are still bare of leaves (top). By fall they will be laden with the fruit (above) that draws wine aficionados to this valley and St. Helena.

FROM THE WEST, a narrow, twisting road rises over the rugged Mayacamas Mountains, then descends toward St. Helena, revealing a stunning panorama of vineyards. Here in the heart of the Napa Valley, the seasons of the grape begin in early spring, when the bare roots and pinioned branches are set off by a carpet of golden mustard, and end with the fall harvest of luscious fruit.

The story of grapes here dates back to the Mexican Republic, which granted large tracts of land to favored settlers. One of those, George Yount, established his Caymus Rancho in the 1830s and planted the grape-vines he had obtained from the Franciscan friars in Sonoma. A dozen miles north, Edward Turner Bale raised cattle and planted wheat on another huge rancho, and in 1846 set up a grist-mill near an oak-shaded stream. Bale could not hold on to his lucrative estate, however. Before he died, he had sold or exchanged much of his land with pioneers drifting into

the valley. But his partly restored mill, with its 36-foot-high overshot wheel, still stands as the showpiece of a state historical park.

The discovery of hot springs in the valley in 1852 led to the founding of White Sulphur Springs Resort and the beginnings of St. Helena nearby. Word of the valley's apparent aptitude for growing grapes also spread. Charles Krug, a Prussian immigrant who had followed the Gold Rush trail to California, began by making wine for other entrepreneurs. But in 1861, after he married Carolina Bale, whose dowry included 540 acres of her father's land, Krug began the Napa Valley's first commercial winery just outside town. A year later Jacob Schram, a Rhineland native, planted grapes on 200 acres, constructed a winery, and hired Chinese laborers to dig out caves at the end of a hilly road. In the next decades other immigrants, like Frederick Beringer and his younger brother, Jacob, added their own vineyards

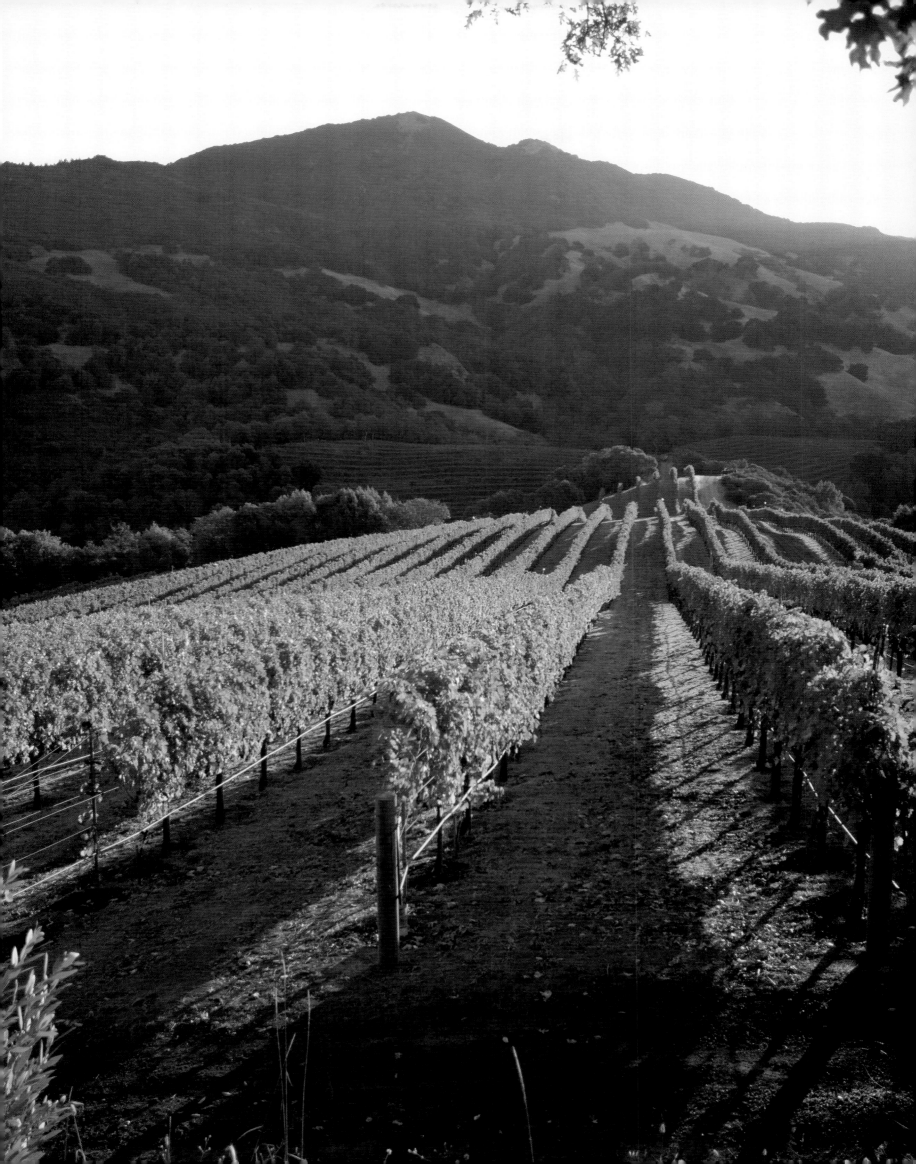

Architecture and artifacts of a bygone age add atmosphere to Napa Valley wineries. At family-owned Spottswoode (above), *the 1884 Victorian farmhouse appears on the estate's labels. Rubicon Estate* (right) – *formerly Niebaum-Coppola – includes the Inglenook mansion, where cedars echo the classical pillars of a portico. And massive stonework distinguishes a valley barn* (above right).

and built great press houses and cellars. The Beringers' stone winery is impressive; even more astonishing is Frederick's Rhine House mansion, with its fine wood wainscoting, decorative Belgian art glass, and ornately tiled fireplaces. Another evocative reminder of those days, now the Culinary Institute at Greystone, began as a castle-like, three-floor cooperative winery in 1889 with its own set of 13 hand-hewn tunnels.

Robert Louis Stevenson helped spread the fame of Napa's wines. The Scottish writer and his wife honeymooned in an abandoned mine bunkhouse on Mount St. Helena, an experience he chronicled – along with praise of local vintages – in *The Silverado Squatters*. St. Helena has returned the favor with the Silverado Museum, where Stevenson memorabilia, including his

The overshot water wheel from 1846 turns again – at least on summer weekends and special occasions – at the Bale Grist Mill State Historic Park (above). A contemporary work, Henry Moore's bronze 'Mother Earth', greets visitors to Clos Pegase winery (right), where the art collection is housed in a 'temple to wine and art' designed by architect Michael Graves.

marriage certificate and a large collection of books, are on display.

Though the last years of the 1800s saw the decline of the vineyards due to phylloxera, St. Helena continued as a resort and commercial center, and Main Street took on its picturesque turn-of-the-century look. After World War II, new vintners with new ideas moved in. By the 1970s the reputation of these wines was assured, and a land preservation movement protected the fields. Around St. Helena, there are almost 300 wineries, which have also created a demand for specialty products like olive oils, mustards, and lavender. Meanwhile, little Yountville, laid out by George Yount 150 years ago, has become a world-wide culinary destination, drawing pilgrims on a wine and food trail through the Napa Valley.

The Miravalle mansion (right) is a centerpiece of Spring Mountain Vineyards, but television viewers may recognize it as a backdrop for the series Falcon Crest. The Napa Valley lifestyle is a draw for vacationers who stay at luxe lodgings like Meadowood (above) and shop for gourmet items at the Oakville Grocery (below right). At Nickel & Nickel an antique auto (below left) signals the winery's affection for the valley's past.

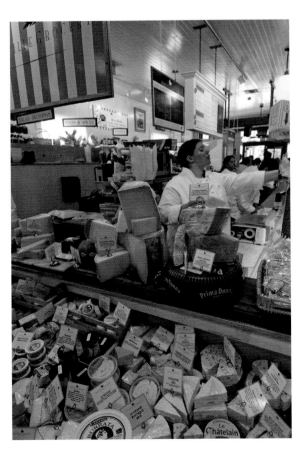

Sonoma

The heart of Sonoma, its green, gracious Plaza, pulses with life. Schoolchildren on a field trip open brown-bag lunches. Businessmen file in and out of the stout stone City Hall. And the yellow-brick former Carnegie Library is now a visitors' center.

It's not hard to imagine this eight-acre space in the late 1830s, when Mexican troops under the command of Mariano Guadalupe Vallejo used it for drills, races, and games. Vallejo, who plotted out the square with a hand compass, was a pivotal figure in Sonoma's early history. But the mission came first, founded in 1823 as the final link in the chain of 23 and the only one established under the Mexican Republic. It lasted a mere dozen years, until secularization, which Vallejo arrived to oversee in 1834. The mission today is mostly a re-creation, with a simple, naively decorated sanctuary where a chapel once stood. Just across the street, though, is the original two-story adobe Cuartel de Sonoma, a museum of the barracks where Vallejo's soldiers were quartered.

Many other Plaza buildings offer time-capsule glimpses of Sonoma's past. The Toscano Hotel, which began as a general store in the mid-1850s, was a hostelry for foreign quarrymen three decades later. Its furnishings recall the days when drinks were served at

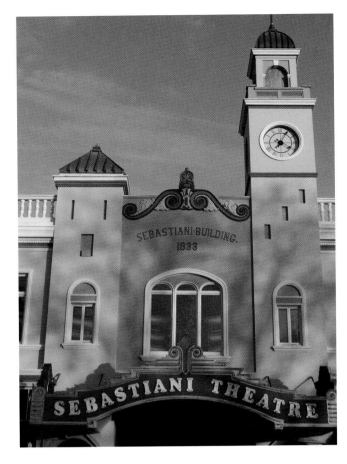

the front-room bar and soup tureens graced blue-checked tablecloths in the dining-hall in the back. Not far away balconied adobes, Western false-front façades, 1850s cottages, elaborate Victorian residences, and early 20th-century stone structures all tell their tale of the Californios, Yankee, and other immigrants who found their way to Sonoma.

The two-story adobe called the Blue Wing (left) has a past as colorful as its name. The oldest section dates to 1840 and housed some of the soldiers guarding the mission; later the building became a hotel and saloon and played host to famed bandit Joaquin Murietta as well as young army officers like Ulysses S. Grant and William Tecumseh Sherman. The Sebastiani Theatre, a Depression-era 'movie palace', actually opened its doors in 1934 (above).

A simple cross adorns the sanctuary of the Mission San Francisco Solano (right), last in the line of 23 that extends through California. Across a side street stands the tile-roofed Cuartel (above, at right), the adobe barracks that sheltered troops of the Mexican Republic. Today the building is a museum, like the Toscano Hotel next door.

On June 14, 1846, a small group of settlers staged a revolt against the Mexican Republic. They arrested Vallejo, stitched a bear insignia on to a flag in the Cuartel, and raised it at a corner of the Plaza. After 22 days, though, the Bear Flag Republic was over, as the rebels threw in their lot with the U.S. troops who had begun fighting the Mexican-American War.

Vallejo enthusiastically joined the new California. Even the house he built in 1851 demonstrated a 'Yankee' spirit in its Carpenter Gothic style. It, too, is now a museum, with family belongings filling the sunny rooms and the gnarled forms of old grape-vines in the fields in front. Vallejo used some of the mission vines to make his own wine, which he offered to guests

like Count Agoston Haraszthy. A colorful Hungarian immigrant, Haraszthy had made his way to Sauk City, Wisconsin, then to San Diego and San Francisco, where he was accused of embezzling funds from the Mint. Nevertheless, in 1856 he bought 833 acres in the Sonoma Valley and a year later was producing wine at the landmark Buena Vista winery, where he built the imposing stone-walled press house that serves as a tasting room.

That was the beginning of California's wine industry, but problems lay ahead. Sonoma's grapes were weakened by phylloxera in the 1870s and 1880s, and what that root-eating louse didn't kill off, Prohibition did. For much of the 20th century, the area slumbered

General Mariano Guadalupe Vallejo, a towering figure in Sonoma, embraced American society wholeheartedly with the design of Lachryma Montis, his estate at the edge of town (left). The Carpenter Gothic-style house from 1851 has intricate gingerbread under the eaves, among other Yankee details. Here, Vallejo and his wife, Maria, raised 16 children. Family furniture and artworks fill the home, including one of the upstairs bedrooms (above). A walking tour of the streets around the Plaza reveals historic structures at every turn. The Cook/Hope House (opposite above) may be one of Sonoma's earliest wood frame houses, dating to the mid-1850s. The oldest sections of the Ray/Adler Adobe (opposite below) are even older, going back to 1846.

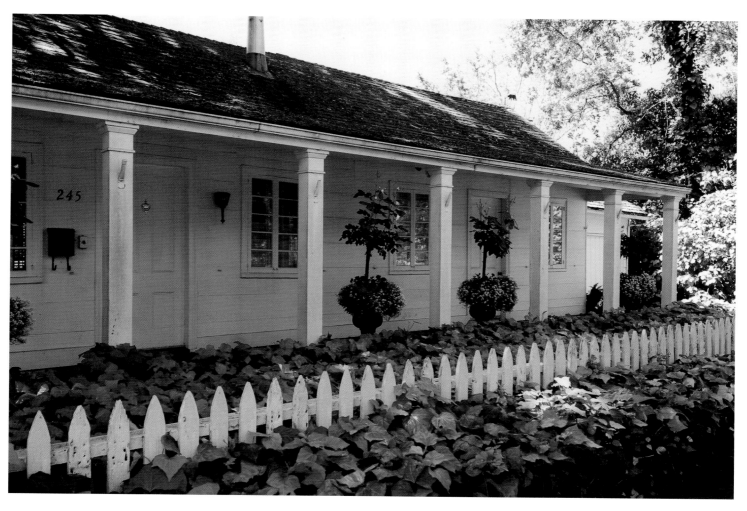

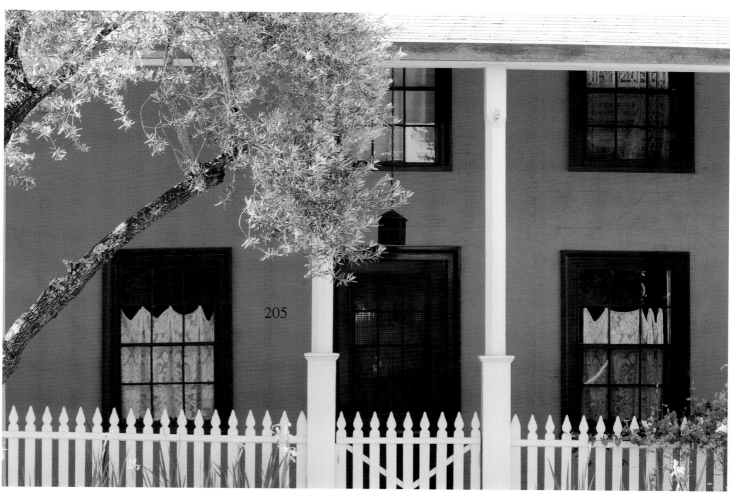

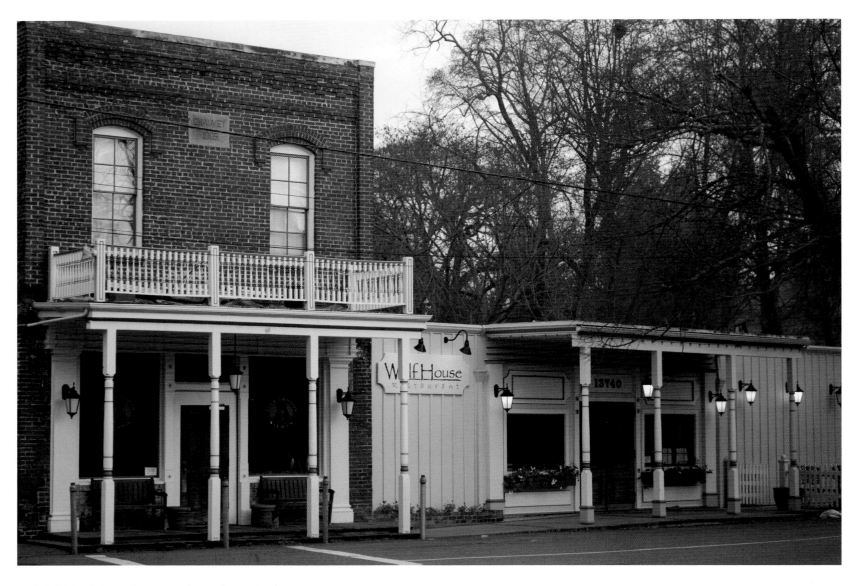

A hillside of vines takes on an abstract beauty in the Valley of the Moon (opposite), *north of Sonoma. The area takes its name from a book by Jack London, who lived for years near Glen Ellen* (above), *where a turn-of-the-century saloon bears his name and the adjacent restaurant recalls his ill-fated mansion. Many small wineries line the roads here. They are the spiritual descendants of Count Agoston Haraszthy, who founded the Buena Vista winery* (right). *The press house there remains a popular tasting spot.*

as an agricultural community and a quiet resort centered on hot springs in the valley that lay between the Sonoma Mountains and the Mayacamas to the east.

It was in the wooded hills near Glen Ellen that writer-adventurer Jack London and his wife, Charmian, found a retreat in 1909. For years they lived in a crowded ranch cottage and planned a magnificent stone-and-wood mansion amid the redwoods. Before they could move in, however, their dream Wolf House burned. Now only its roofless ruins remain, part of Jack London State Park, along with London's grave and the House of Happy Walls, which Charmian built as a shrine to her husband's memory.

The roads through the Sonoma Valley are once again laced by thriving grape-vines, however, and dotted with bed-and-breakfast inns and fine restaurants that celebrate the area's memorable vintages with renewed vitality.

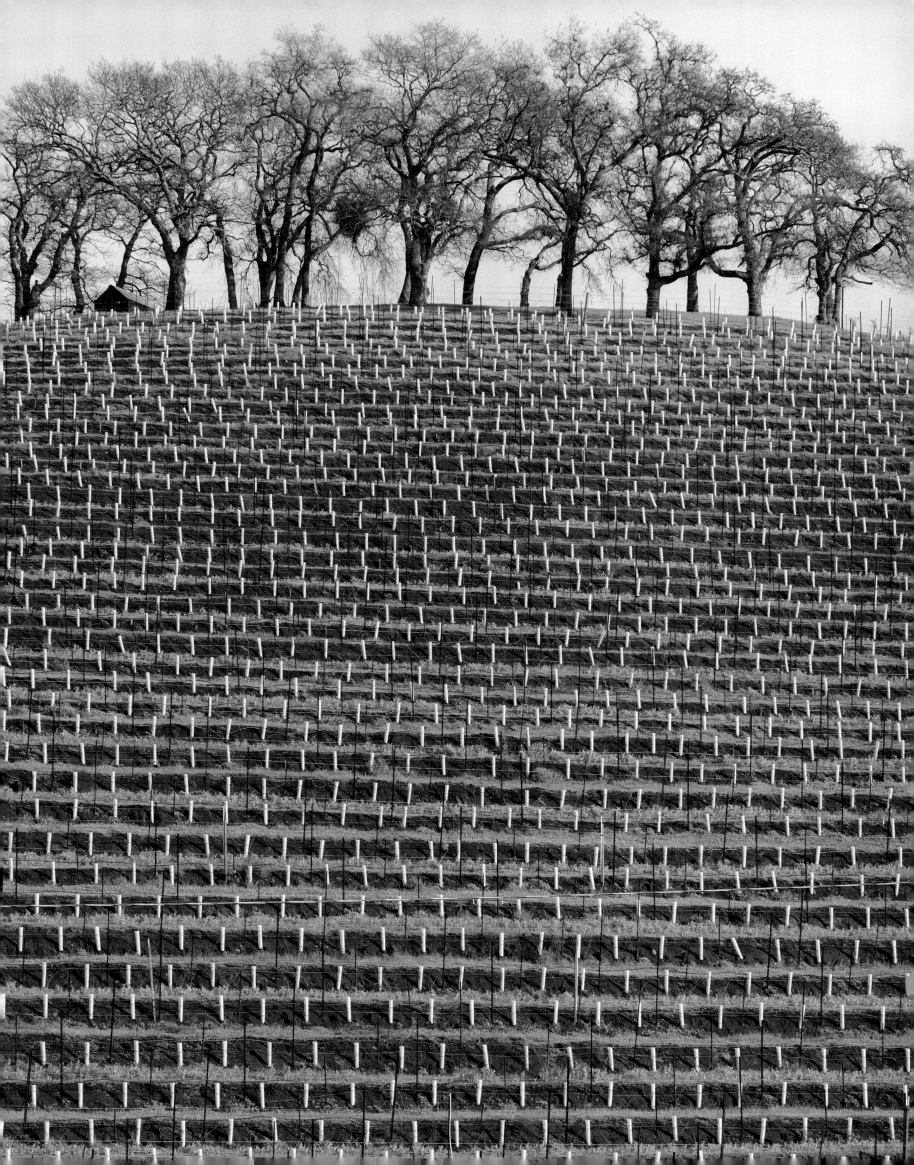

Sonora, Columbia, & Jamestown

THE PAST AND PRESENT mingle wonderfully in Sonora, where chance conversations with shopkeepers reveal a passion for memorabilia and local history. Today the Sierra foothill town is the county seat and a gateway to the Yosemite National Park. Almost 150 years ago, however, Sonora, Jamestown, and Columbia were all part of the Gold Rush frenzy that brought an influx of miners from around the world. The region's first strike took place at Jamestown in mid-1848; the following March, Mexican miners discovered gold about four miles east, at a place they named for their home – Sonora. A year later, another party found rich deposits four miles away at nearby Columbia, but the lack of a year-round river there made mining difficult. Finally an extensive system of pipes, flumes, and ditches was constructed to carry water; by 1853 the camp had mushroomed to a town of more than 25,000 people.

The four-sided clock tower of the Tuolumne County Courthouse (right) has been a local landmark in Sonora since 1898. According to some stories, it was oriented to face the home of one of the town's lumber barons. The interior is embellished with a marble and metal staircase, and the upstairs court-room has carved rails with floral posts.

82

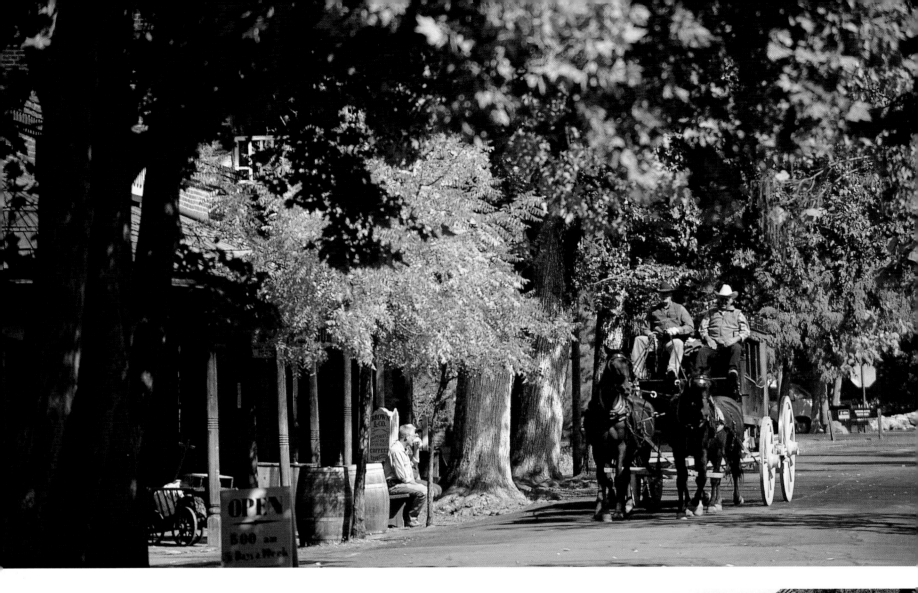

When Columbia's first wooden buildings succumbed to fire, brick ones went up in their place: a Wells Fargo Assay Office, a court-house, shops, hotels, and eating and drinking establishments lined the Western-style sidewalks. As the gold petered out, the buildings were abandoned, but most remained standing, and in 1945 they were incorporated into the Columbia State Historic Park. Now contemporary visitors can pan for gold, shop in century-old emporiums, stay in a 19th-century hotel, and listen to costumed docents tell Gold Rush stories.

Jamestown offers a different kind of museum. The preserved façades of Main Street open up to antique stores, boutiques, and restaurants. But a block away the sheds and workshops of the Railtown 1897 State Historic Park pay homage to the Sierra Railway, which transported lumber and served the turn-of-the-century

A stagecoach ride conveys visitors along the streets of Columbia State Historic Park and into the past (above). *Though the town was all but abandoned by World War II, the buildings still stood. Restored, they now bring Gold Rush days to life, with shops that include a purveyor of miners' supplies* (right), *two firehouses* (far right *and* opposite above), *and a Wells Fargo office and a bank* (opposite below).

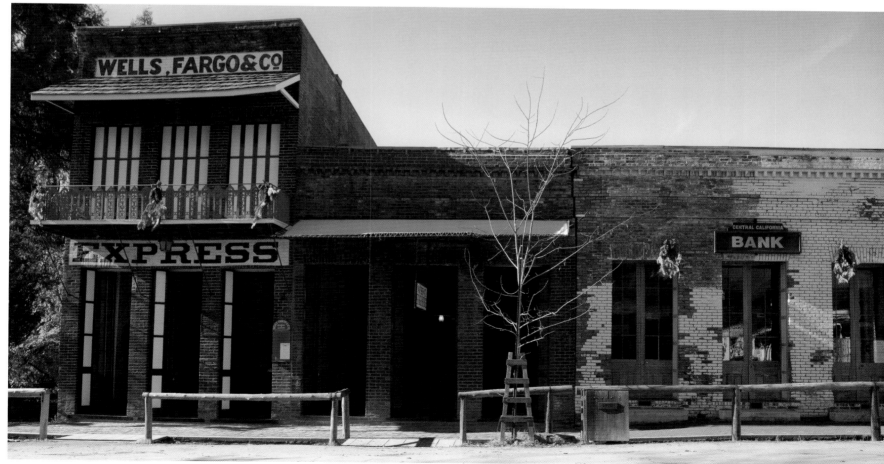

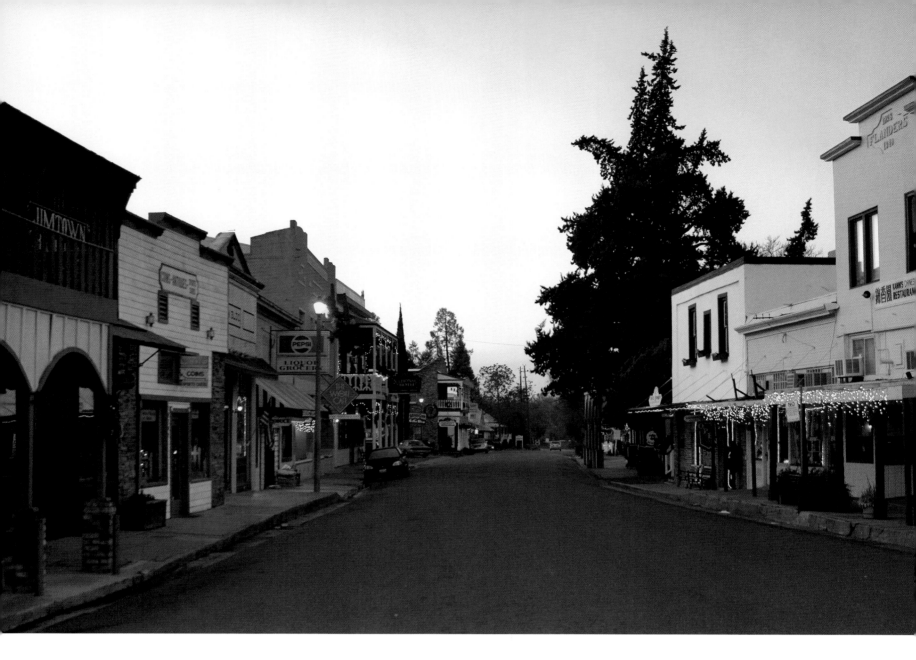

mining community. In the round-house, an array of locomotives are on display; on weekends there are rides on the old steam engines, which have appeared in countless television shows and movies.

In Sonora, historic residences and sites are interspersed among modern homes and businesses. The story of westward migration and the Forty-Niners – including the immigrants who populated Chinese Camp, Italian Bar, and Algerine (French) Camp – is explained at the Tuolumne County Museum, in the fieldstone-and-brick jail that dates from 1857. That same year a freed slave built the Sugg House, one of the town's oldest homes; his family later expanded the simple adobe-brick structure and ran it as a boarding-house.

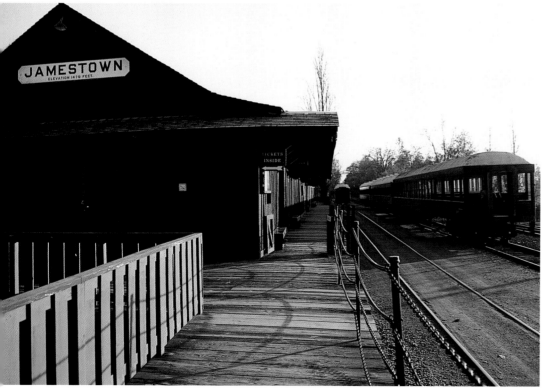

*L*ittle Jamestown (above), *sometimes called Jimtown, is an inviting collection of Western-style hotels, restaurants, and shops. Within a few blocks is the Railtown 1897 Historic Park* (left), *which includes a collection of steam and other locomotives and antique railway buildings.*

The rowdy spirit of Gold Country shows up inside and out in both Jamestown (below) and Columbia (bottom). Even the architecture of the era had a colorful exuberance (below right). In Railtown (right) placards recall the reach of the railroads of the past. With its trove of trains, the park has been a frequent site of movie scenes.

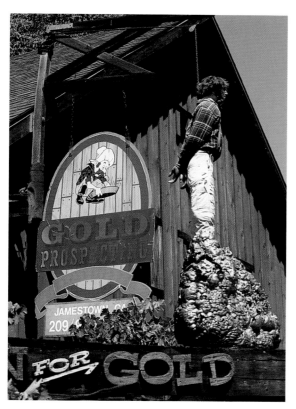

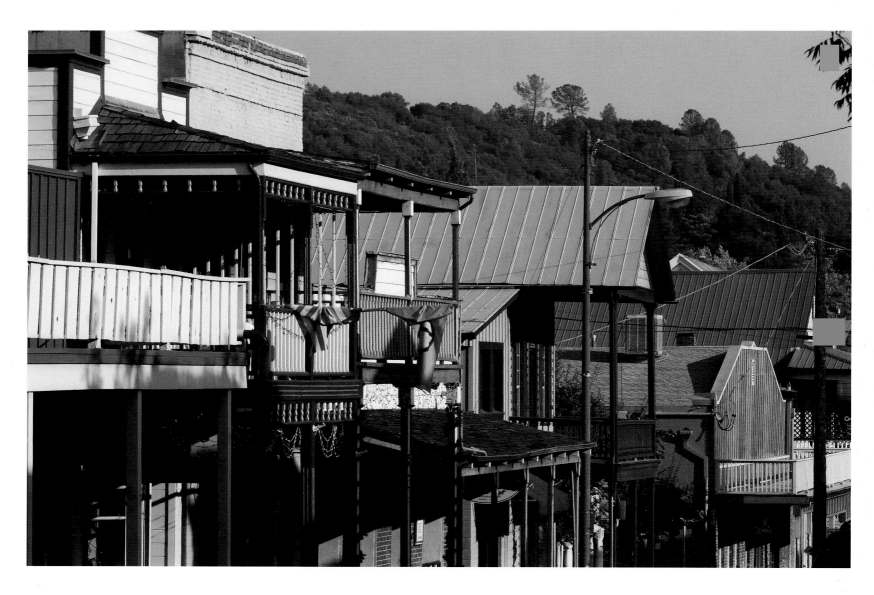

St. James Episcopal Church went up in 1859; the 'red church' is a local landmark, easily recognized by its redwood walls, Gothic windows, and soaring steeple. The stately yellow Tuolumne County Courthouse, with its impressive four-sided clock tower, has dominated the center of town since 1898, while the Bradford Building, once a bank, has its own distinctive corner cupola. The building now houses art studios and a gallery, with the walk-in vault used for exhibits. Renovated hotels, atmospheric bars, and antique shops dot Sonora's Washington Street, along with a store selling 19th-century garb, an old-fashioned ice-cream parlor/used bookstore (with a re-created mine entrance downstairs), and even a print shop whose walls are hung with vintage photographs. Best of all, though, the past lives on through local history buffs who regale you with tales of secret passageways, colorful characters, and the days when the Bonanza Mine ran deep under town.

The distinctive steeple of Sonora's 'red church,' actually St. James Episcopal Church, stands out against a cloudless sky (opposite). Built in 1859, it's one of the most visible symbols of the heritage of the town, whose main street retains the balconies and arcades of an earlier era (above). The National Hotel in Jamestown (left) has also been in existence since 1859, though patrons in those early days arrived by a different kind of horsepower.

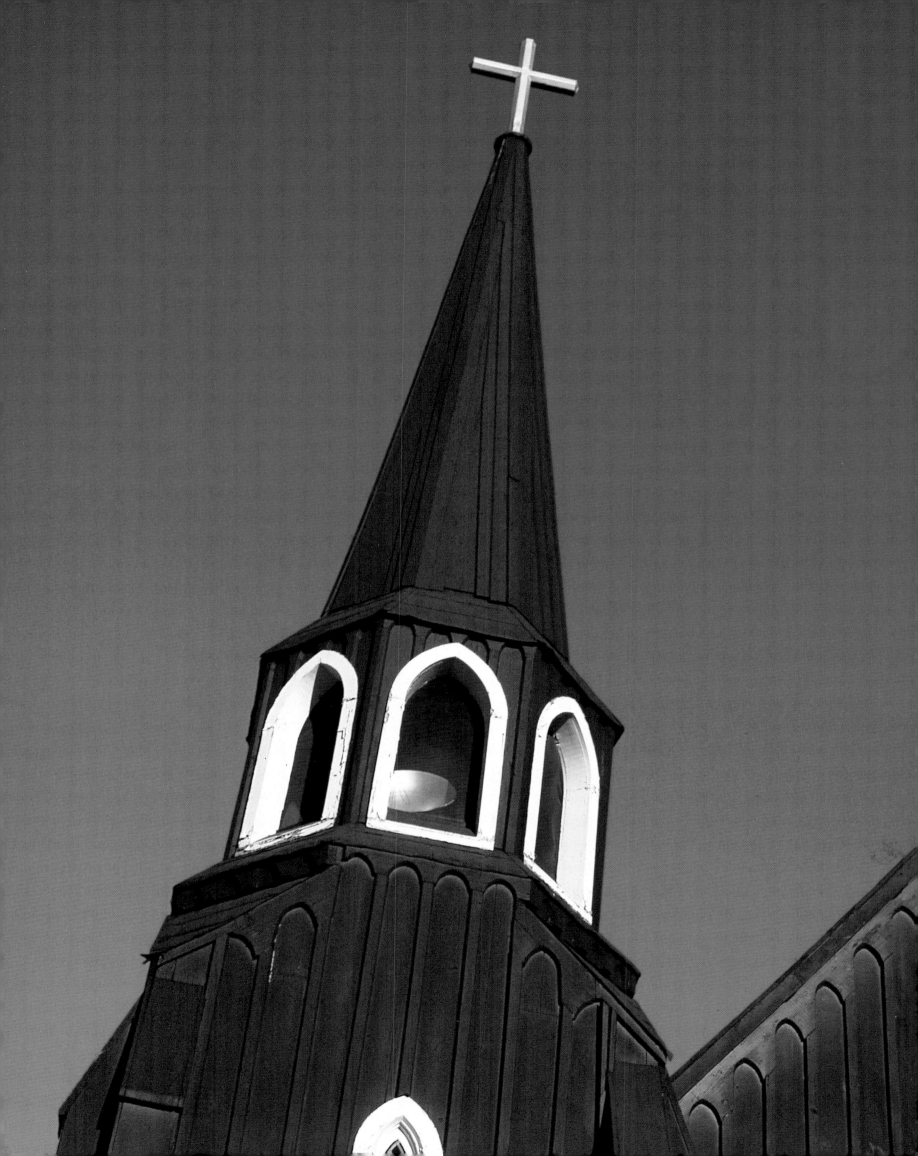

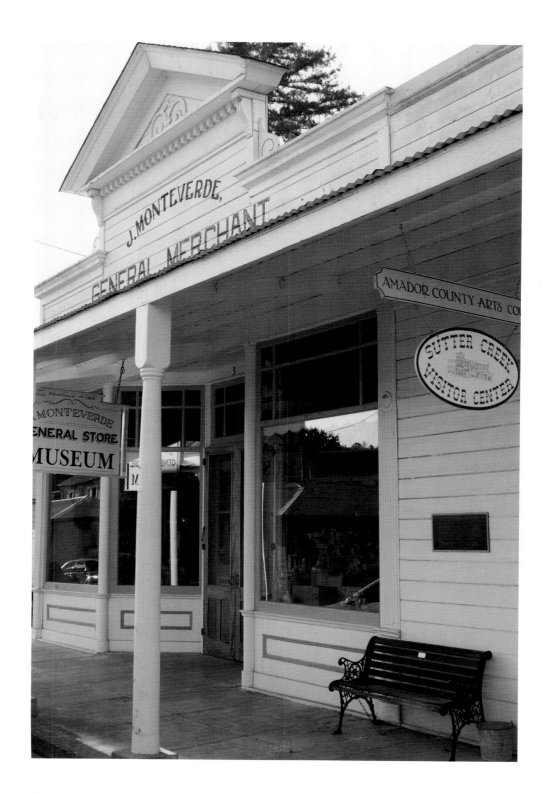

Sutter Creek

THE MONTEVERDE STORE, a few steps off Sutter Creek's Main Street, looks much as it did in 1898, when Giovanni Monteverde, a native of Genoa, Italy, first opened his emporium of general merchandise. There are dry goods on the wooden counters, containers of Quaker Oats on the shelves, and an oak icebox built into the wall. In the rear, a wood stove stands near the desk in the corner 'office,' where the owner kept a tally of accounts. The store served the neighborhood for more than 70 years, until the day in 1971 when Monteverde's daughter put a note in the window saying the place would be 'closed for a few days' and never returned. The store was later willed to

the town and reopened as a museum and visitor center in 1992. Since then, travelers have rediscovered the charms of Sutter Creek, which is cradled by rolling hillsides dotted with vineyards and orchards as well as old mine buildings.

The town got its start in the 1840s, when Captain John Sutter sent men there to cut lumber for his sawmill in Coloma. After gold was discovered in January 1848, this settlement also burgeoned into a miners' camp. But there was little placer gold – the flakes and nuggets that washed into creeks – and instead a network of deep underground mines developed. Eventually there were eight within just a few

Sutter Creek cuts lazily through farmland (opposite) *that begins on the outskirts of the pretty town to which it gave its name. Antique shops now line Main Street, but the goods inside the Monteverde General Store* (above) *reflect the products that filled its shelves over the last century.*

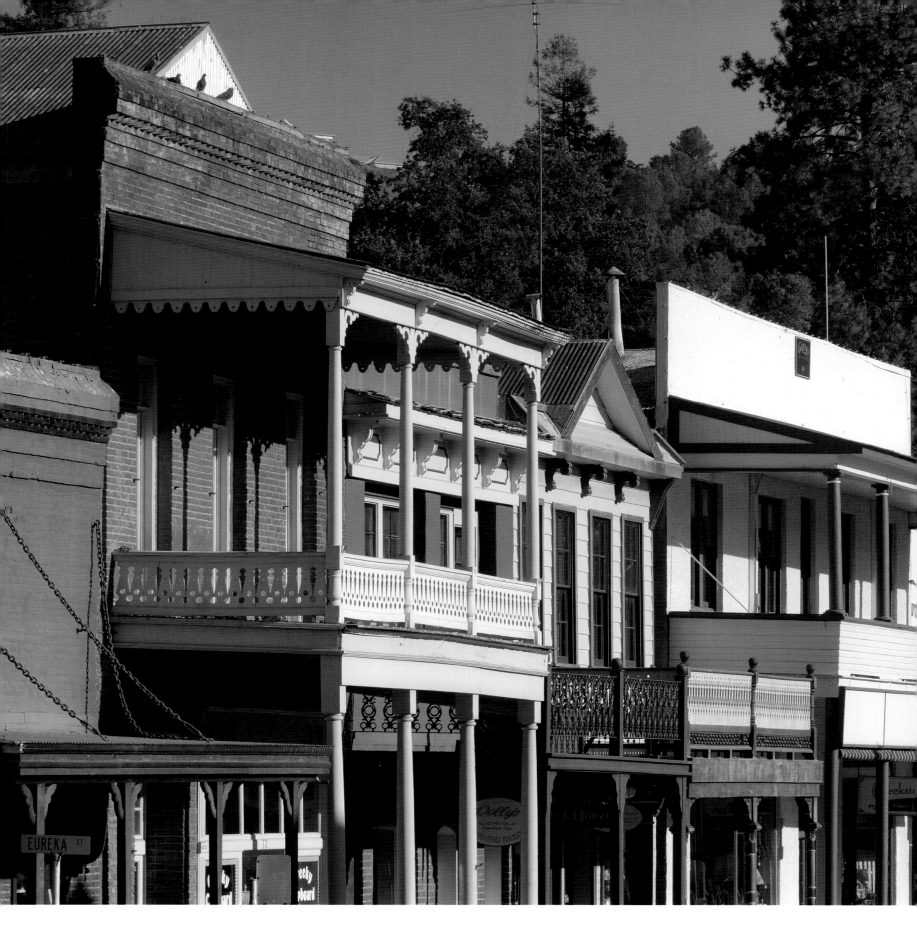

Overhanging balconies and other decorative touches add late 19th-century flair to a Main Street block (above). The United Methodist church at the end goes back to 1862, but the spire was added only in 1976.

miles, and they lasted until the 1950s. Even Sutter Creek's post-office stands on the site of an old stamp-mill, with a shaft below the bell tower.

In the late 19th century, immigrants flocked here from around the world, especially France, Cornwall, Italy, and Croatia, to seek their fortune. Bakeries, barbershops, grocery stores, and saloons – lots of saloons –

sprang up. In 1873 Knight's Foundry was built to produce the wheels, machinery, and tools needed in the mines. Now part of a non-profit educational corporation, the water-powered foundry still casts iron architectural elements for historic renovations. Sutter Creek's houses and shops evoke its early days, with verandas, balconies, arches, greenstone façades, and

other decorative touches. The mansions at the south end of town reflect the neoclassical style, but many other homes resemble New England salt-box cottages; indeed, some of those were prefabricated and transported around Cape Horn by ship, then put together here. One residence from the 1850s, the Brignole House, has an unusual cross-shaped design and a sunken living-room that some say resembles a ship's interior and others claim was used for meetings of the mysterious Knights of the Assyrian Cross. Other buildings from the mid-19th century have been turned into

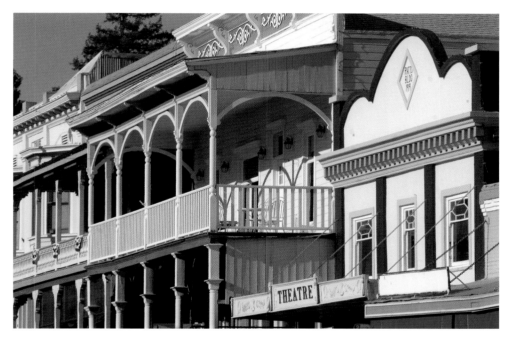

The Ratto Theatre (top, at right) *dates to 1919; its restored interior is once again in use. The Sutter Creek Palace building* (right)*, built in 1896 as a saloon and restaurant, still provides food and drink amid Victorian décor* (above).

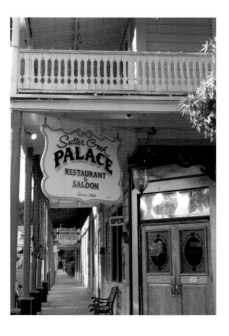

welcoming bed-and-breakfast inns or antique stores and art galleries, which show off the pine floors and brick walls of their old interiors.

At the edge of town, the Sutter Gold Mine explains the most recent chapter of local history. Opened in 1989, it excavated millions of dollars' worth of gold before shutting down in 1991. But as guides lead their underground tours, explaining changes in mining techniques over the last century, you can see the veins of quartz and gold glittering just out of reach.

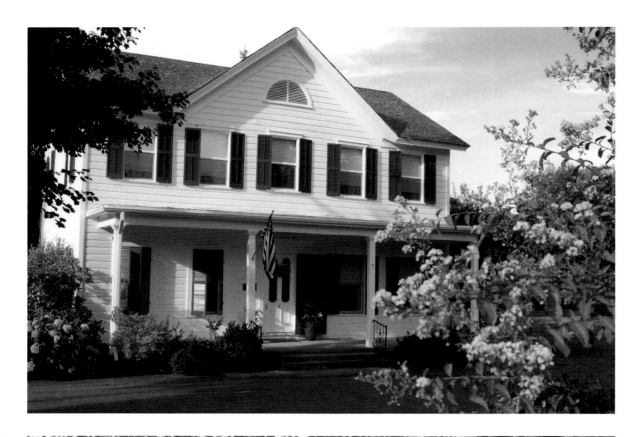

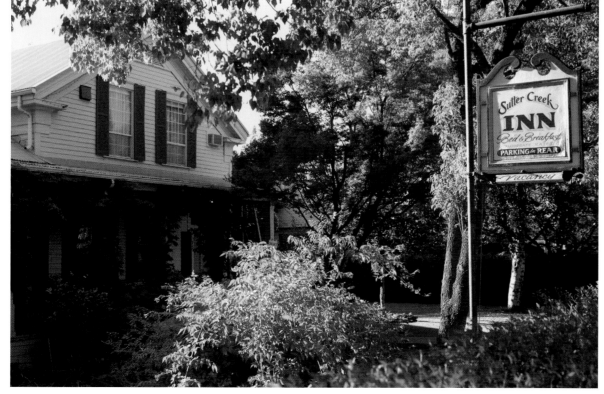

White clapboard and green shutters strike a harmonious note at the stately Sutter Creek Inn (below left), constructed around 1859. The color scheme is echoed at the former Downs mansion (above left), which went up in the 1870s. The Spanish Street location now boasts lovely gardens, but originally this was the site of the town's first mill and foundry. Out in the countryside the look leans more toward weathered barns in grassy fields (opposite above).

*A*n old miner's cart and tools are
on display at the Sutter Gold
Mine (below), *which was active as
recently as 1991.* Knight's Foundry
(right) *continues to turn out
ironwork.*

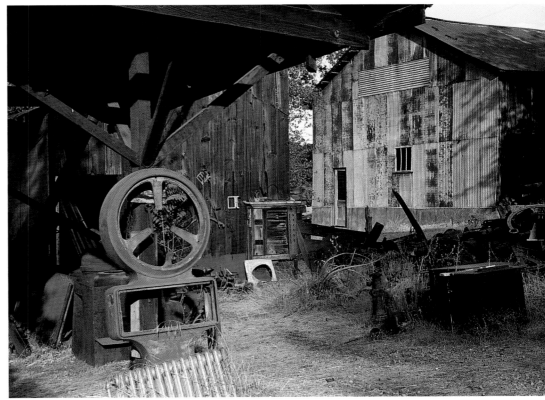

Truckee

RAILWAY TRACKS RUN through the center of historic Truckee, which sits among the verdant pines and alpine peaks of the Sierra Mountains. The rails are a clue to the role of this town – some 15 miles north-west of Lake Tahoe and 35 miles west of Reno, Nevada – as a conduit for people and goods a century ago. Today, the yellow Western-style depot still serves passengers, but it also houses an information center for visitors who come to enjoy the atmospheric restaurants, antique stores, and Victorian buildings that stand just across the street, along Donner Pass Road.

The California Gold Rush of 1849 and the Nevada silver boom a decade later opened up a road that ran from the deserts of Nevada to the Sacramento Valley. With the prospectors came merchants and suppliers, like the entrepreneur who built a log cabin in 1863 – Gray's Toll Station – offering food and shelter. In 1868 the arrival of the Central Pacific Railway led to the rise of Truckee's

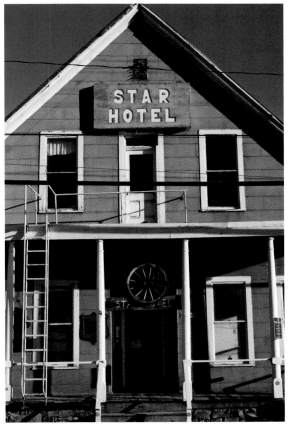

*T*ruckee's historic downtown (left) *dates to just after the Gold Rush, when the town sprang up along a route through the Sierras. Logging was an early industry; a Truckee lumber mill owner built the Star Hotel* (above) *in the 1860s.*

97

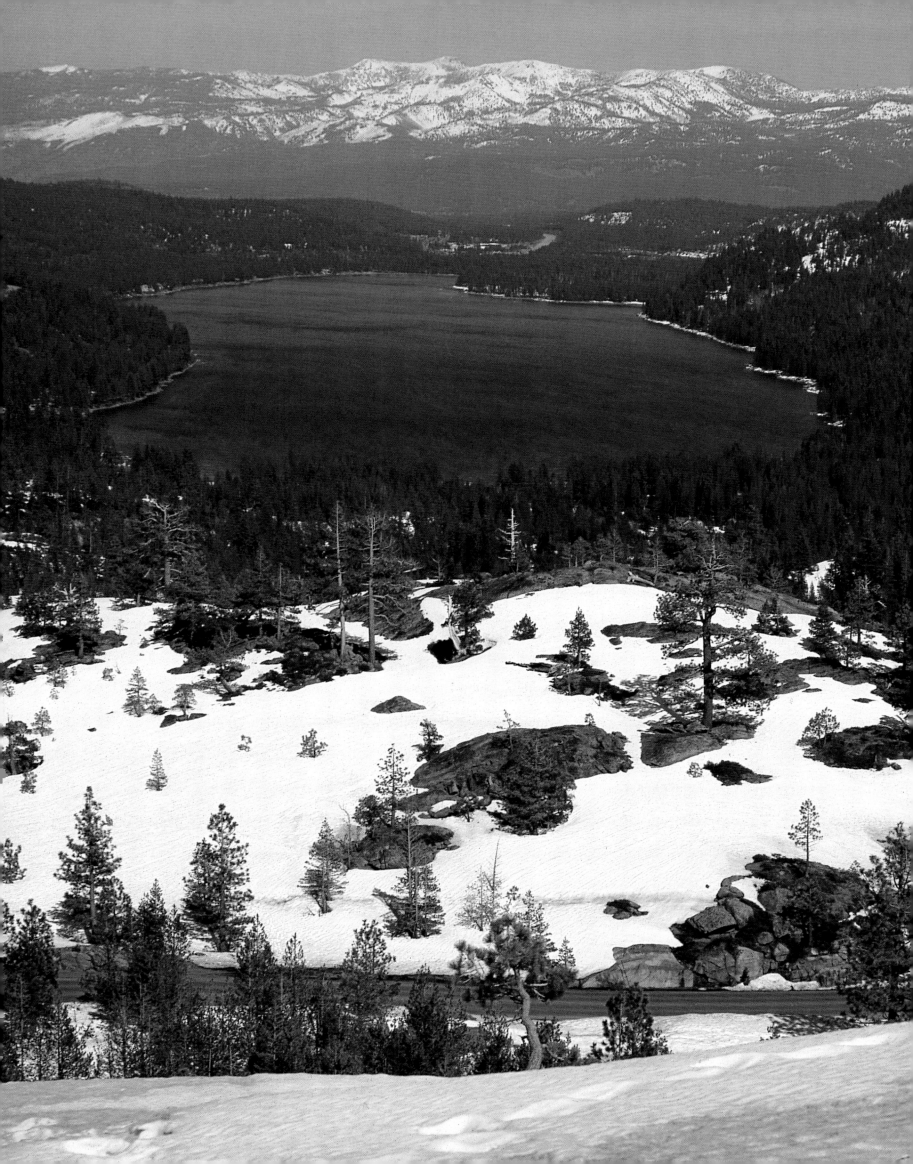

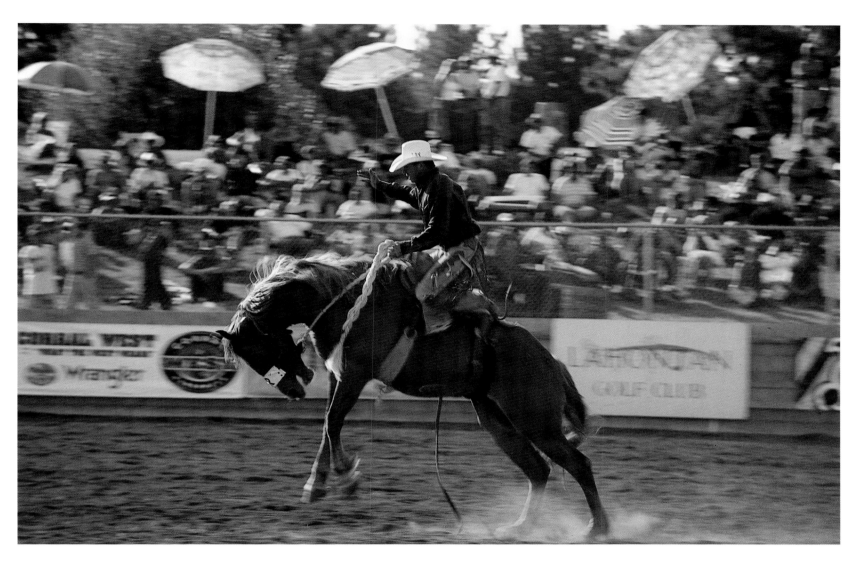

*D*onner Lake's blue waters (opposite) *are framed by the Sierras' snow-covered peaks. Mountains that once seemed impassable have become winter sports havens for cross-country and downhill skiers.*

logging and lumber industry, which stripped the hillsides for timber to shore up Nevada's silver mines and to build frame houses in Sacramento and San Francisco. The railroad also brought tourists, who transferred to a narrow-gauge line that ran to scenic Lake Tahoe.

Truckee was a lawless town in those days, ruled in part by the 601 Vigilance Committee, organized in 1874-75. The look of the main street recalls that era with one-and two-story Western façades and overhanging balconies. The Capitol Building, built in 1872, and once a saloon, now houses a shop of bath and beauty products daintily arranged on old-style wooden shelves. Down the street, the Truckee Hotel, which opened as the American House in 1873, has been restored to its Victorian décor. Other historic sites include the Truckee Jail, built in 1875; the Rex Hotel Building, where decorative glass has replaced the bottles of a former speakeasy; and Cabona's, which offers men's and women's clothing in a shop that first sold general merchandise in 1918.

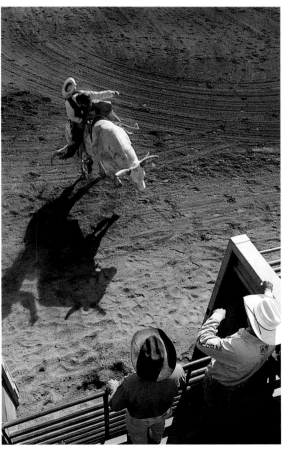

*E*very August rodeo buffs arrive *in Truckee for championship competitions in saddle bronc riding* (top) *and bull riding* (right), *after a showing of the colors* (above).

A couple of miles west, the Donner Memorial State Park commemorates the ill-fated party of emigrants who tried to make their way to California through the pass that now bears their name. A group of 91 people, led by Illinois farmer George Donner and his brother Jacob, left Missouri in spring 1846, but a 'short-cut' wasted their time and resources. Exhausted and running late, the group fought among themselves. Bad decisions and bad luck dogged them: the families rested a week before tackling the difficult Sierras, then winter set in early – the worst in a century – and stranded them in several camps near Donner Lake. The snowpack eventually reached 22 feet, the height of the base of the Pioneer Monument outside the park's Emigrant Trail Museum. As members of the Donner party died, the starving survivors turned to cannibalism. Finally, between February and April 1847 three sets of rescuers led the 49 who were left through the mountains to safety. Their story became famous as a horrific cautionary tale of westward migration.

Ironically, the snow and mountains that so marked Truckee's past continue to shape its identity today: the town is a gateway to ski meccas like Squaw Valley, Northstar-at-Tahoe, and Alpine Meadows.

Rainbow and brown trout are among the prized fish that bring out anglers to Donner Lake (opposite) in summer. Other outdoor enthusiasts take to the Truckee River, riding its currents in rubber rafts (right). Winter is a harsher season. Early snows in 1846 stranded the Donner party, leading to disaster for those travelers, immortalized in the Pioneer Monument (below).

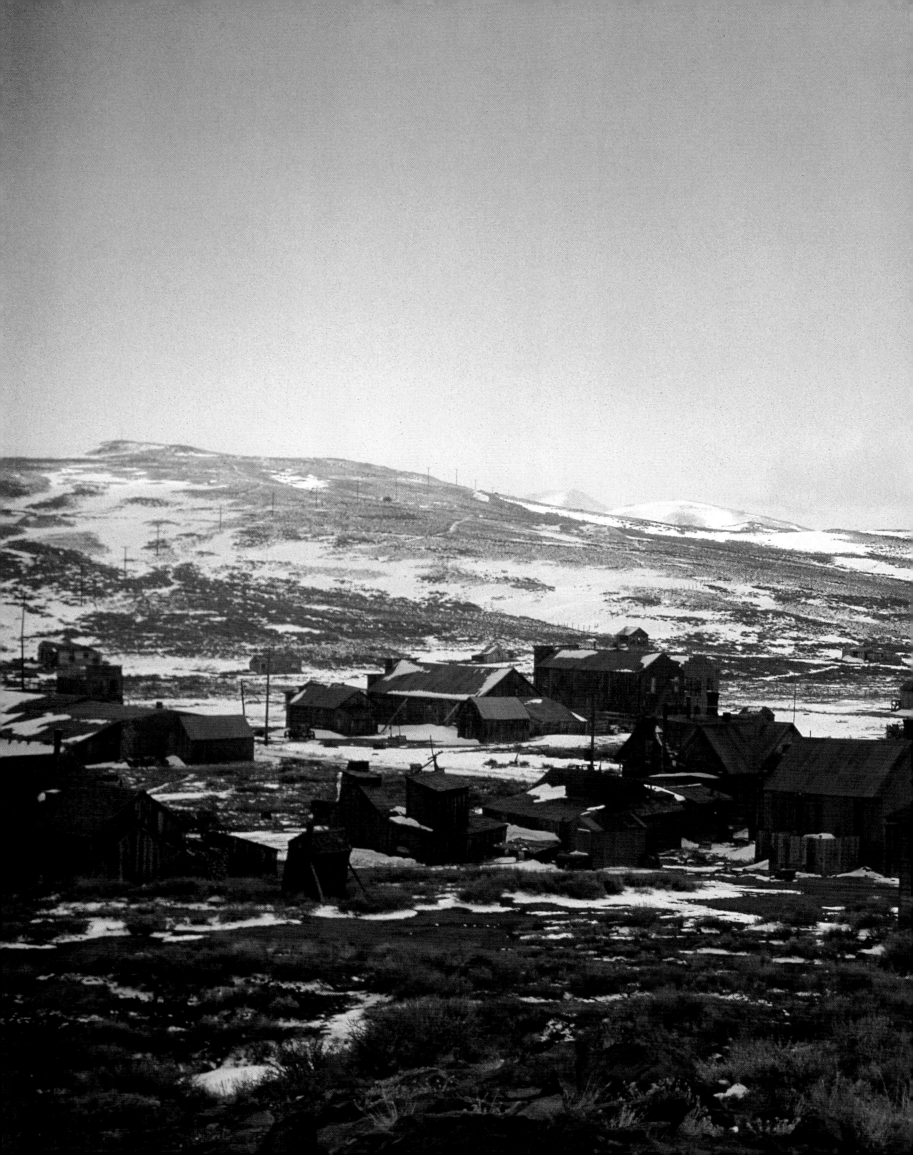

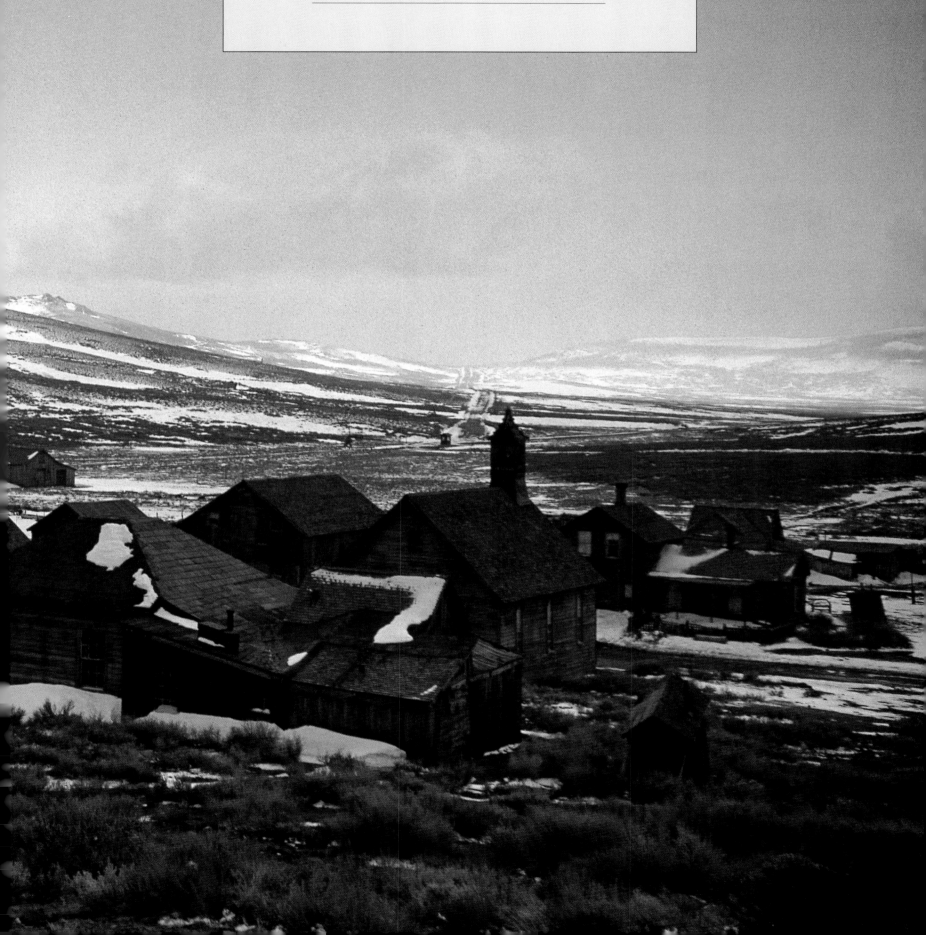

GHOST TOWNS

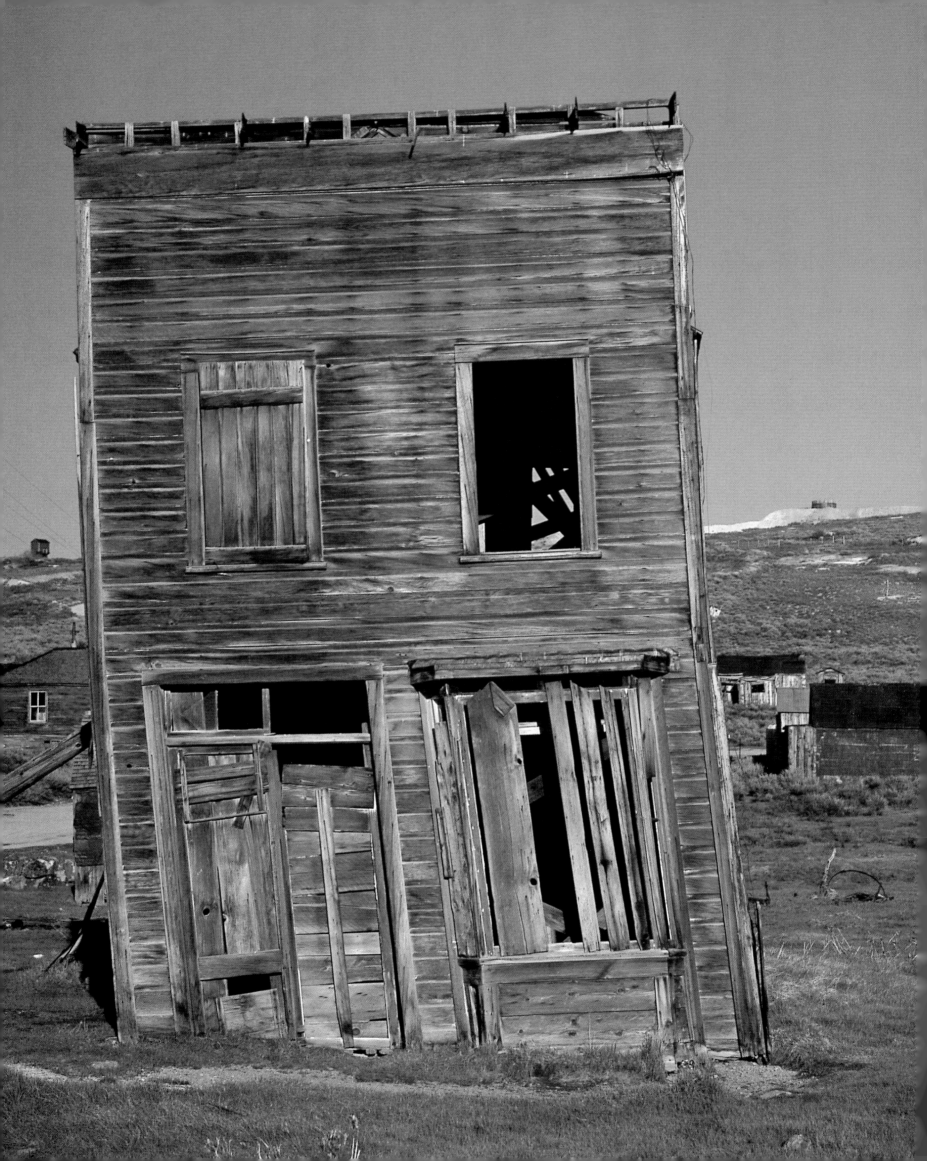

In the high, dry desert on the eastern side of the Sierras, wind riffles the brush and whistles past weathered wood buildings that seem to teeter on the brink of destruction. Through the windows you can see the scattered belongings of residents who apparently have just walked away. Legends hang in the air – of gunfights, robberies, murders, and the dire deeds of the Bad Man from Bodie. Bodie is the quintessential California ghost town, an evocative reminder of thousands of now-vanished mining settlements, the Angels Camps and Poker Flats immortalized in the work of Mark Twain and Bret Harte.

In 1859 W. S. Bodey and E. S. 'Black' Taylor launched a small gold rush here with their lucrative strike. Though Bodey himself died in a blizzard before he could reap many profits, his name lived on (with a different spelling). Thousands of prospectors pulled millions in ore out of the ground before moving on to other diggings. Almost 20 years later, the prospectors came back in droves, drawn by new stories of fabulous riches.

By 1879 Bodie claimed 8,500 people and 2,000 buildings – churches and hotels, a thriving Chinatown, and scores of saloons, dance-halls, and other houses of illicit entertainment. It was a violent and lawless place, where more than one outlaw undoubtedly contributed to the profile of the fearsome 'bad man' himself. By 1881, when the gold was gone, the boom was over, too. Fires destroyed many of the structures; winter snows and summer sun took a toll on the rest. Bodie became a ghost town, designated a state historic park in 1962, to be preserved in 'a state of arrested decay.'

Bodie's story is a sidelight of the saga of the Gold Rush, which transformed all of California with a speed and intensity hard to imagine. After James Marshall discovered gold flakes at John Sutter's sawmill at Coloma, on January 24, 1848, all efforts to keep the news a secret failed miserably. By May, shouts of 'Gold! Gold from the American River!' were heard on the streets of San Francisco, which was still a sleepy town of a few hundred people. Sailors deserted their ships, workmen dropped their tools, clerks abandoned their desks. As the news spread around the world, young men and old began to make their way overland and around Cape Horn, pouring in to the streams and gulches of the Sierra foothills.

*E*ven in early spring the harshness of Bodie's high desert surroundings, part of the reason for the town's demise, is apparent (preceding pages).

*H*ardly upright but still standing, one of Bodie's abandoned buildings (opposite) epitomizes the meaning of 'arrested decay.' Dozens of houses, shops, businesses, and other structures make up the ghost town, including an old schoolhouse (above), where young scholars left books, papers, and a globe scattered on their desks.

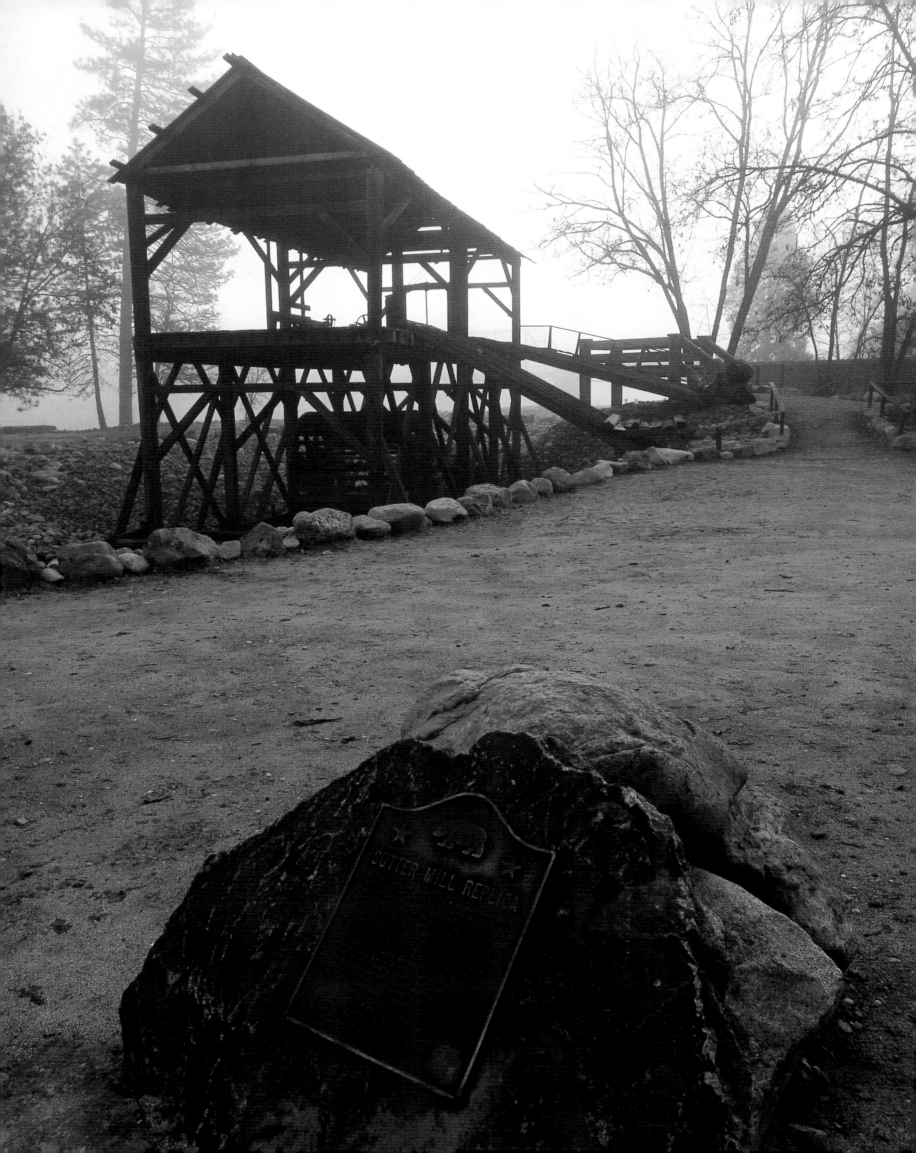

A reconstructed sawmill (opposite) *marks the approximate spot where James Marshall picked up gold flakes in January 1848. His discovery brought thousands of Forty-Niners and other emigrants to California, irrevocably shaping its destiny. Again and again, ore strikes would lead to boom-and-bust towns like Bodie* (left)*. In Locke* (below) *a museum in an old gambling house explains that town's unusual Chinese heritage.*

Mining camps sprang up virtually overnight. At first the gold seekers unrolled their blankets outdoors, then they concocted rude brush shelters, which gave way to tents and later shanties and frame structures. Men from the same country often clustered together, giving rise to places called Chile Camp, Algerine (French) Camp, and, frequently, Chinese Camp. Sometimes an actual town grew up on these spots, perhaps under the civilizing influence of a few women and families who joined the hordes of men in search of their fortunes. Other times, when the ore played out quickly, all signs of a settlement might disappear as swiftly as winter snow melting in the summer sun.

Over and over the pattern was repeated. Columbia State Historic Park began as Hildreth's Diggings, founded when a few miners caught in the rain decided to prospect while their gear dried out. The claims went dry in summer – and water was needed to separate out the gold – but the miners eventually managed to set up an intricate system of flumes and aqueducts, digging out almost 80 million dollars' worth of the metal before the ore was finished and the town a faded shell. Named a park in 1945, Columbia once again has streets of preserved and renovated buildings – from a Wells Fargo Assay Office to a dry-goods store and hotels that welcome guests – and costumed docents who seem to have just wandered in from the 1870s.

The mining town of Calico owed its short prosperity – from 1881 to 1907 – to silver and borax. At one point it had 1,200 residents, 500 mines, and 22 saloons, as well as its share of colorful characters, including a mail-carrying dog. Bought by an entrepreneur in 1951, the place was restored to match old photos of Calico in its heyday. Today, with a third of the buildings original and the rest rebuilt, the town is a county park and the site of popular re-enactments, festivals, and Old West shows.

The blink-and-you'll-miss-it community of Harmony was once a thriving village centered on a well-known dairy. Here, early in the 20th

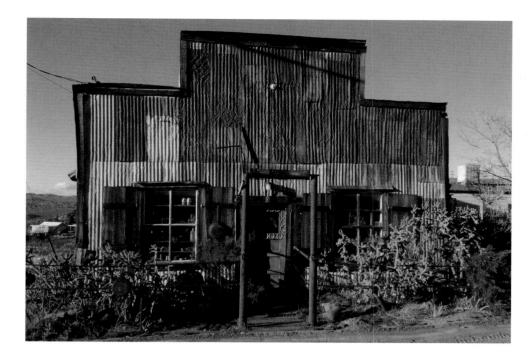

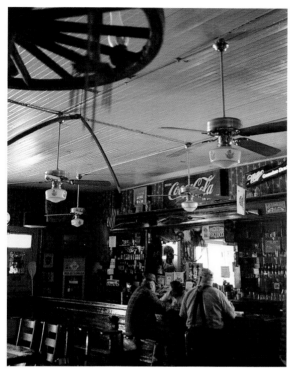

Civil War re-enactors take the part of Union soldiers during a mock battle in the mining town of Calico (opposite). *The settlement itself is part real and part replica, rebuilt from photos taken at the turn of the century. It sometimes hosts Wild West shows, complete with gunfighters* (bottom). *In Randsburg* (left) *it's hard to tell which buildings are inhabited and which are not, though the White House Saloon* (below) *is definitely open to customers.*

century, William R. Hearst would stop to buy butter and cream on the way to his home farther up the coast. The town declined when the dairy moved, and though it was restored as a tiny artists' colony in 1972, only a few galleries and lonely houses on overgrown lots are left. Harmony's claim to existence is validated mainly by an old-style post-office, where the mail is deposited in pretty glass-front boxes with carved metal decorations and ancient tumbler locks. Throughout California shuttered railway depots, once popular resorts, and villages founded on fleeting high hopes all harbor their spirits. Chinese workers established Locke in the Sacramento Delta in 1915. Mostly uninhabited now, it's on the National Register of Historic Places. Other towns attract those interested in an alternative lifestyle.

On the dry hills surrounding Randsburg, a mine entrance is flanked by an assortment of rickety machinery and a few old shacks. Founded in 1895, the town was named for the similarity of its local minerals to those in South Africa. Today the place blends a stage-set Main Street with a dusty desert retirement community. The front room of the local hostelry is jammed with antique bric-à-brac. A retro scarlet Red Crown gas-tank welcomes visitors to a false-front shop that promises 'vulcanizing and retreading,' while next door there's a re-created barbershop – 'fine cigars and hot baths' – and a purveyor of Chili Pea-Ola pickles and relishes. Austin's Second Hand Garage occupies the space behind a corrugated iron façade, and up the road the historic opera house shares a building with an up-to-date café. As for watering-holes, there are two to choose from: an atmospheric saloon that evokes the Randsburg of the past, and a locals' bar where neighbors congregate in the late afternoons to exchange gossip and hoist a few. These patrons may be getting on in years, but they haven't quite yet given up the ghost.

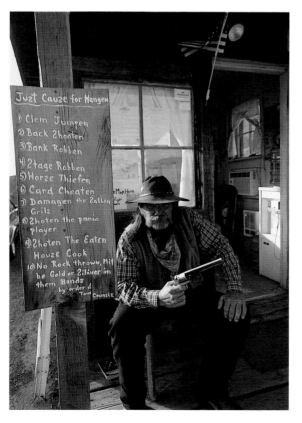

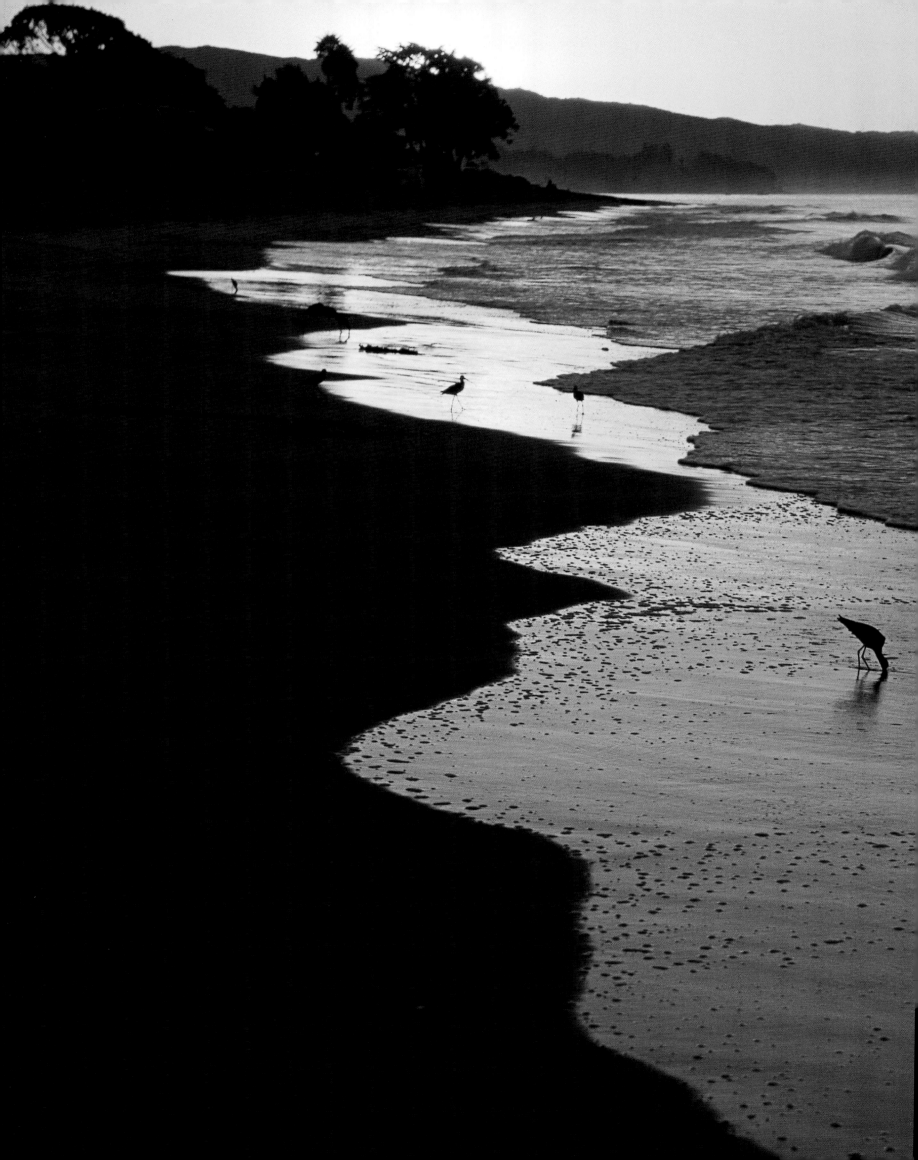

CENTRAL AND SOUTHERN
CALIFORNIA COAST

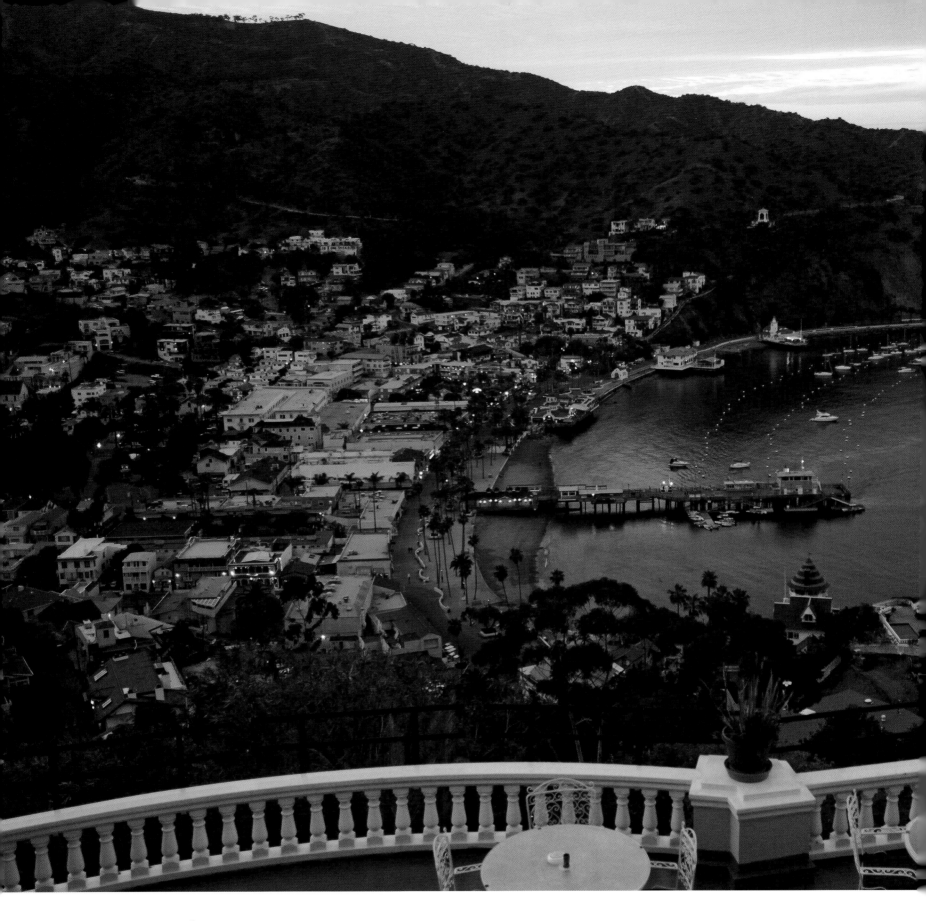

Avalon

AT THE EDGE of Avalon's sheltered bay stands a round, red-roofed building in Art Deco style. The Casino – named for a 'place of entertainment' in Italian – opened to great fanfare in 1929. And from the tiled mermaid in the loggia to the murals depicting fanciful California history in the movie theater, the building has been restored to its glory days. Even now on special occasions people come to dance in the circular ballroom that played host in the 1930s and '40s to big bands like Jimmy Dorsey's. The Casino was just one of Avalon's attractions. Part of the fun for visitors was simply being on Santa Catalina, an island 8 miles wide and 21 miles long, 22 miles off the southern California coast.

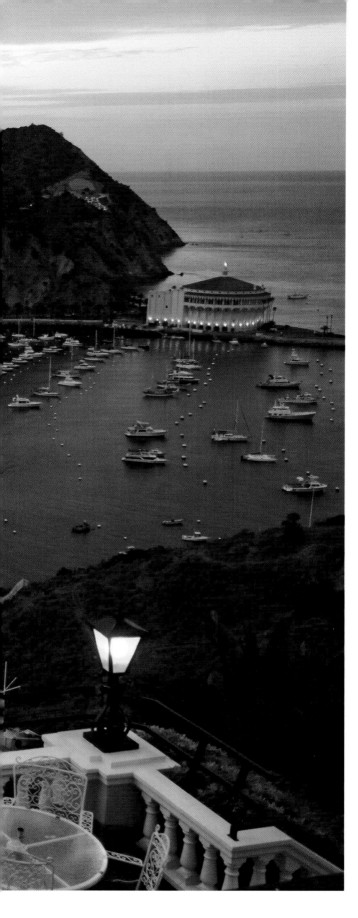

Over the centuries Catalina had been home to Native Americans, claimed by Spanish explorers, and settled by sheep herders and cattle ranchers. However, Avalon's incarnation as a one-square-mile resort town of lodgings, restaurants, and water-oriented activities dates from 1887, when a Michigan entrepreneur bought the island. He put up a hotel and wharf, but in 1891 hard times forced him to sell to the Banning family, who ran the steamships to the island. In the following decade Avalon prospered, attracting vacationers, boatmen, and particularly fishermen, some of whom founded the famed Tuna Club, which established big-game fishing as a sport. Presidents, royalty, and Hollywood celebrities would fill its roster of guests and members.

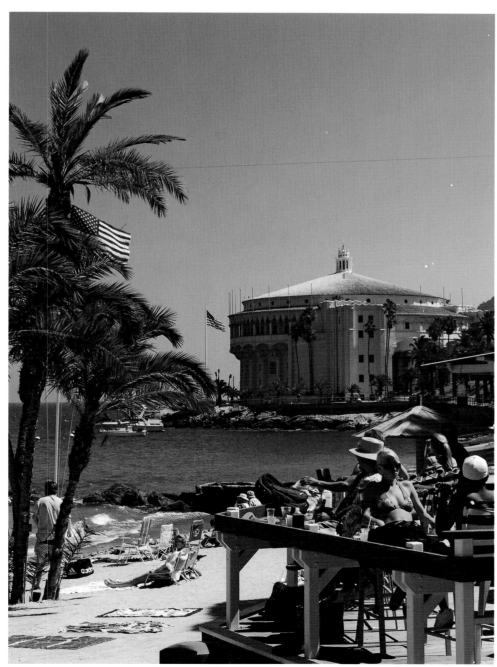

At sunrise, shore birds have Montecito's Miramar Beach to themselves (preceding pages).

The twilight panorama from the Inn on Mt. Ada takes in Avalon's scenic harbor (above). *The Casino* (right), *Catalina's most famous landmark, has striking Art Deco murals* (top right) *outside and a restored theater indoors.*

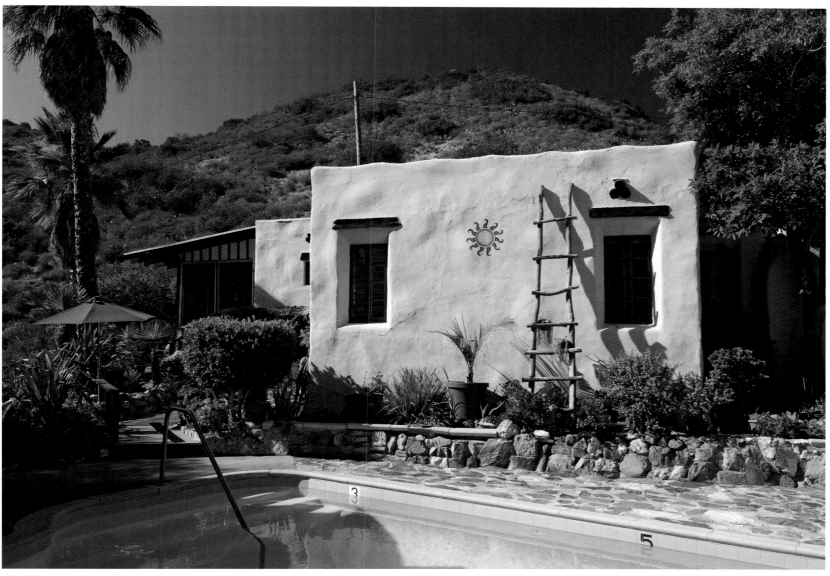

The homes of two of Avalon's famous residents now play host to visitors who find the relaxed Santa Catalina atmosphere a world away from busy mainland California. The Inn on Mt. Ada (all opposite), *named for original owner Mrs. Wrigley, has carefully preserved the Georgian colonial details of the 1921 house. Panoramic terraces and sitting areas invite guests to slow down and savor the view. On the facing hillside, Zane Grey's getaway* (above *and* right) *has its own colorful pueblo style. According to Avalon stories, the writer used to carouse noisily and late with Tuna Club buddies, displeasing Ada Wrigley, who arranged to have a nearby carillon sound at eight in the morning.*

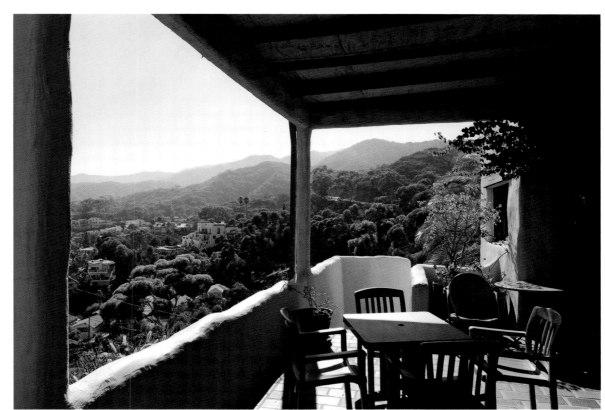

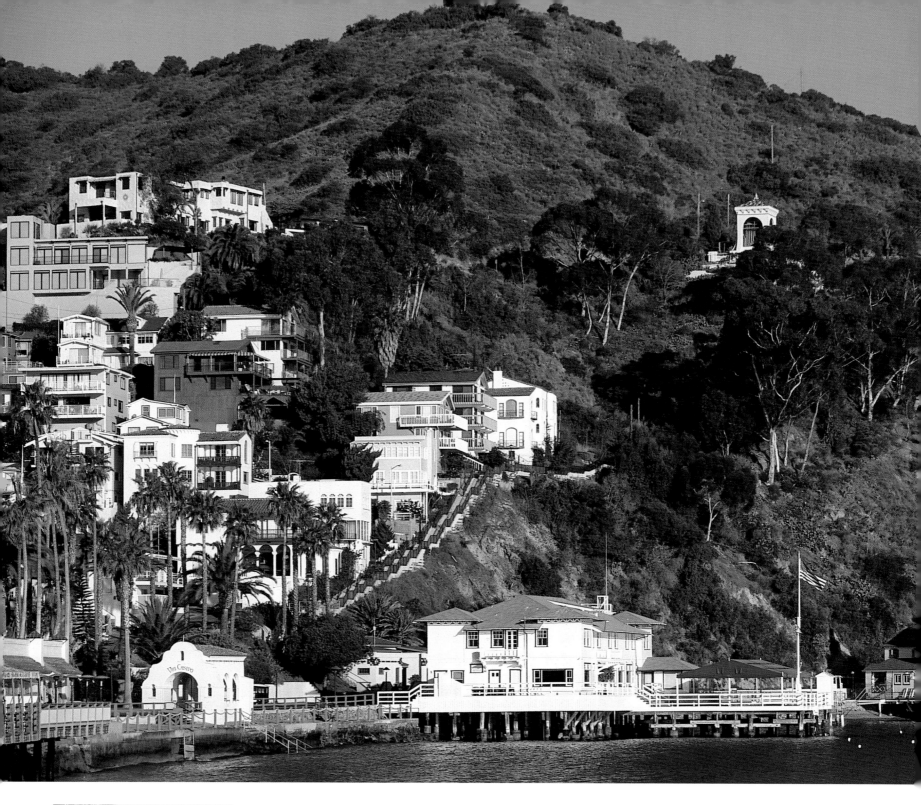

World War I slowed the pace of visitors, and in 1919 Catalina was sold again, this time to chewing-gum magnate William Wrigley Jr., who tirelessly promoted his island. As owner of the Chicago Cubs, he brought the baseball team to Avalon for spring training. And when Wrigley's wife, Ada, demurred at staying in a hotel, the couple built a sunlit hillside mansion, now a stunning bed-and-breakfast overlooking the harbor. Wrigley also set up a ceramics factory to make dinnerware, art pottery, and colorful decorative tiles, which adorn fountains and façades all over Avalon. His son came up with the idea for the Casino, and his wife was responsible for the Botanic Garden, with its towering memorial to her husband's memory. Wrigley's greatest legacy, though, may be the non-profit conservation organization that governs Catalina's rugged interior – home to several endemic species of flora and fauna…and about 200 bison.

These animals arrived in the 1920s as part of a movie shoot – Catalina has stood in for Tahiti, North Africa, and the American frontier, among other places – of *The Vanishing American*, based on one of Zane Grey's

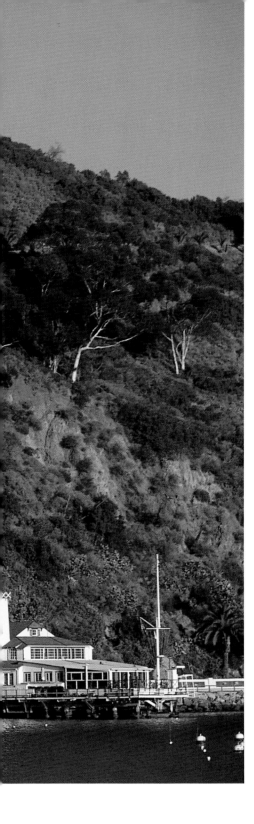

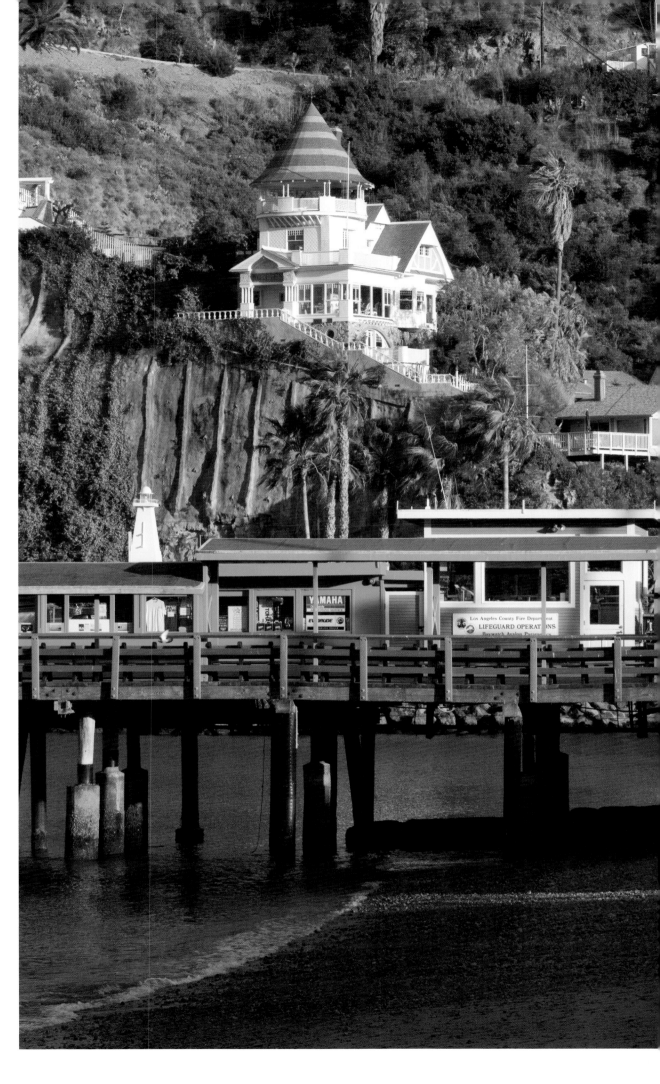

*T*he esteemed Tuna Club occupies a prime spot on Avalon's waterfront (above), between the Via Casino Archway and the Yacht Club, with its tower. Ordinary sailors and fishermen might frequent the town's green pleasure pier (right), not far from the Wrigley Plaza Fountain decorated with the island's ceramic tiles (opposite below).

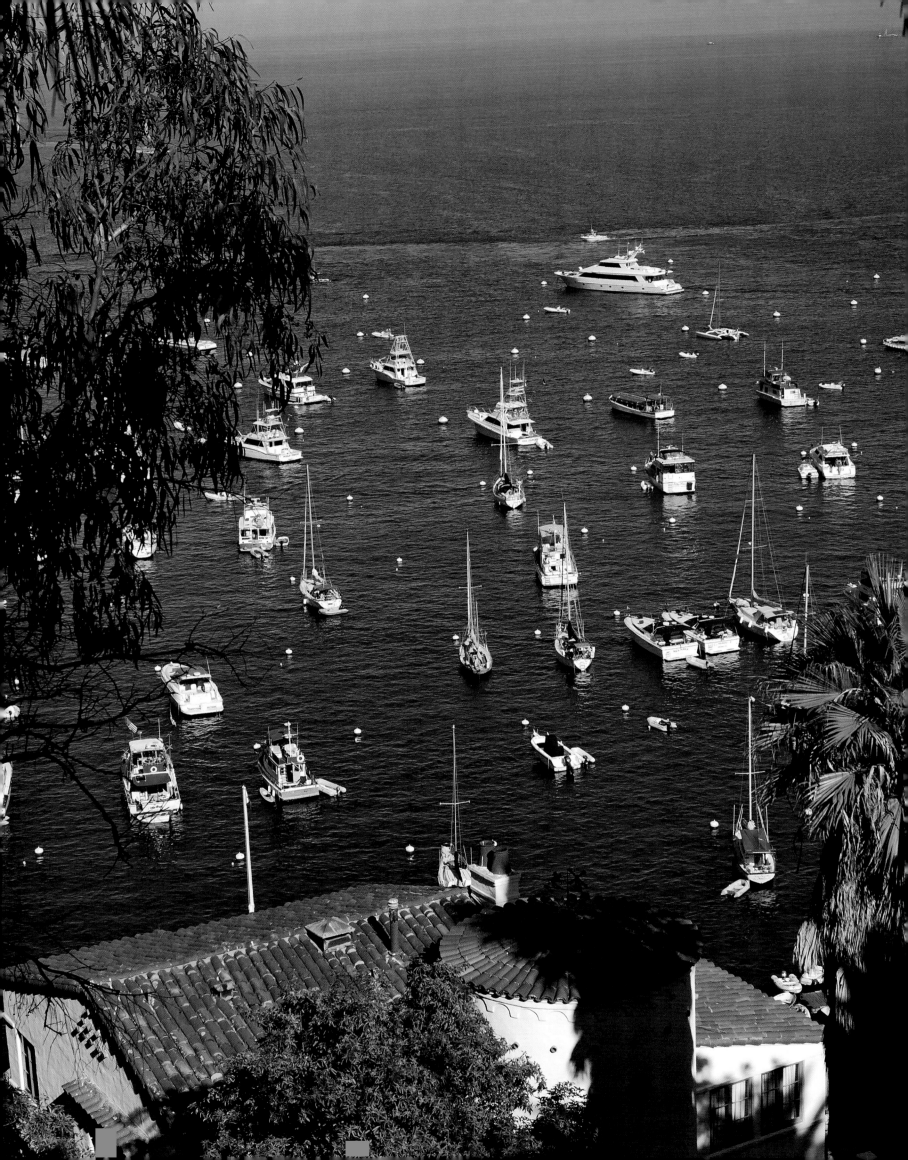

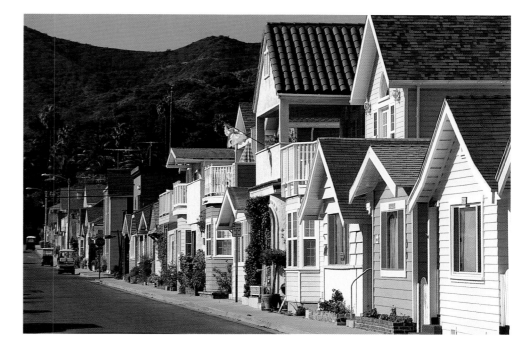

A mélange *of water craft, from luxurious yachts to simple sail-boats, anchors off Avalon* (opposite). *The popularity of the town with fishermen led to temporary tent sites that evolved into the tiny house lots of 'The Flats'* (right). *Newer and bigger houses climb the hills above downtown* (below), *but the means of transportation remains undersize: only golf carts are allowed* (below right).

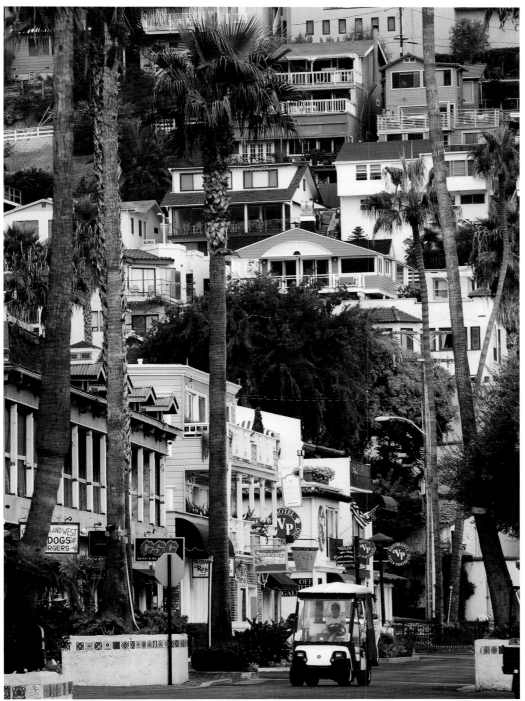

novels. Grey himself was a famous Avalon resident. The pueblo-style home he built in 1926 has a spectacular view of the waters he loved to fish. Today, divers and snorkelers throng to the rich kelp forests that harbor bright orange garibaldi, opaleye, rays, and calico bass. Farther offshore fishermen chase marlin and other bill-fish, and Catalina's coves remain a favorite destination for sail-boats and yachts. Other vacationers come for a romantic weekend or a family getaway. They stroll Avalon's waterfront, savor seafood on its green pleasure pier, and buzz around the little streets in the golf carts that substitute for autos here, succumbing to the charms of a classic resort unlike anything else in California.

Cambria

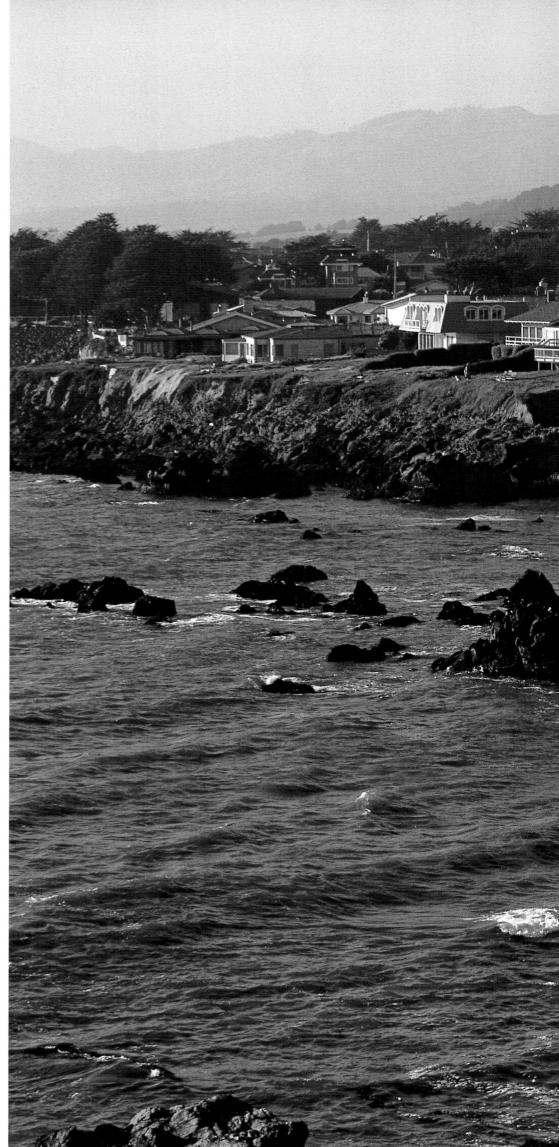

THE BELL OF the Old Santa Rosa Schoolhouse still rings out on Main Street, sounded not by a teacher but by a visitor to the Allied Arts Gallery housed inside. Cambria, a ranching and dairy community at the southern edge of Big Sur, has become a weekend getaway for arts and crafts lovers, as well as those who enjoy its undulating grasslands, pine-forested hills, and dramatic beaches.

The town got its start in the mid-1800s, when businessmen began to buy up land from old Mexican ranchos. Around 1863 William Leffingwell built a small sawmill at a point on Moonstone Beach that bears his name. Just three years later, two entrepreneurs plotted the few streets that became the heart of Cambria's east village. By the end of the decade Italian-Swiss settlers had begun to ranch and establish dairies; meanwhile Cambria grew into a thriving seaport and whaling station.

Dramatic headlands edge Cambria's coastline (right), offering spectacular Pacific views to the houses that have sprung up here in the last few decades. In recent years, a growing colony of elephant seals (below) has taken up residence, too, a dozen miles north.

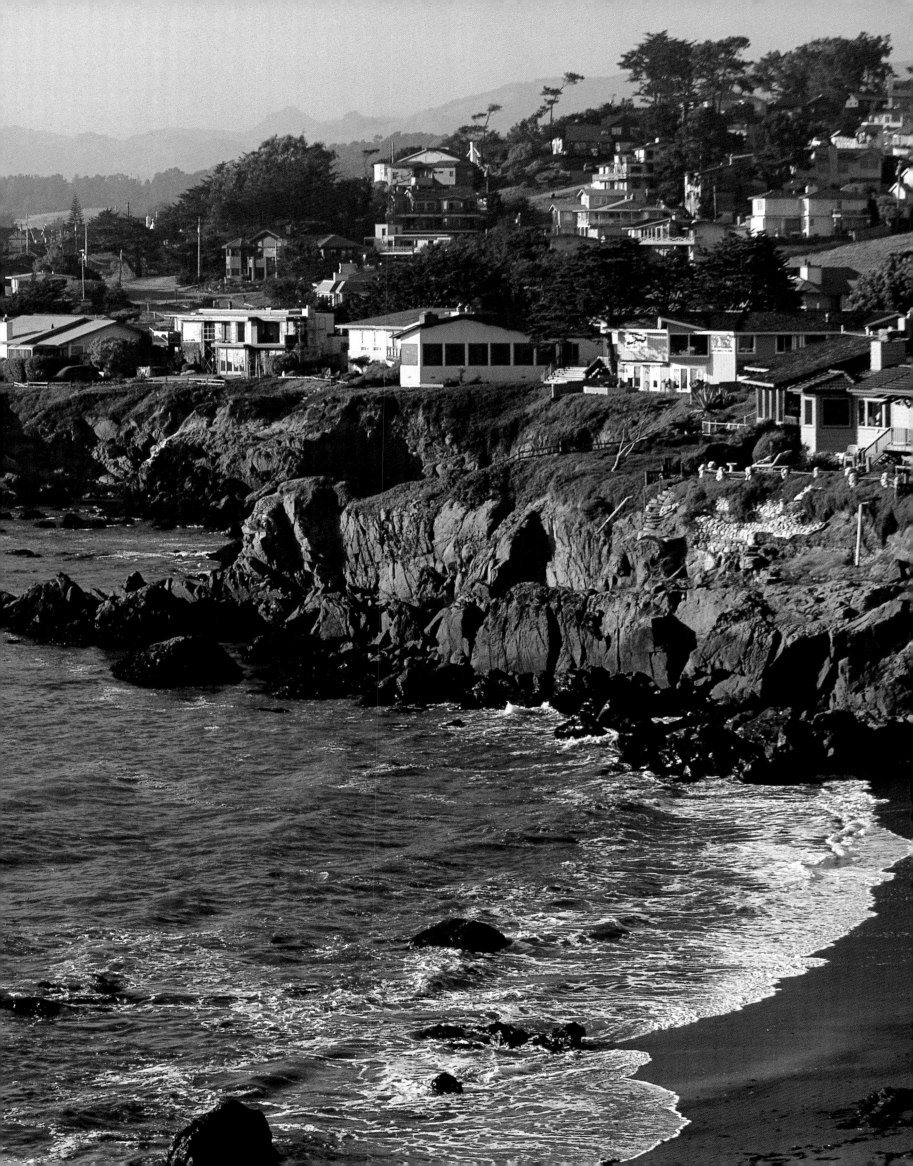

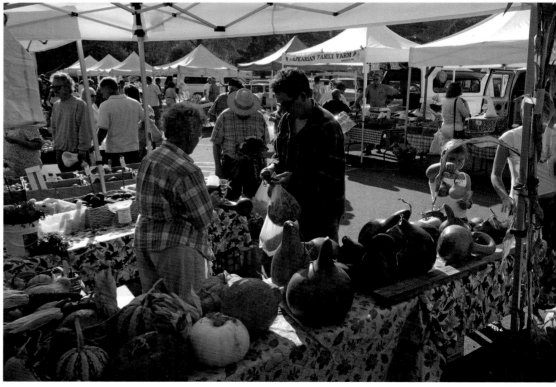

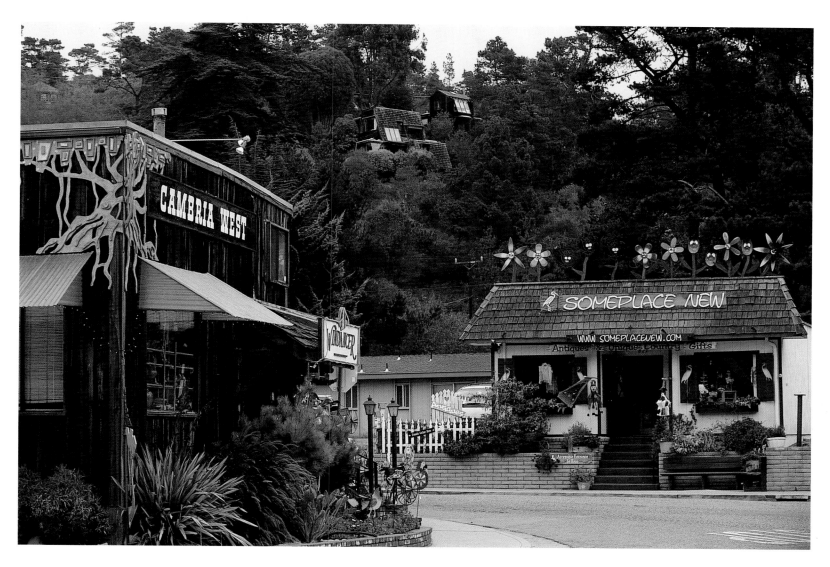

From bay windows to flat façades (opposite above) *Cambria's architecture embraces a range of styles. Many buildings display touches of artistry outside* (opposite below left) *or within; the board-and-batten redwood blacksmith shop* (right) *has exhibited sculpture in recent years. The weekly farmers' market* (opposite below right) *brings out locals and visitors for produce and flowers, and in the west village* (above)*, gift shops also incorporate blooms in their décor.*

Late-19th-century clapboard cottages, two-story Victorians, and flat-front façades – and the schoolhouse – line the town's quiet thoroughfares, though most of these now contain craft and antique stores, boutiques and restaurants, and an occasional bed-and-breakfast. The Guthrie-Bianchini House, which dates to about 1871, is being renovated for the Cambria Historical Society. A fire in 1889 destroyed part of the town, and when the railroad connected to inland San Luis Obispo, Cambria lost much of its coastal shipping. Yet the place hung on, and as the roads improved in the early 1920s, land developers once again began selling lots.

Just south of the town, the hamlet of Harmony grew up around a popular dairy. Today, there are only a few weathered wood buildings – a quaint post-office and a

couple of artisans' workshops. But decades ago William R. Hearst would stop here for butter and cream on the way to his nearby ranch. The influential newspaper magnate had grown up summering on the rugged 66,000 acres his father had bought in 1865, and in 1919, when Hearst inherited the property, he hired architect Julia Morgan to help him fulfill long-held dreams of a home at San Simeon.

His Mediterranean-Spanish-style castle crowns a ridge 1,600 feet above sea-level, with two wedding-cake towers, three guest-houses, elaborate gardens, a Roman pool and tennis-courts, 38 bedrooms, and some 22,500 inventoried objects, which include 155 Greek vases, 4,000 rare books, carved ceilings and choir stalls, statuary, tapestries, and religious art. Movie stars and international politicians like Charlie Chaplin, Cary Grant, Winston Churchill, and Calvin Coolidge enjoyed Hearst's generous hospitality. Today, thousands of visitors tour Hearst San Simeon State Historical Monument each year, marveling at one man's architectural fantasy.

William Randolph Hearst showcased Old World art and artifacts in his New World castle at San Simeon. A Roman temple façade embellishes the Neptune Pool (above), *and classical statuary dots the gardens* (right). *Blue and gold mosaics add brilliance to the indoor Roman Pool* (opposite above) *and 17th-century lamps illuminate the Gothic study* (opposite below right). *Silver graces the long dining-room table* (opposite below left), *where Hearst also put out catsup bottles during dinner.*

Simpler pleasures, like exploring tide pools and sandy coves, abound at Cambria's Moonstone Beach, named for the smooth semiprecious stones that wash up here. A boardwalk runs along the low bluff, a favorite spot for jogs and strolls. To this parkland, Cambria has added the East West Ranch Trail, a protected expanse of grassy headland where egrets stand sentinel, deer hide under occasional trees, and otters play in the waves. Fanciful wooden benches invite one to sit and contemplate an exhilarating vision of coast and ocean.

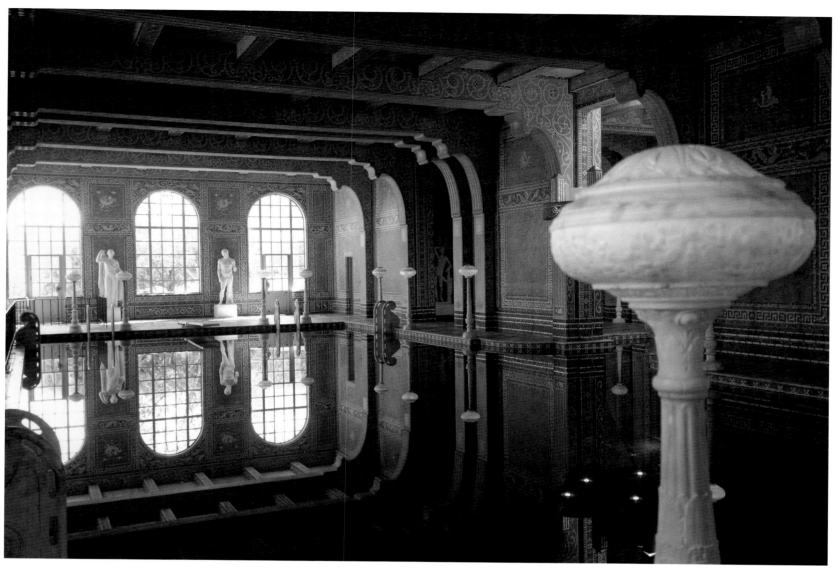

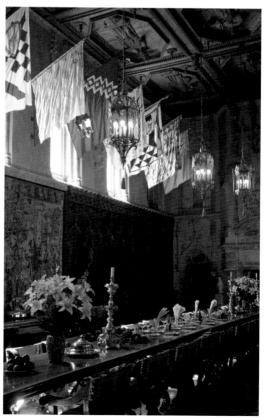

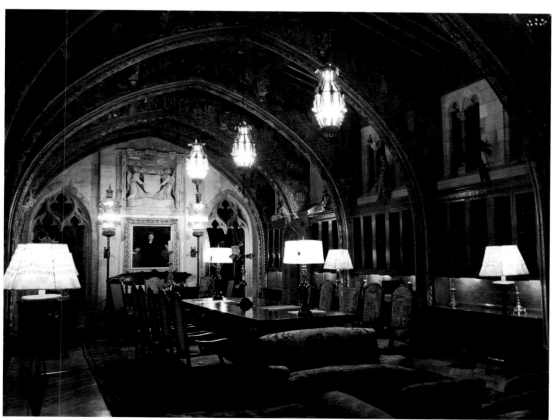

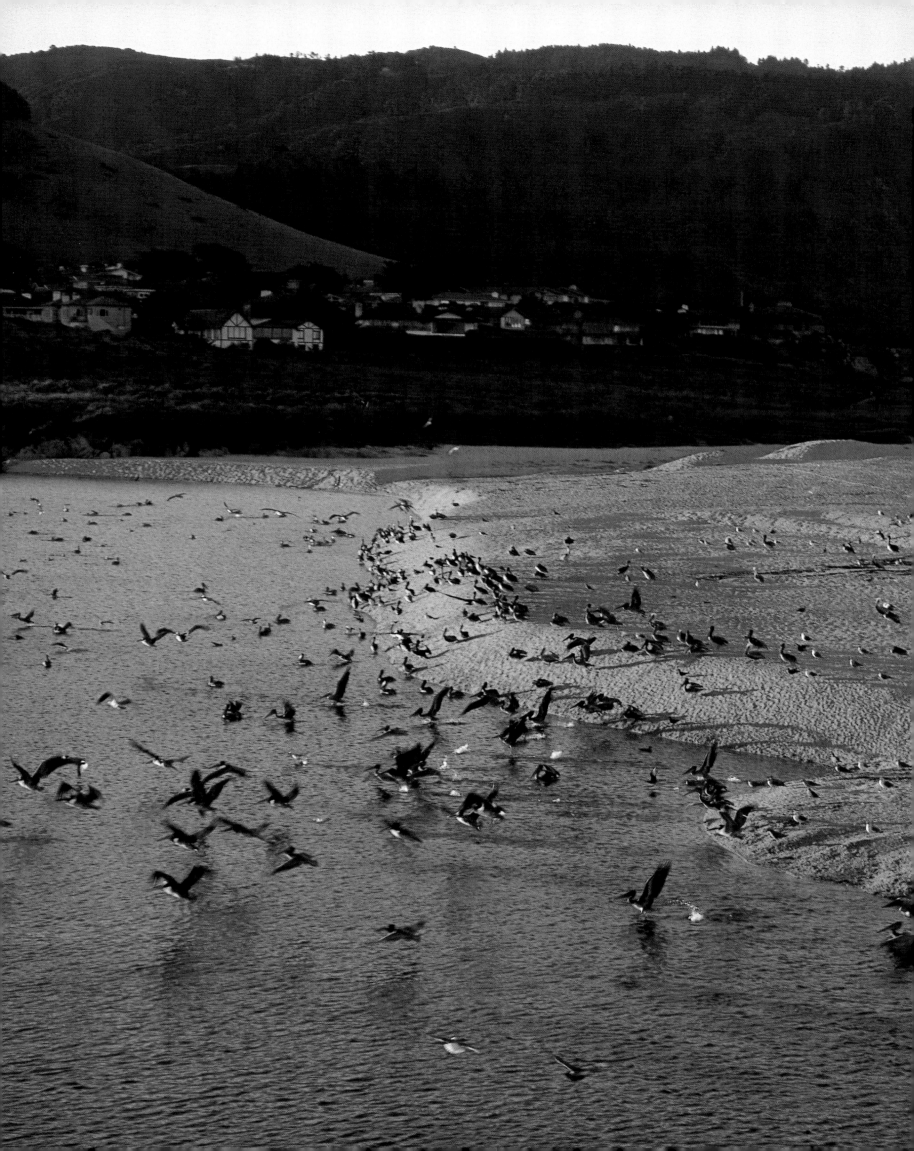

Carmel-by-the-Sea

AN ARTSY CHARM hangs over Carmel-by-the-Sea, which prides itself on bohemian history and contemporary chic. Almost 100 galleries – filled with paintings, sculpture, fine photography, and antiques – cluster in the town, which is often crowded with visitors. Interspersed with the art are boutiques, cafés and romantic restaurants, and atmospheric inns. At the heart of downtown is Ocean Avenue, which leads, not surprisingly, to the beach. The startlingly white sand stretches to the golf resort of Pebble Beach in one direction and the woods of Point Lobos in another. Aptly named Scenic Road winds along low cliffs, showing off exhilarating water views and a line of cottages that range from California cute to jaw-dropping gorgeous.

The town grew up around the turn of the 20th century, more than 100 years after the Spanish built a mission and presidio in nearby Monterey. In 1771 Father Junípero Serra moved his mission here to the mouth of the Carmel River, and though the Franciscan friar went on to found eight other missions, this remained his headquarters. His original wood structure was replaced in 1793 by today's stone church, with two unmatched towers and a lovely basilica, where Serra is buried.

Carmel's mission was secularized in 1834, and its extensive lands dispersed to various ranchos. Artists moved into the area in the late 1800s, and after the turn of the century one development company started marketing lots to 'brain workers', university professors who bought small cabins in the woods; after the San Francisco earthquake in 1906, they were joined by refugees from that city. Within a few decades writers also discovered the town, which eventually attracted such creative

Sea-birds wheel and dip above the sands at Carmel River Beach (left). Tourists flock to the art galleries and boutiques of downtown Carmel (below), where shopping has an aura of discovery, since none of the stores – or houses – here have street addresses.

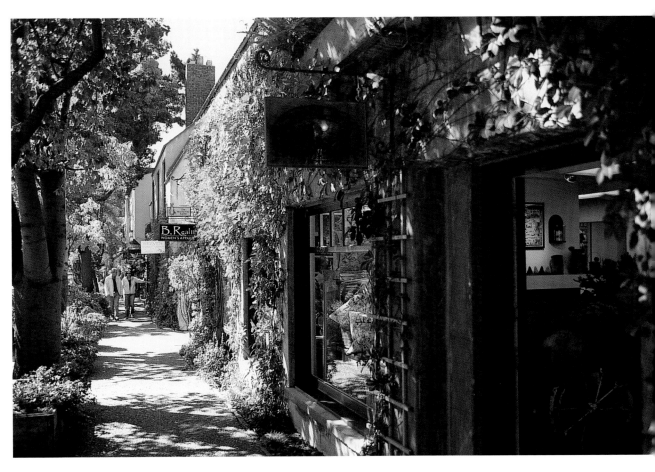

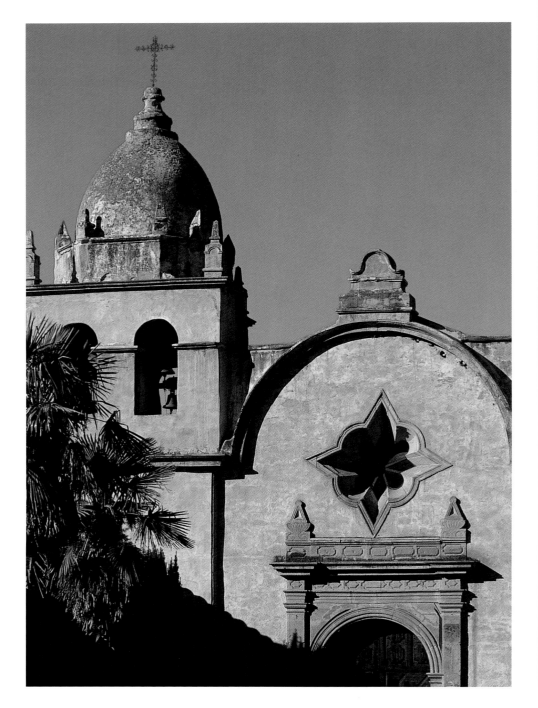

personalities as Jack London, Robinson Jeffers, Upton Sinclair, Sinclair Lewis, and Ansel Adams. A few of the village's off-beat characteristics today include a lack of streetlights, neon signs, or street addresses. The celebrity connection persists, too: actor/director Clint Eastwood served as mayor during 1986-88 and remains a local restaurateur and entrepreneur.

Every August Carmel-by-the-Sea hosts the Concours d'Élégance, which includes an auto show, auctions, races, and road rallies. Unusual, expensive, and simply fast cars are everywhere, and visitors and residents turn out to watch vintage automobiles do a 50-mile tour through the town and beyond, to some of Carmel's most scenic neighbors.

To the north is Pebble Beach, an exclusive enclave of residences, resorts, and world-class golf courses, laced by Seventeen-Mile Drive. As early as the 1880s guests of Monterey's swank Hotel Del Monte would explore the peninsula in horse-drawn carriages. Today, cars follow the twisting road over the hills and along the coast, pulling out for picnics on the sand at Spanish Bay or stopping for views of cormorants and harbor seals at Bird Rock, golfers swinging away on spectacular fairways, or age-old cypresses on stunning cliffs.

To the south of Carmel is Point Lobos State Reserve, a gateway to Big Sur. Once the site of a whaling station and an abalone cannery, the park spreads over a wooded headland indented by rocky coves where kelp swirls in jade-green water. In spring and summer sea-birds colonize the islets; almost all the year round harbor seals and sea-lions laze on stony outcrops, to the sounds of crashing waves.

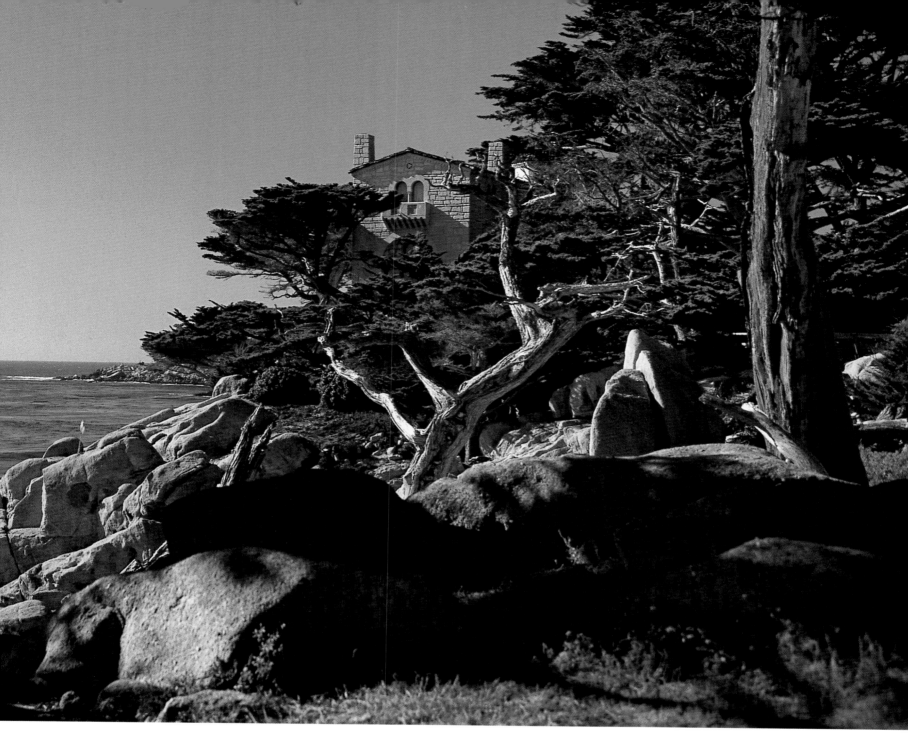

*T*he sculptured forms of cypress trees and great rock boulders mark Seventeen-Mile Drive's Pescadero Point (above), *the northernmost spot of Carmel Bay. In the south part of town, at the mouth of the Carmel River, stands the mission that Father Junípero Serra founded in 1771 (opposite above). He chose to be buried there, and a basilica marks his resting spot (opposite below). The annual Concours d'Élégance brings out collectors of antique cars and other automobile aficionados (right).*

*T*he hand-hewn log Whalers Cabin in Point Lobos State Reserve (opposite) was built in the 1850s as a residence for a Chinese fisherman's family. Today it houses exhibits on the history of Whalers Cove. Offshore rocks roil the waters at Point Pinos (below), north of Pebble Beach (right), where the carefully manicured golf course has its share of sandy hazards.

Montecito and Summerland

IT'S CALLED THE California Riviera, not just because this gorgeous bit of Central California coast is sandwiched between 3,000-foot mountains and the ocean, but also because its east-west orientation creates a Mediterranean climate. And also, just possibly, because advantaged Montecitans share the glamour and cachet of their French counterparts.

The first European residents of Montecito were soldiers from Santa Barbara's presidio who received land here for their service. By the mid-1800s they were joined by other settlers, who established farms, orchards, and dairies. And soon the area's benign winters and temperate summers caught the attention of 'horticulturalists' like Francesco Franceschi (who

*P*rized real estate, Montecito's *Miramar Beach* (above left) *bristles with tall narrow houses, with their feet in the sand and decks galore, all the better to take in the sweep of ocean* (left) *that contributes to a Mediterranean climate year-round.*

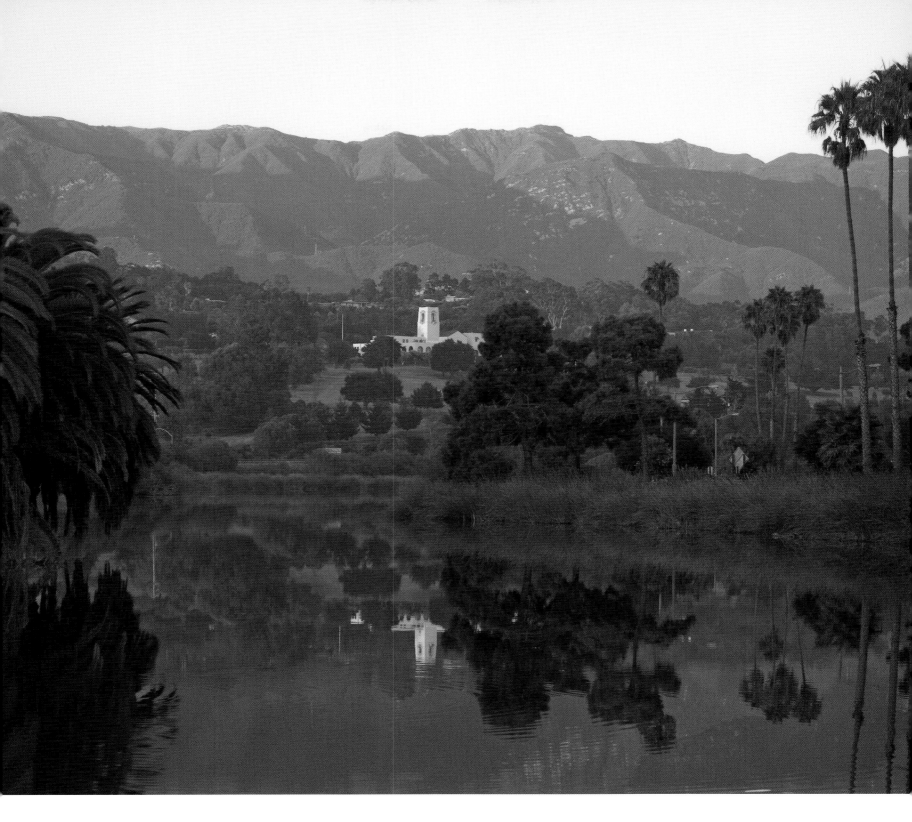

California's mission era is reflected in the architecture of the Montecito Country Club (above), mirrored by the placid waters of a bird refuge. Lucky's brings the more contemporary vibe of a New York steakhouse to Coast Village Road (right), where celebrities and celebrity-watchers often come to shop.

introduced zucchini to America) and nurseryman Kinton Ralph Stevens. Their prized plants graced the magnificent gated estates built by wealthy families from the East and Midwest – Armours, Swifts, and McCormicks, among them – who began to spend the cold months in Montecito. Great mansions, many in the popular white-walled, red-roofed Spanish colonial revival style, went up behind stout hedgerows or along twisting canyon roads that provide surprising ocean views.

In 1925 George Fox Steedmen, a St. Louis industrialist, commissioned Casa del Herrero, a re-created

Andalucian farmhouse with extensive Moorish-Spanish-inspired gardens. Today his antique-filled home is a museum that offers a glimpse into the gracious Montecito lifestyle as it was 80 years ago.

The original Kinton Stevens estate was bought in 1940 by Madame Ganna Walska, a wealthy, much-married, Polish-born opera singer, who renamed the place Lotusland. Over the next 40 years she used mass plantings and rare specimens to create a world-class botanical showpiece that now welcomes visitors.

Another villa-style residence, Mira Flores, became the headquarters for the Music Academy of the West, a summer institute for young performers. In fact, Montecito has long had an appeal to musicians and actors, who found it a quick and often romantic getaway from Hollywood, 100 miles away. Dame Judith Anderson had a home here; Charlie Chaplin once owned part of the Montecito Inn, and David Niven, Audrey Hepburn, and Gloria Swanson all

Montecito is known for fabulous estates, but its gardens are also glorious. The formal green spaces at Casa del Herrero (opposite) include tiled fountains among its outdoor 'rooms.' At Lotusland (below) the plantings include innovative arrangements of Old Man cactus near the house, as well as Japanese gardens, bromeliad gardens, aloe gardens, and, of course, a lotus pond. The grounds of San Ysidro Ranch (left) contribute to the inn's reputation as a romantic getaway.

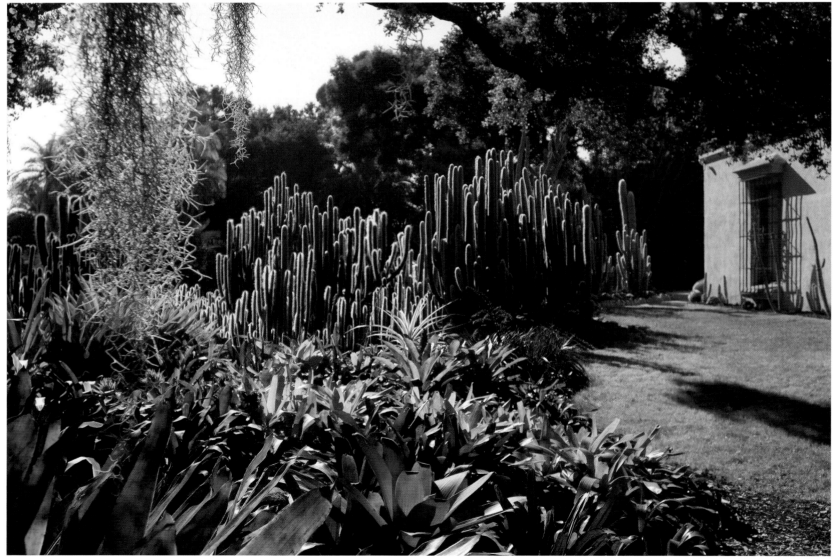

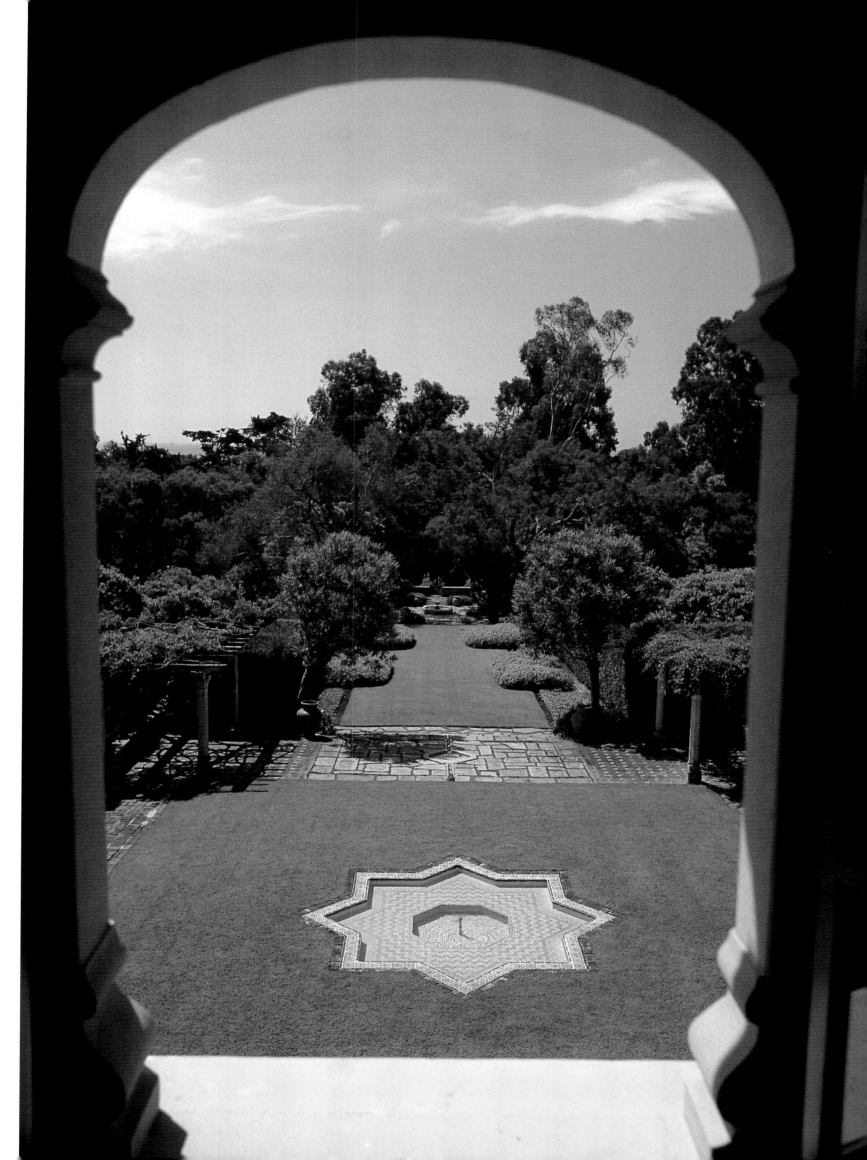

In good weather – almost all the time – chic cafés set their tables outdoors along Coast Village Road (left), the better to people-watch. Residents and visitors alike turn out to see a bike brigade in patriotic colors roll down San Ysidro Road as part of Montecito's annual July 4 parade (below).

vacationed at San Ysidro Ranch – owned in part by Ronald Colman – where the Kennedys honeymooned. The entertainment connection lives on: the boutiques and chic restaurants along Coast Village and East Valley Roads offer plentiful opportunities for celebrity sightings of residents like Jeff Bridges, Kevin Costner, John Cleese, and Oprah Winfrey, and other famous visitors.

At the eastern edge of Montecito lies the hillside beach town of Summerland, which was founded as a colony for spiritualists in 1888. Their tiny lots – 25 by 60 feet – were laid out on streets named for leading mediums of the day and sold for $25 each. Six years later a resident drilling for water struck oil instead, and by the end of the century 22 oil companies had wells on a dozen wharves along the water. The boom was short-lived; by the 1920s the oil era was over. Yet stories of spirits lingered on for decades. Eventually, Summerland with its long, flat golden sands, became a surfers' place, though today the bikini shops and water-sports shacks share the main street with purveyors of fine antiques and luxe *objets d'art.* Spiffy new Victorian-style houses are interspersed among the centuries-old houses and barns – which perhaps still harbor a ghost or two.

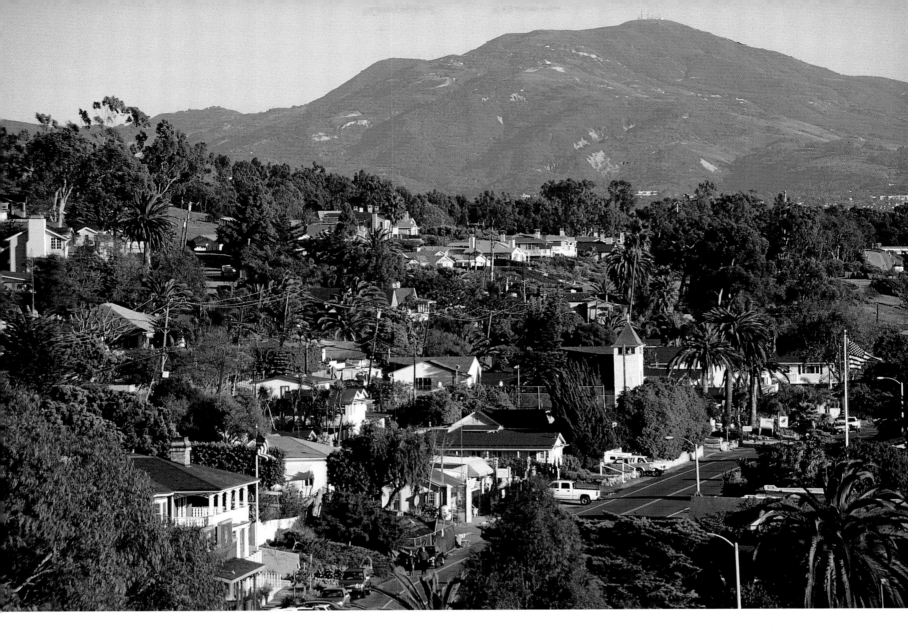

*S*ummerland's hills give way to
mountains in the distance
(above). *The compact town was
founded in the late 1800s as a
spiritualists' colony. Now surfers
commune with the waves* (right).

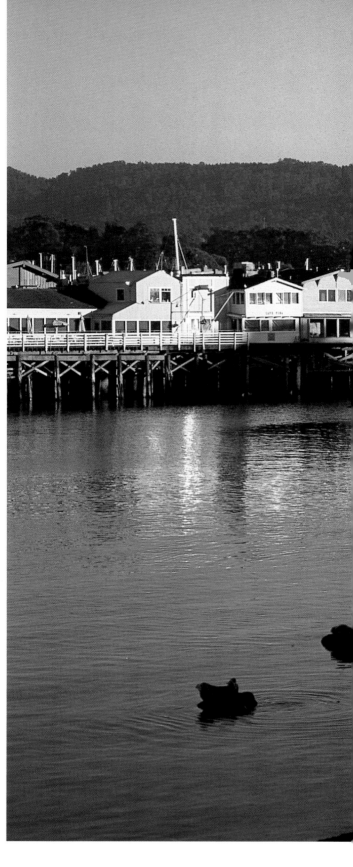

Monterey

MONTEREY'S BAY IS a marvel, a broad curve that ends in a fish-hook peninsula. Even in summer, the waters – protected as part of the Monterey Bay National Marine Sanctuary – are chilly, but they teem with life. Ribbons of kelp harbor myriad species of fish; otters, sea-lions, and harbor seals cavort within view of shore. Cormorants, pelicans, and other sea-birds dive for food or cluster on rocky outcrops. Farther out, dolphins and

whales cut a wake through the waves. The bay has become a playground for humans, too, attracting sailors, kayakers, and divers, even surfers. And it has shaped the up-down-and-up history of Monterey itself.

The first European to see the bay – Juan Rodriguez Cabrillo – sailed past in 1542. Sixty years later, Sebastian Vizcaíno claimed the area for Spain. But 150 years would go by before that country took an active

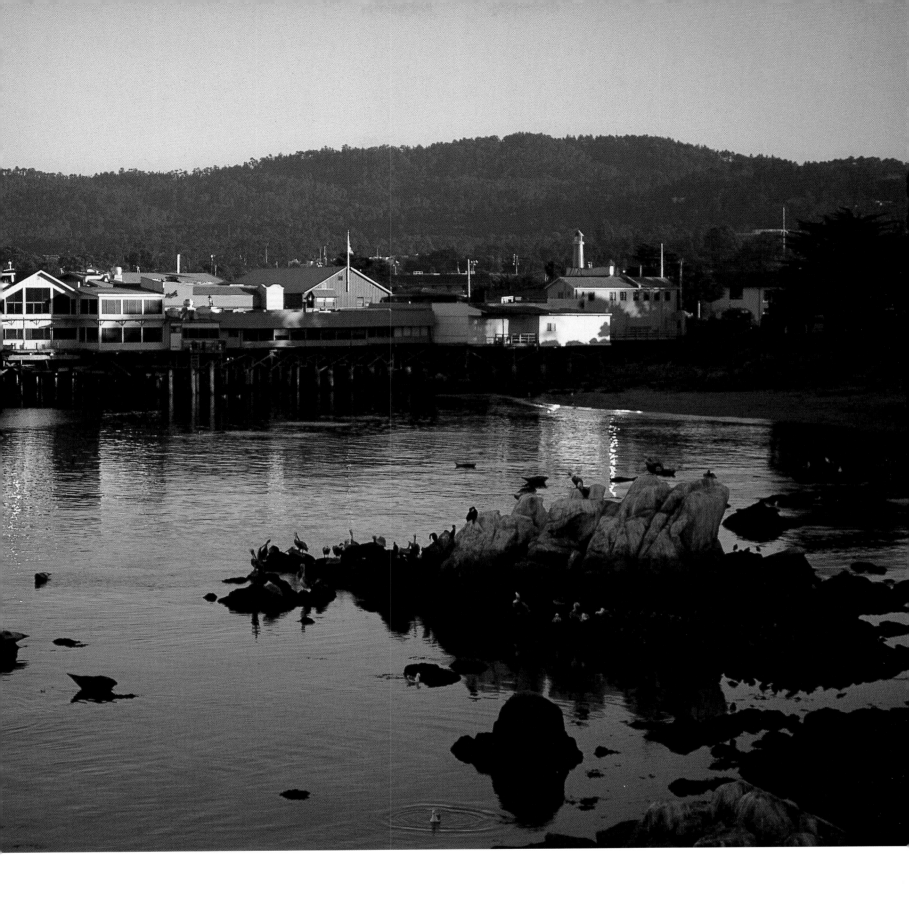

interest in this part of the New World. Then, fearful of Russian encroachment, King Charles II dispatched Gaspar de Portolá and Father Junípero Serra from Mexico to found a mission and presidio. In 1770 Serra, a Franciscan monk, established San Carlos Borromeo de Monterey, and the church – with a cream-colored Spanish baroque façade and a simple wood-ceilinged sanctuary – has remained in continuous use ever since.

Monterey became the capital of Alta California in 1776, but gradually Spain's control over its colony weakened, until Mexico won independence in 1821. Under the new regime, foreign traders paid their duties here and exchanged their wares for local hides and tallow to be shipped to the East Coast and Europe. Today, the Custom House built in 1827 has been restocked with casks, crates, and trade goods of the era.

Sea life is paramount in Monterey, where Fisherman's Wharf (above) *hosts a long line of seafood restaurants, and sea-lions and cormorants congregate around the Coast Guard Pier* (opposite below). *Offshore, sail-boats wait at anchor* (opposite above).

During the years of the Mexican Republic all foreign traders came to Monterey's Custom House (above) to pay duties and do business. Today, the building, erected in 1827, is a museum, filled with the goods of those days. California's first theater (left) stands a block away. An English sailor named Jack Swan constructed it in the 1840s as a warehouse and boarding-house with movable partitions, and he permitted American soldiers to pass the time by performing melodramas inside.

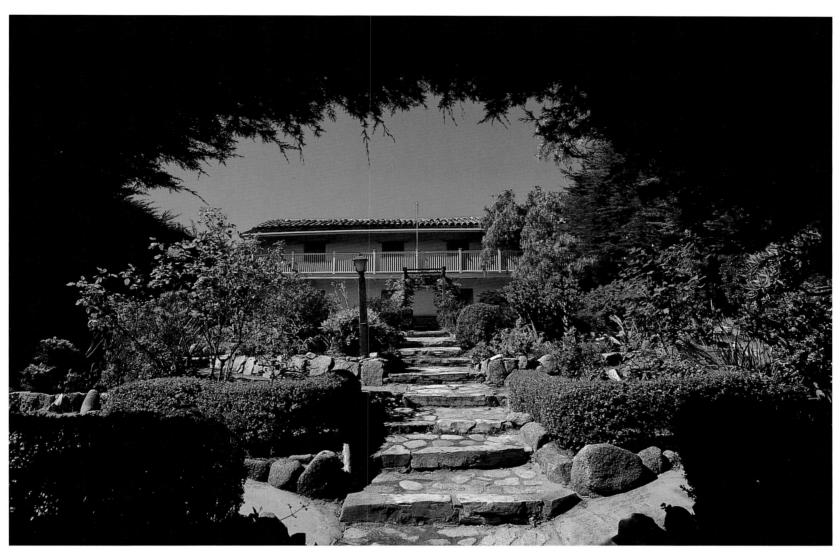

And the Californio society that grew up over the next two decades is similarly reflected in the houses from the 1820s to the 1850s that are part of the Monterey State Historic Park. Casa Soberanes and the Cooper-Molera Adobe, for example, reveal the architecture, furnishings, and gardens of those days, as does the home of Thomas Larkin, a merchant and the American consul to Mexican California.

The Mexican-American War put Monterey under U.S. control in 1846, and three years later a constitutional convention for the proposed state of California was held at Colton Hall. Inside the impressive stone edifice, 48 delegates hammered out the state's boundaries, forbade slavery, and decided to move the capital to San Jose. After that, men and resources were drawn to the gold fields, and Monterey became a sleepy oceanside village once again.

Around 1875 Methodist ministers began to hold camp meetings at the edge of town, in a community that grew into charming Pacific Grove. A few years later the first stirrings of tourism began, as the Southern Pacific Railway carried vacationers to the new Del Monte Hotel. But most local people continued to live

A stone path leads to the Casa Soberanes Adobe (top), *one of many homes included in the Monterey State Historic Park. The house, from the 1840s, retains the* sala, *or parlor, where dances were frequently held in Californio society, but the furnishings range from 1800 to the 1970s. The Cooper-Molera Adobe also dates to the 1800s. Its painted façade on one side* (left) *contrasts with advertising on the other* (above).

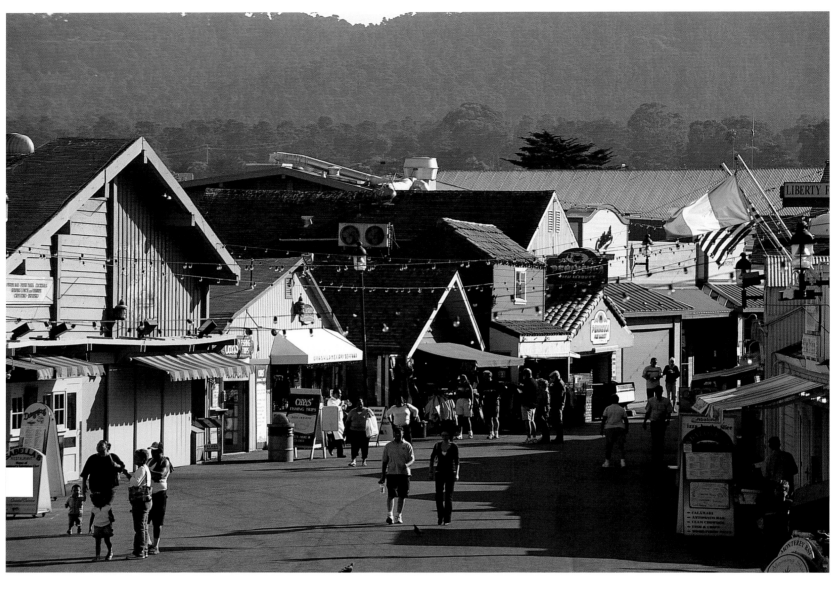

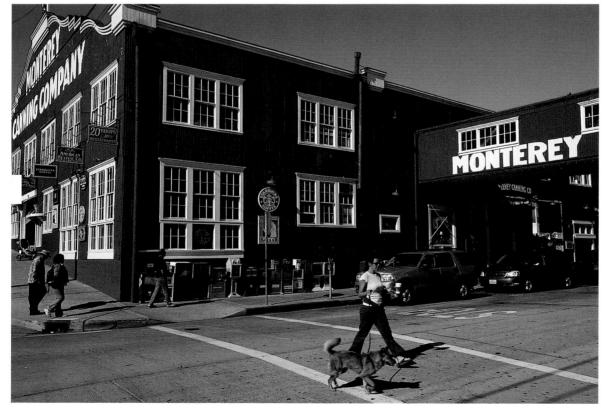

Visitors stroll Fisherman's Wharf (top), looking for tasty seafood. For years the town catered to that desire with sardine canning factories (left) — now filled with shops — whose characters were immortalized by John Steinbeck (above).

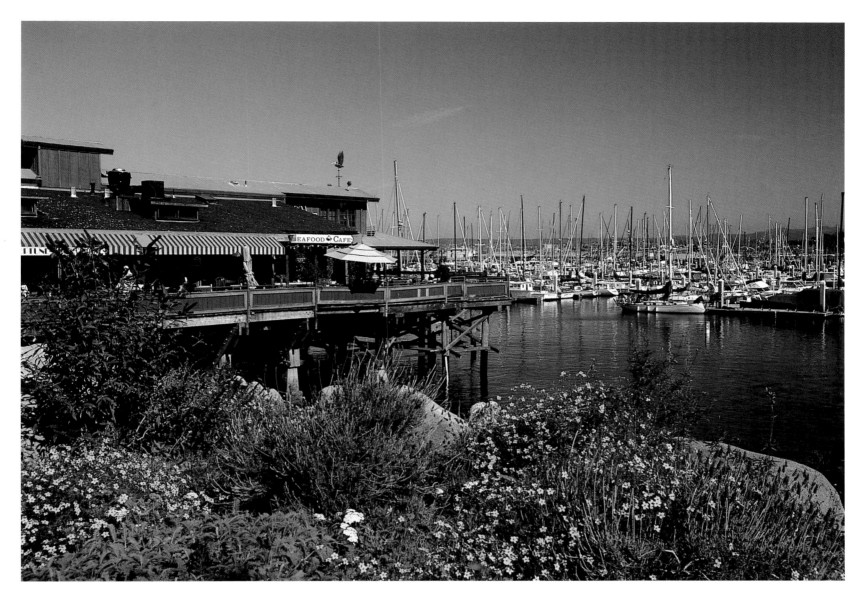

by agriculture and fishing. By the early 1900s Italian immigrants had established a thriving sardine industry. Huge factories were built along the waterfront, with long piers to receive the catch, which was processed, canned, and loaded on to waiting railway cars.

The town had its assortment of colorful characters, including noted marine biologist Edward 'Doc' Ricketts, immortalized by his friend John Steinbeck, the Nobel Prize-winning writer born in nearby Salinas. Steinbeck's classic novel *Cannery Row* kept the place's atmosphere alive long after the sardines were fished out in the 1950s, the canneries closed, and the once-raffish neighborhood went into decline.

That all changed after 1984, when the Monterey Bay Aquarium opened on the site of the Hovden Cannery. This brilliant showcase for the life of the bay and the oceans beyond has two-story tanks, interactive exhibits, kelp forests, and fabulous creatures from tiny jellyfish to tuna, sharks, and sea turtles – 550 species in all. Along Cannery Row shops and restaurants now fill the warehouse-like spaces, while outside, a walkway and bike trail edge the endlessly fascinating bay.

*P*leasure craft line the harbor beyond Fisherman's *Wharf* (top), *waiting to take sailors out into the bay. Landlubbers can get a look at jellyfish* (above) *and other undersea creatures at the Monterey Bay Aquarium.*

San Juan Capistrano

IT WAS MUSIC that made San Juan Capistrano famous. In 1939 a radio broadcast about the legend of swallows returning every spring – on the Feast of St. Joseph, March 19 – inspired composer Leon René to write the poignant melody and romantic lyrics that have brought generations of travelers to this Southern California town. René's piano and sheet music are on exhibit at the Mission San Juan Capistrano, founded in 1776 by Father Junípero Serra. Its sandstone walls once enclosed a community designed to produce all the food and materials needed for the padres, the soldiers who accompanied them, and the Native Americans they wanted to convert. By 1811 there were 14,000 head of cattle and sheep and tons of corn and barley, as well as living quarters, warehouses, metal furnaces (the first in California), tallow and wine vats, spinning and weaving yards, and places to worship.

The mission's ambitious Great Stone Church was completed in 1806, after nine years of construction. This sanctuary hearkened back to the cathedrals of Europe, with eight domes painted by native artisans, brick niches for statues of saints, and four huge bells. But the church stood for only half a dozen years. An earthquake in December 1812 toppled the structure, leaving ruins that retain an aura of grandeur. Still standing, though, is the Serra Chapel, built in 1792, with simple whitewashed walls that focus all attention on a stunning gilt baroque retable from Barcelona, more than 350 years old.

The roofless walls of San Juan Capistrano's Great Stone Church (left) still stand as a symbol of faith, though the ambitious sanctuary was devastated by an earthquake in 1812. When the building collapsed, 42 worshipers perished; the mission's bells, named for saints, also were damaged but were recast in 2000 (top).

145

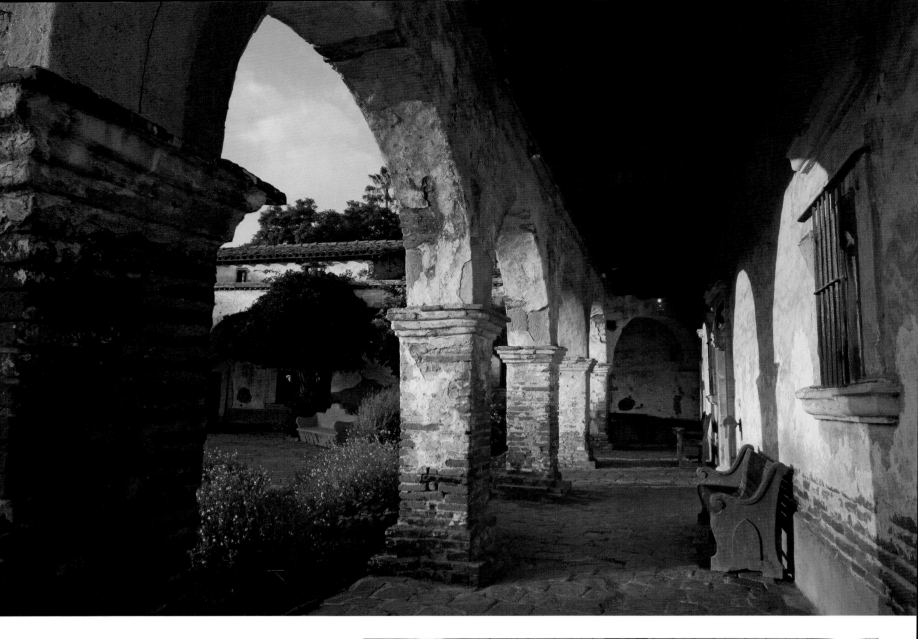

As the community grew, about 40 adobes for soldiers and converts went up outside the mission walls in 1794; a number of the dwellings – including the Rios Adobe, now the residence and law office of a tenth-generation descendant of the building's original occupant – survive in the historic district along tree-shaded Los Rios Street, which also includes board-and-batten cottages from the late 1800s. One of those is now the O'Neill Museum, where historic photographs and period clothing and furniture add context to the story of the 1870 home. San Juan Capistrano's evolution is also visible throughout Old Town, whose boutiques, antique stores, and restaurants are housed in Californio adobes of the 1830s and '40s and Victorian buildings from the 1880s.

One Italianate mansion was the home of Judge Richard Egan, a gregarious Irishman who surveyed the Santa Fe Railway line and loved to entertain. Among his guests was Polish actress Helena Modjewska, who would help popularize San Juan Capistrano's charms. Later Mary Pickford also played that role, as Hollywood used the mission as a location for one of her silent movies.

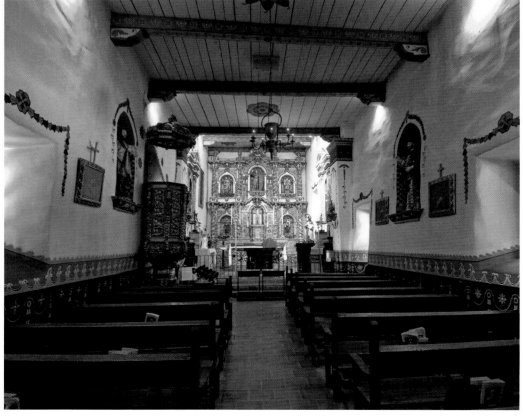

*A*rched porticoes enclose the central courtyard of the mission (opposite above), *where Indian converts once carried on the work of the community, like spinning, weaving and animal husbandry. Now the rooms along the side contain museum exhibits and artifacts. The long, narrow Serra Chapel (opposite below) leads to an exquisite baroque retable from Spain. The streets of San Juan Capistrano are a living architectural museum, with the 1830 Yorba Adobes (above, at left) and the unusual two-story Garcia Adobe (above, at right),* also from the rancho era. The Rios Adobe (right) *is the oldest residence in California still occupied by the same family.*

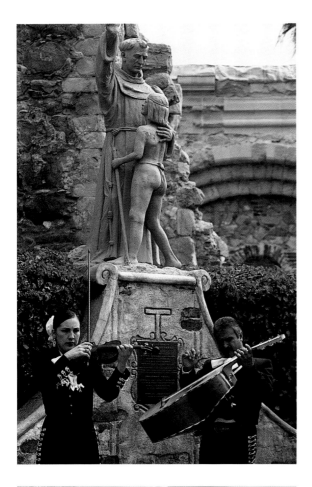

*V*olunteers in period garb re-create the early 1800s
at Mission San Juan Capistrano on monthly
'Living History Days' (right). The biggest fiesta takes
place each March during the Return of the Swallows
celebration, with mariachi players (above *and* top),
Indian dancers (both opposite above), *and the*
fandango (opposite below right). *The birds themselves
appear not only in avian form but also as colorfully
costumed tots* (opposite below left).

The dome of the old train depot now marks Sarducci's restaurant (opposite), a popular dining spot alongside the railway tracks. Up the street the San Juan Depot (below) makes use of a 1927 Pullman dining car as a setting for meals. Michael Graves drew on local style for his contemporary San Juan Capistrano Regional Library (bottom).

In 1887 the railroad's arrival boosted the region's agriculture, making it easier to ship out the valley's oranges and fueling rising land values in the process. And though today's Amtrak passengers buy tickets from self-service machines, the domed, redbrick depot from 1894 has been converted to a restaurant, with waiting-rooms as private dining areas and platforms incorporated into the décor.

San Juan Capistrano's powerful preservation movement was galvanized in the 1960s after a historic home was razed. Fearful that their heritage was being lost, citizens instituted building codes that left the hillside sightlines uncluttered and ensured that architecture in the commercial district conformed to historic styles. That challenge didn't stop architect Michael Graves from designing the city library in 1983. His imaginative creation is a postmodern building, whose towers, colonnade, and red-tile roof evoke San Juan Capistrano's traditions with contemporary *élan*.

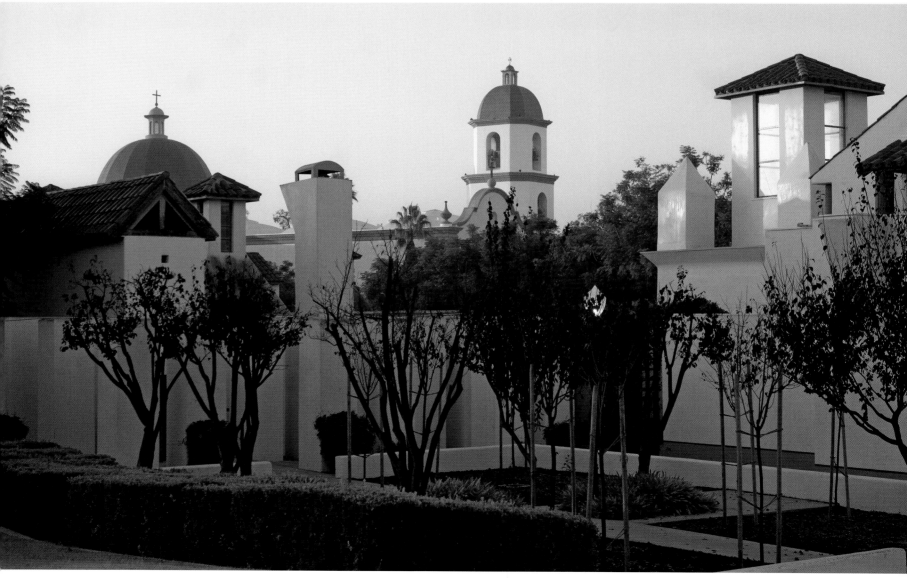

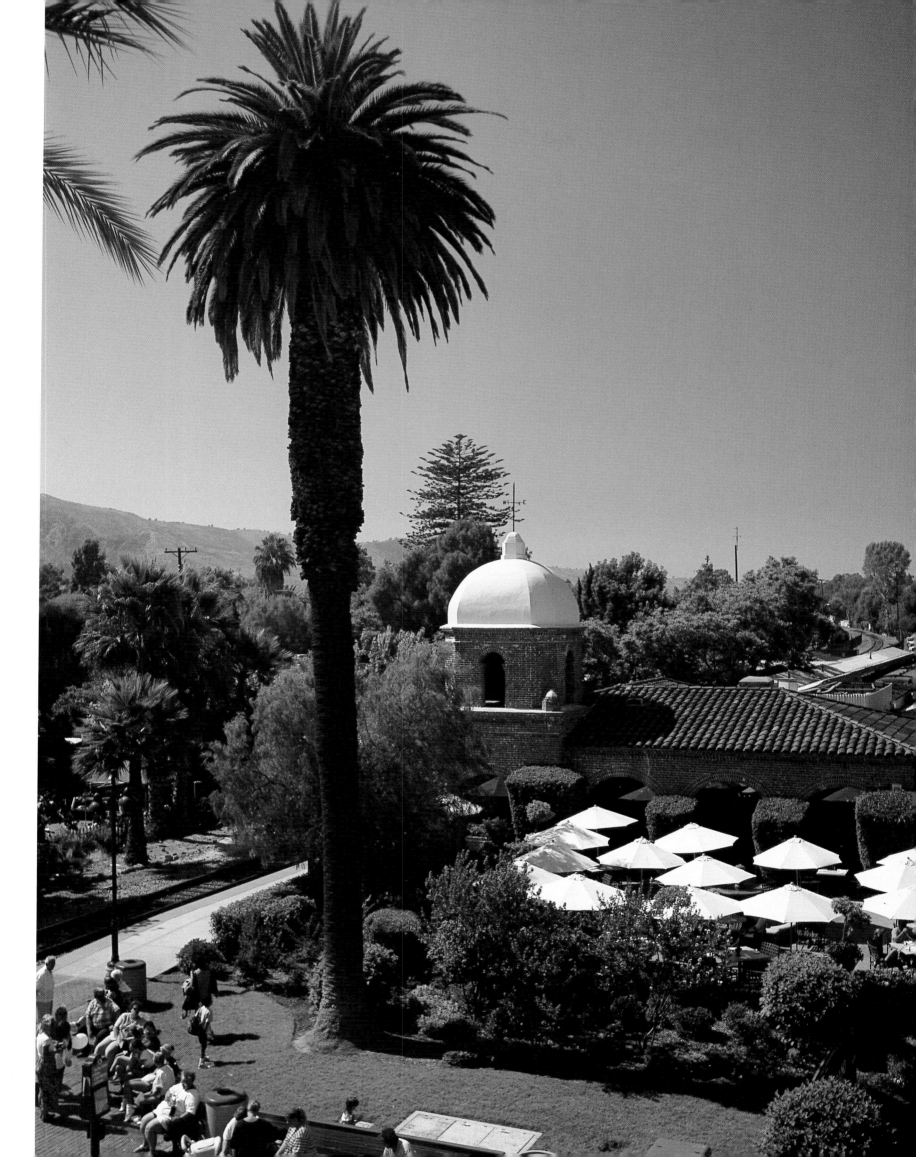

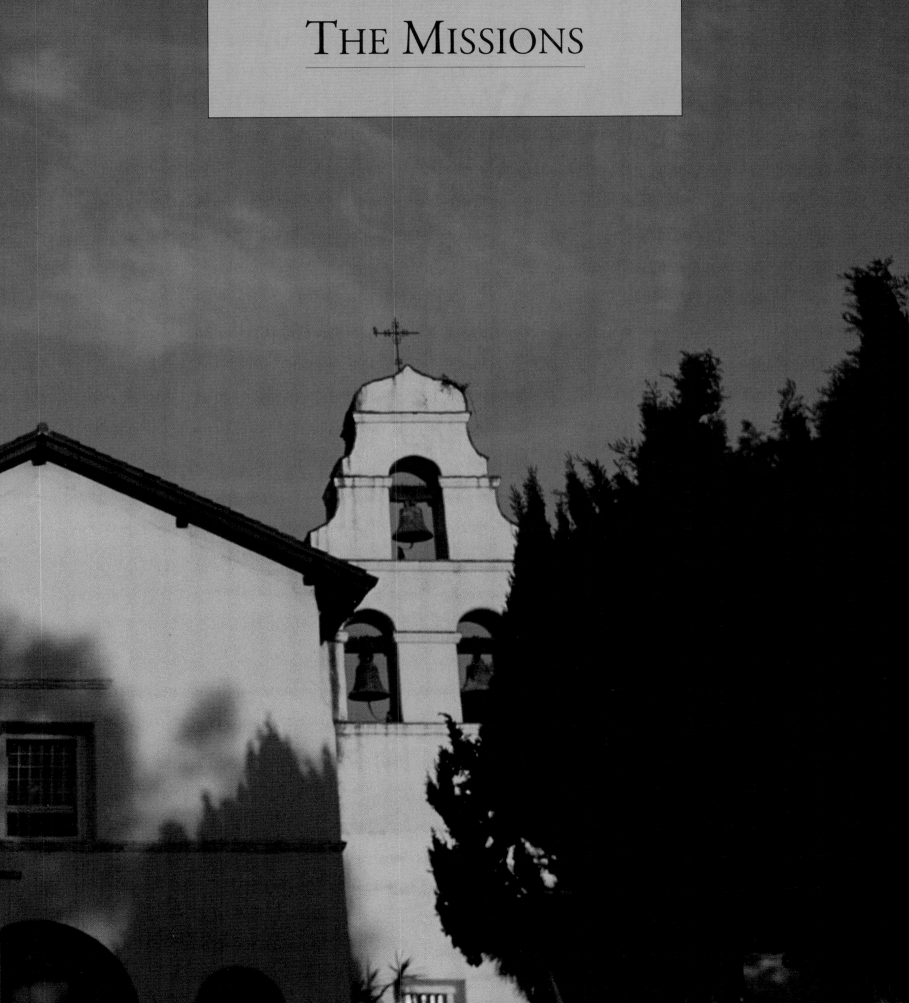

THE MISSIONS

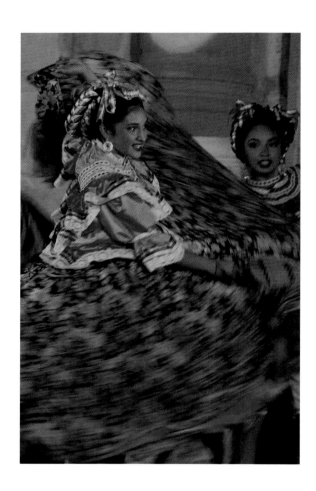

*S*an Juan Bautista's patron saint, Saint John the Baptist, stretches his arms to heaven before the sun-gilded façade of the mission church, which has been in continuous use since 1812 (preceding pages).

*F*lamenco dancers find a platform on the steps of the Santa Barbara Mission – still an active parish church – during the city's annual Fiesta (opposite). For several days every August, parades, concerts, displays of Mexican dance (above), and revelry celebrate the 40 years when the mission and presidio were ruled by Spain.

With swirling skirts, flashing smiles, and the sounds of flamenco, the official opening of 'Old Spanish Days,' Santa Barbara's annual Fiesta, takes place on the broad steps of the gracious mission founded in 1786. If the myth behind the celebration exceeds the reality – the Spanish ruled here for just 40 years – perhaps that fits the setting. For the story of this mission, and the 20 others famously located a day's journey apart on the Camino Real, is also a blend of history, romance, controversy, and beauty.

California's earliest missions were the work of the son of Mallorcan farmers, a Franciscan friar named Father Junípero Serra who left an academic post in Europe to serve as a missionary in the roughest outposts of the New World. When the inspector-general of New Spain organized a land-and-sea expedition to settle Alta California, he tapped Serra as the religious leader.

Ascetic in temperament and plagued by a leg injury most of his life, the priest stood just over five feet tall; he proved to be a towering figure nonetheless. Accompanying the military commander Gaspar de Portolá, Serra walked overland from La Paz in Baja California to San Diego Bay and a planned rendezvous with three Spanish ships. Though the expedition was fraught with misery and disaster – one of the galleons was lost at sea, and in all half the troops died – Portolá eventually pushed as far north as Monterey Bay, while Serra stayed behind and founded the first California mission at San Diego de Alcalá on July 16, 1769.

The next year, when the commander again went north, Serra was with him. On June 3, 1770, Serra dedicated San Carlos Borromeo, in Monterey's presidio. But worries about having randy soldiers so close to young Indian women converts made him move the mission a year later, to its present site at the mouth of the Carmel River. Before his death in 1784, Serra himself would found seven other missions, though most of the original buildings are long gone, destroyed by fire, earthquakes, or the elements before being rebuilt. The Serra Chapel at San Juan Capistrano is the only sanctuary where he is known to have said mass.

The priest chose to be buried in the Carmel Mission that was his headquarters; Serra's grave is in the basilica near a gloriously painted wood-and-gilt altar, a copy of the Spanish baroque-style masterpiece in

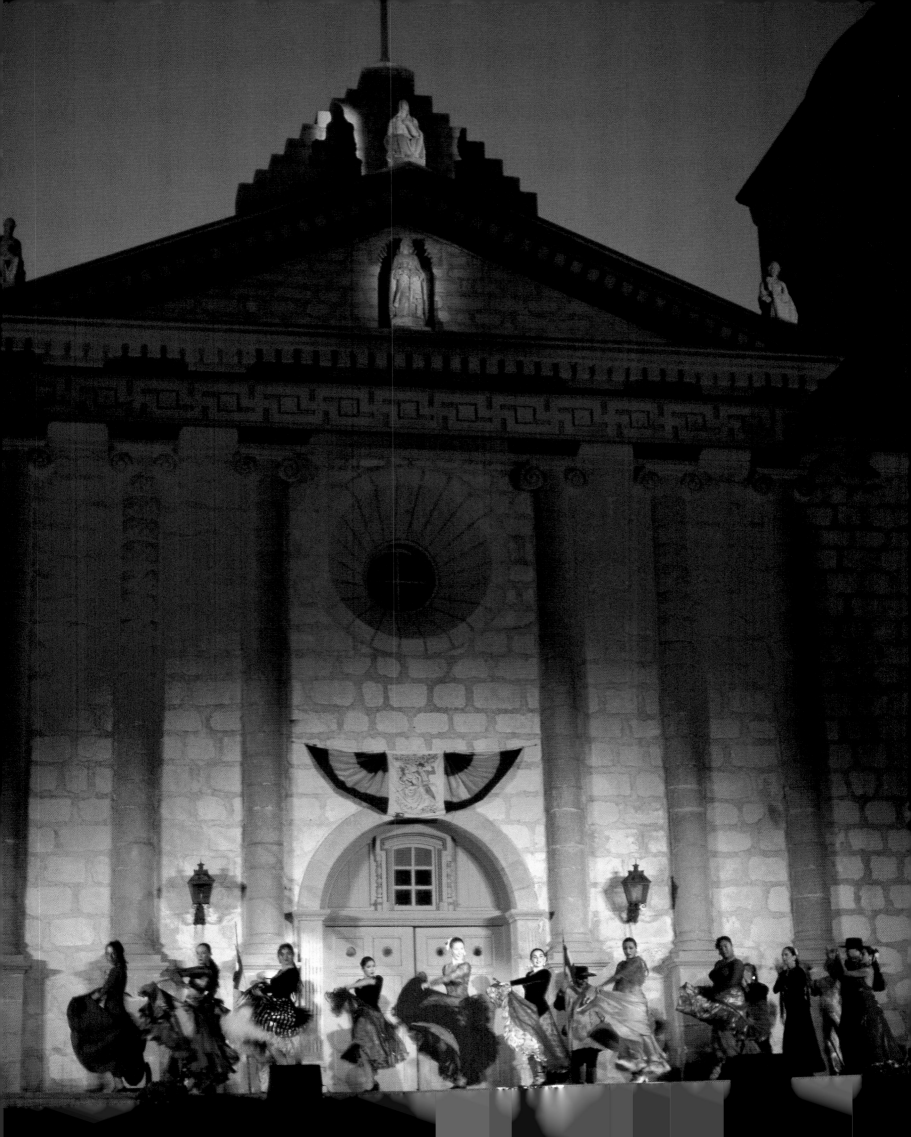

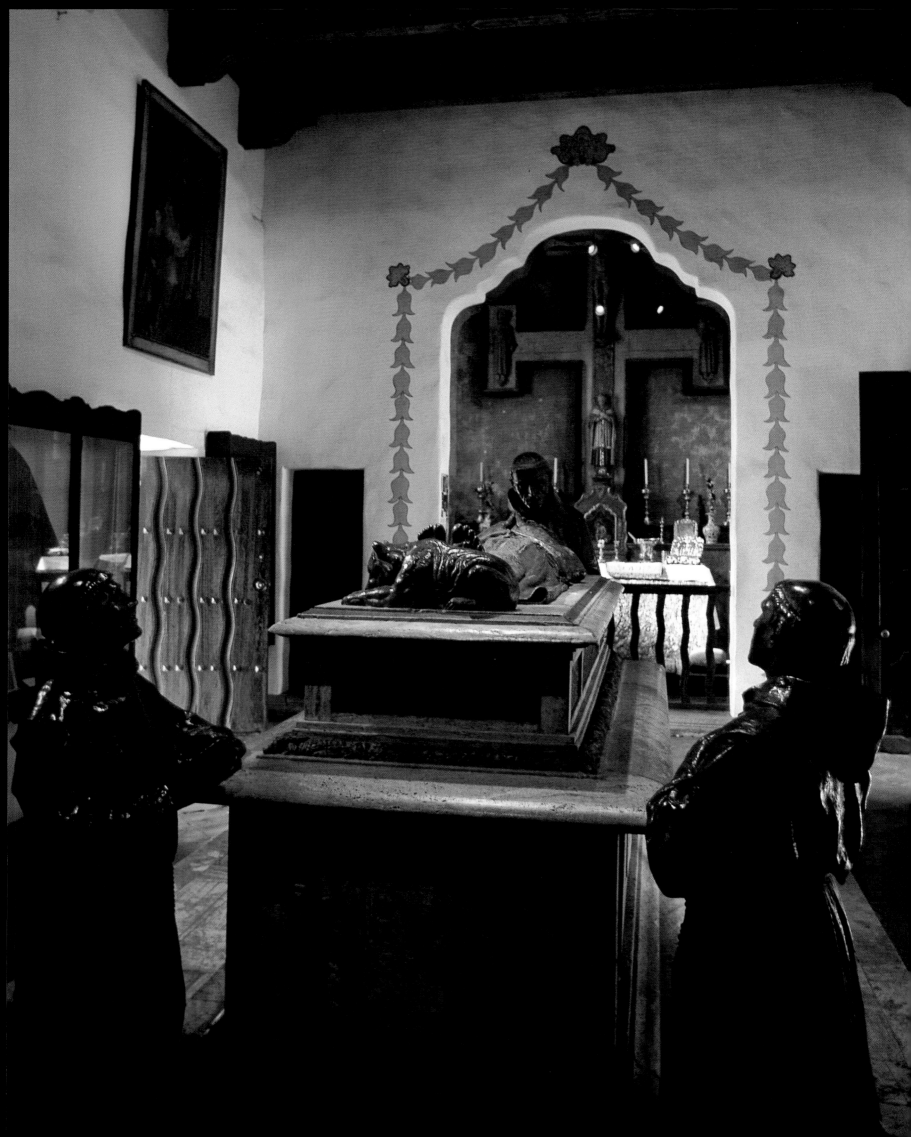

San Francisco's Mission Dolores. His disciples carried on, filling in the map from San Luis Rey de Francia in the south to San Rafael Arcángel in the north, until Mexico declared its independence in 1821. After that only one other mission was established, Sonoma's San Francisco Solano, in 1823.

The missions were more than churches; designed to extend Spain's reach north from Mexico using just a few troops, they were veritable city-states, meant to be self-sufficient communities that raised crops and cattle and produced their own goods, while the padres baptized the Native Americans. The goal was to turn the Indians into *gente de razón*, 'men of reason,' worthy of being citizens, and in theory the missions were to last only a decade before the land was turned back to its original inhabitants. For almost 50 years, however, the Franciscans remained in control.

Most of the missions were built to a similar pattern, near a good source of wood and water, with land for fields and grazing – and a large number of potential neophytes, as the converts were known. Usually a huge enclosed plaza included the sanctuary in one corner and a cemetery outside. Along the walls were dormitories for the young Indian women, accommodations for the priests and a few soldiers, a refectory and cooking facilities, workshops, and storerooms, as well as sheds for weaving, brick-making, pottery, and tanning hides. Nearby might be a smithy, grist-mill, tallow vats, cisterns, aqueducts, laundries, and housing for Indian men and couples. As Indian artisans built the structures, they decorated the chapels with vivid designs that sometimes mimicked the Old World elegance of marble or wood, or were naively colorful and direct.

Of course, the Native Americans had to forsake their villages and the way of life that had sustained them for centuries. Once at the mission, they were compelled to stay and work, lending some credence to the argument that this was slavery under another name. Many fell prey to disease; others tried to run off but were caught and brought back.

In most years the missions were extraordinarily productive. In 1832, the system boasted 151,000 head of cattle and nearly as many sheep; over the years 1,457,000 tons of wheat were harvested. As for the most valued product, the padres baptized 87,787 Indians. Two years later, however, the wealth would disappear, as Mexico started secularization, seizing the lands

The Serra Cenotaph (opposite), *the work of Carmel sculptor Jo Mora, stands in the Mission San Carlos Borromeo and commemorates the famed Franciscan and three other priests. Junípero Serra was actually interred near the altar in the basilica. Native American artisans provided decoration for many of the missions, like the receptacle for holy water at San Juan Bautista* (above left), *the ceiling in San Juan Capistrano* (top), *and the doorway of San Antonio de Padua* (above) *in Jolon.*

*E*ighteen straight pillars distinguish the colonnade at La Purisima Mission (opposite); at Mission Santa Inés (below) an arched opening reveals an interior garden. A statue of Junípero Serra (right) graces the cemetery garden at San Francisco's Mission Dolores. At Mission San Luis Rey (above), near Oceanside, a bas-relief reminds parishioners of their mortality.

and granting ranchos in most cases not to the Indians but to friends, relatives, and political connections. John 'Don Juan' Forster, an English immigrant married to the sister of the Mexican governor, bought San Juan Capistrano and its land for just $7,000. He and his family used some of the buildings as a residence. But elsewhere, as structures were left untended, roofs caved in and adobe walls crumbled in the rain and sun. The Indian workmen scattered. The properties were returned to the church in the 1850s and 1860s, but earthquakes and lack of funds continued the deterioration. A few of the missions remained parish churches; those in Santa Barbara, Carmel, and San Juan Bautista are still vibrant centers of their communities.

Around the turn of the century, interest in preservation and renovation of the missions began to grow, as novels like *Ramona* and even silent movies cast the days of the padres in a new, romantic light. Mission revival architecture – details like thick adobe walls, scalloped façades, red-tiled roofs, and shady arcades – appeared on other buildings, influencing the look of many small California towns.

Today, all but a handful of the missions hold services and invite visitors to tour historic rooms and exhibits. La Purisima Mission, a state historic park, carries the re-creations further, with restored workshops and living quarters where 100 active docents in period costume once again bring the mission era to life.

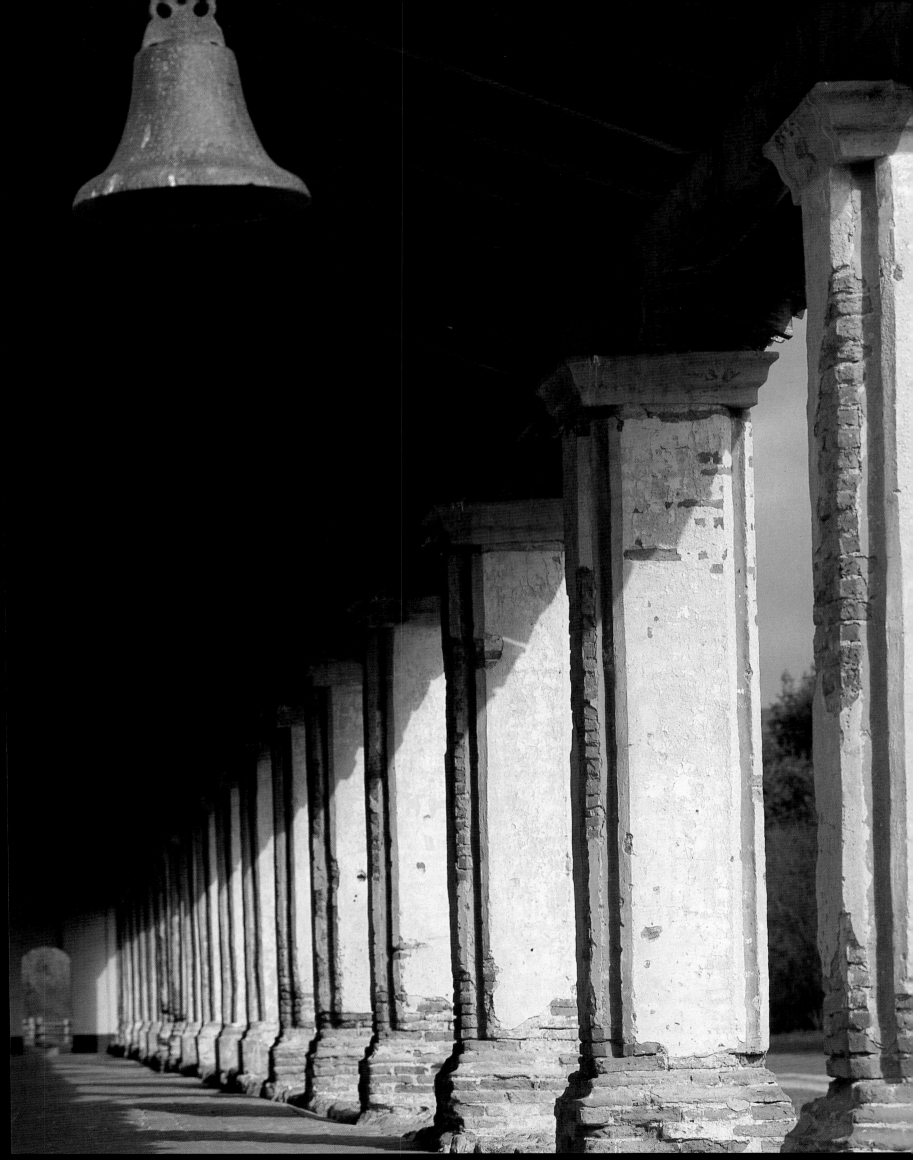

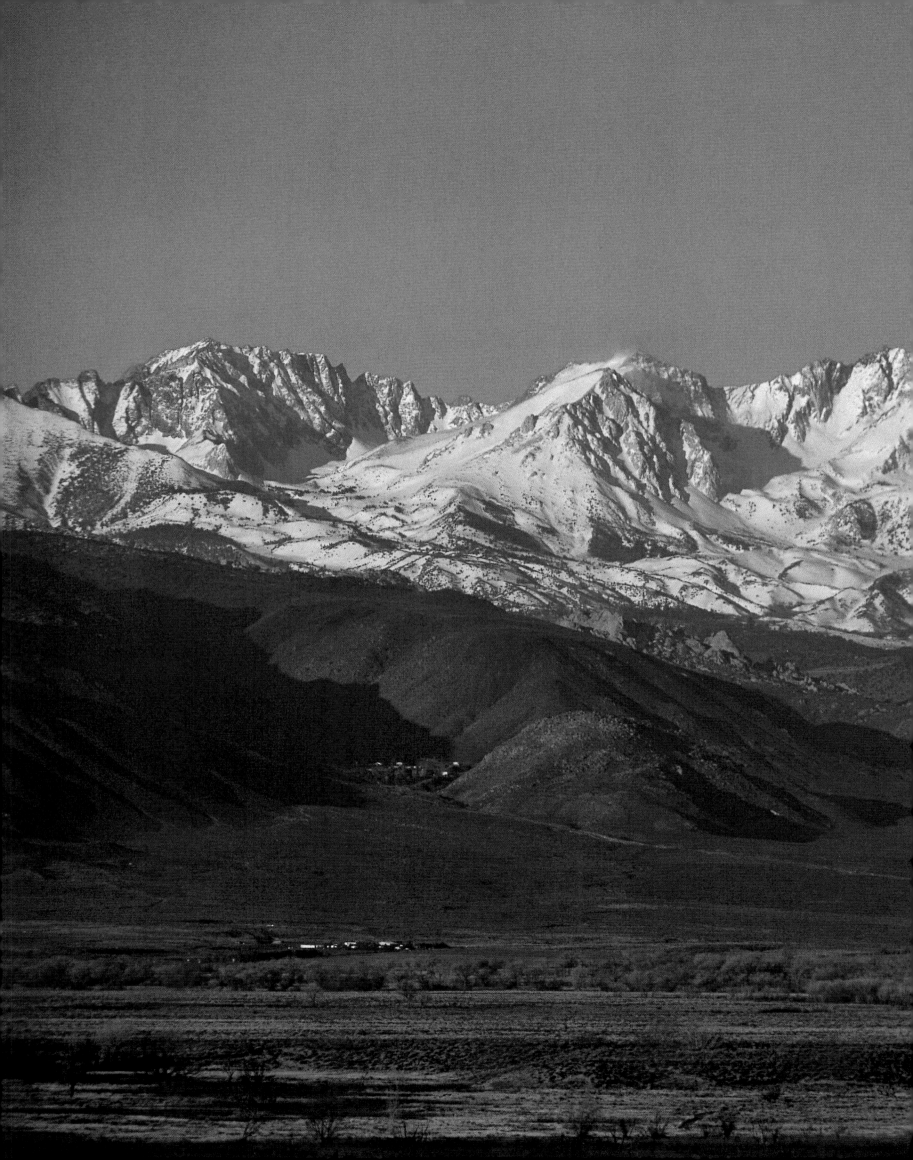

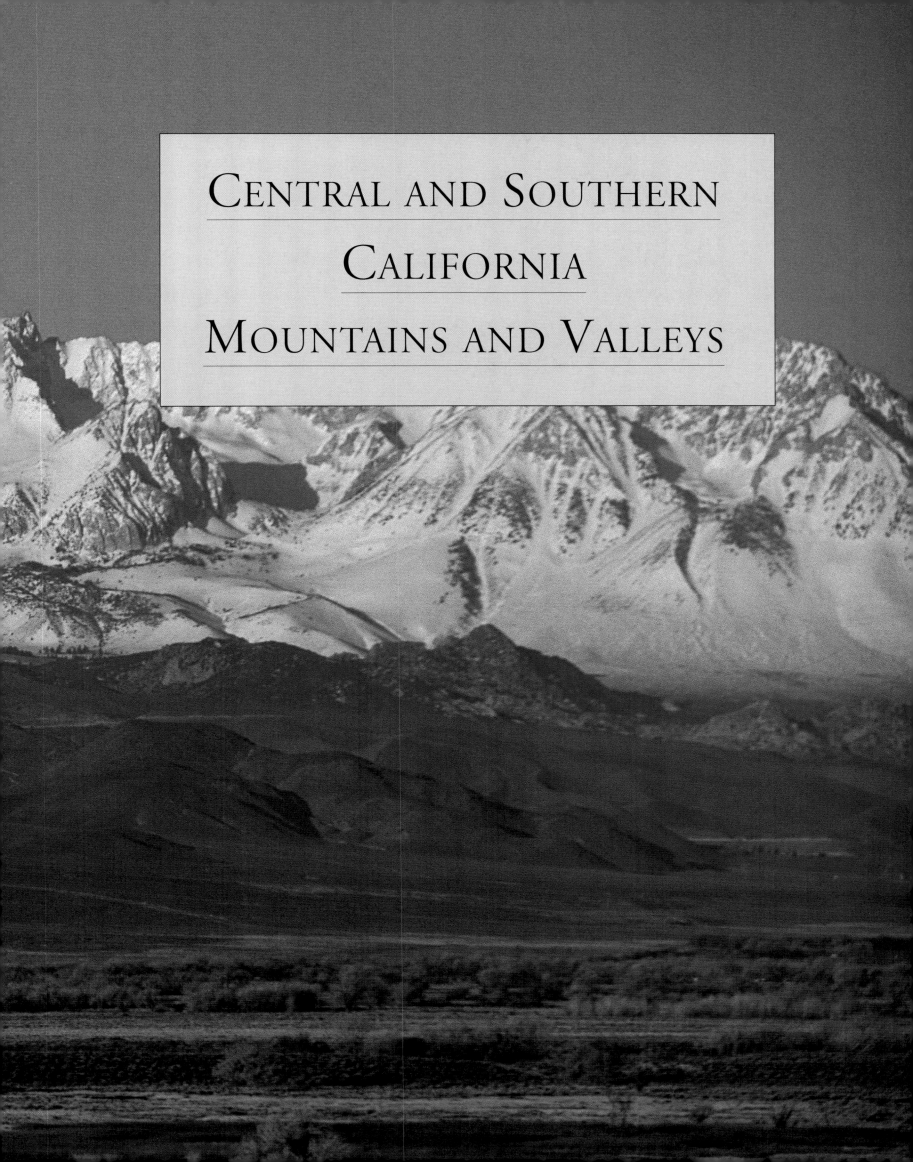

CENTRAL AND SOUTHERN
CALIFORNIA
MOUNTAINS AND VALLEYS

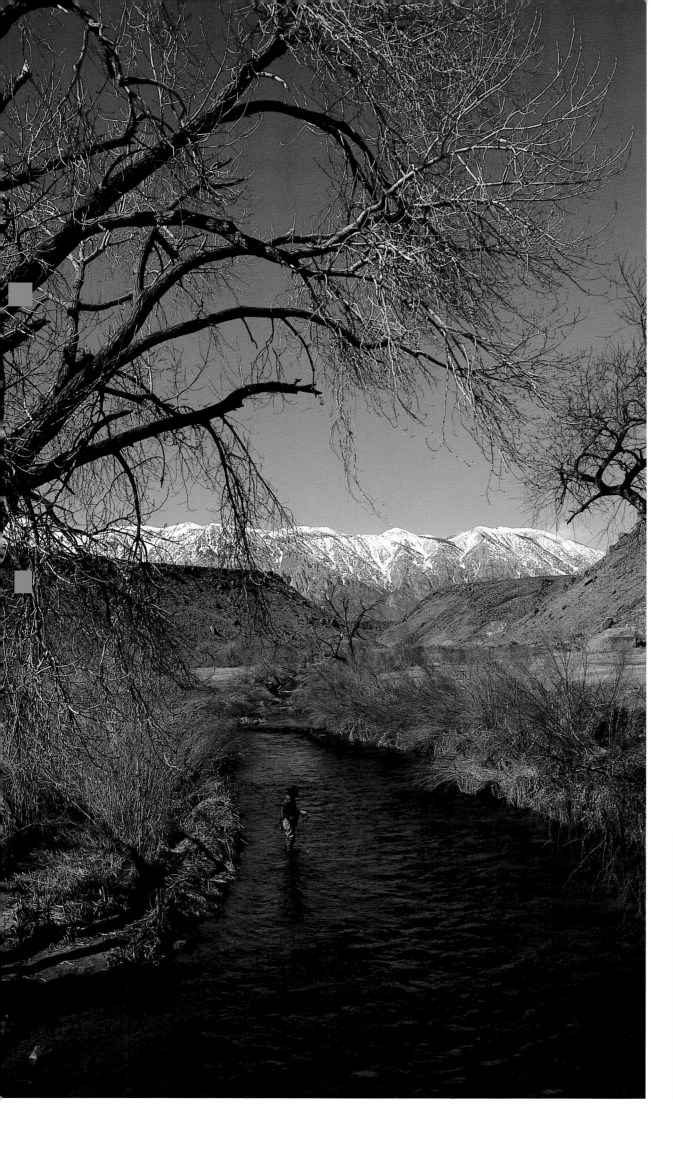

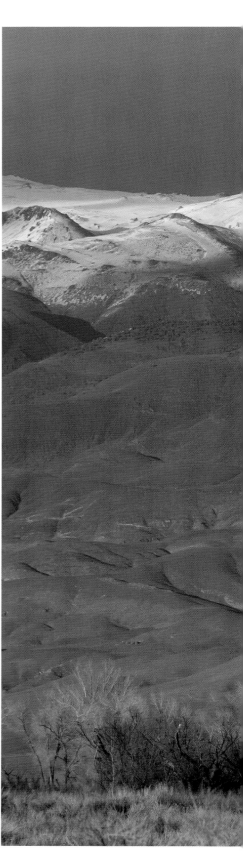

*M*agnificent mountains, almost 14,000 feet high, define Owens Valley on the eastern side of the Sierras (preceding pages).

*E*arly spring's chilly water cannot stop an avid angler in the Pleasant Valley Reservoir (left) on the Owens River near Bishop. The White Mountains (below) present a softer outline on the Nevada border, but their heights are still formidable.

Bishop

TWO RANKS OF magnificent mountains nearly 14,000 feet high define the Owens Valley: the eroded heights of the White Mountains stand on the east, and the craggy Sierra Nevada loom to the west. In between lies the town of Bishop, welcoming fishermen, campers, climbers, hikers, and pretty much anyone with a taste for adventure. The dramatic setting seems made for superlatives, and, indeed, the eastern ridges harbor groves of bristlecone pines, gnarled driftwood-like trees that are earth's oldest living organisms.

On the valley floor the vegetation leans more toward scrub, rabbit brush, and occasional cottonwoods. It's a challenging environment, yet people have lived here for centuries. Between 500 and 2,000 years ago, unknown tribesmen left their mark in mysterious petroglyphs – circles, zigzags, and other designs carved on reddish rocks near volcanic tableland or in inaccessible canyons.

Later this became the territory of Paiute Indians. And by the middle of the 19th century, cattlemen were driving their stock through the region, from the San

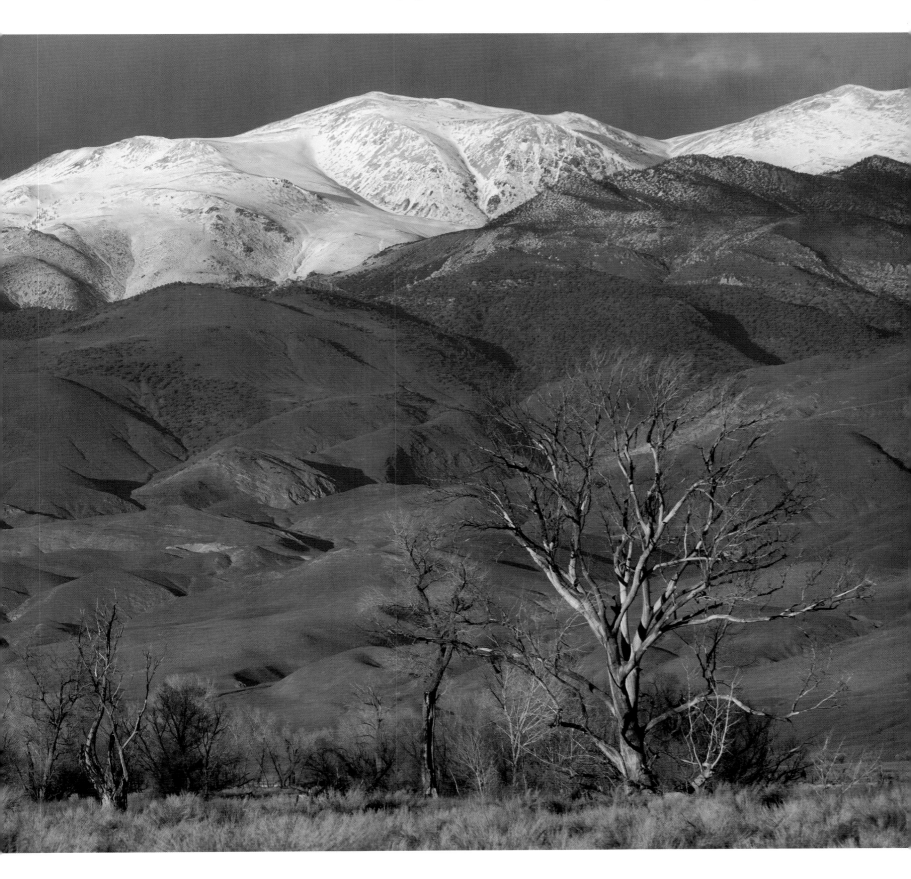

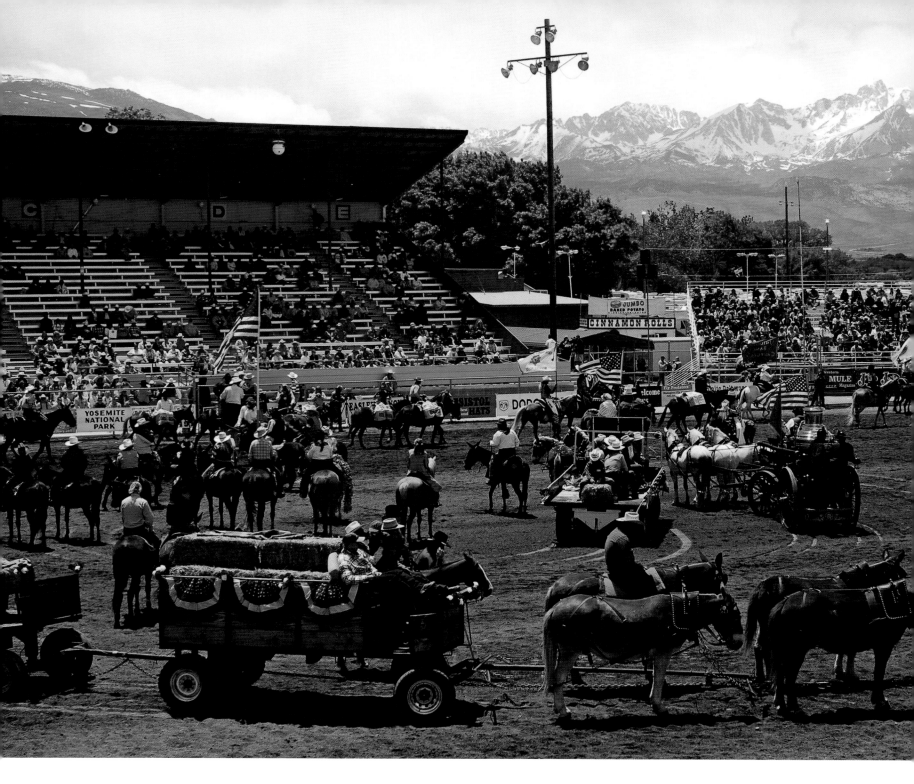

*H*orse and mule trips are a favorite activity in outdoorsy Bishop. To celebrate the opening of the summer packing season, the town holds Mule Days every year around Memorial Day weekend. Muleteers show off their teams in the main arena (above) *and parade their animals through town* (opposite above). *The five-day event* (opposite center *and* below) *also includes the presentation of flags, a mule race, and driving and decorating competitions.*

Joaquin Valley, over the Sierras, to beef-hungry prospectors in mining camps to the north. The valley seemed to promise good grazing grounds, and in 1861, Samuel Bishop and his wife established a homestead on the creek that now bears his name. They didn't stay long, but a year later a settlement had sprung up two miles away.

As Bishop grew, so did its Wild West atmosphere, but little of the turn-of-the-century town remains. Its heritage is recaptured mostly in a dozen murals that depict people, places, and colorful events: the local bakers who produced bread for Basque shepherds; the mules and their packers who transported ore from the Champion Spark Plug Mine; a country inn; corner shops; and a legendary 1887 shoot-out. Photographic art that celebrates the area's natural environment – the

work of late photographer Galen Rowell – is on display at his gallery in the renovated bank building, with its pressed-tin ceiling and impressive vault.

Other historic structures have been moved to the Laws Railroad Museum, around the atmospheric depot where, from 1883 until 1960, passengers boarded the narrow-gauge railway that linked Laws to Nevada's Carson City. Today's re-created town has a general store, a print shop, a post-office, and a doctor's office/pharmacy lined up along the street. Across the tracks – where Engine #9 heads half a dozen passenger cars – there's a blacksmith shop, garages, and a wagon barn. Most evocative, though, is the little schoolhouse, with photos of generations of Bishop children above their worn wooden desks.

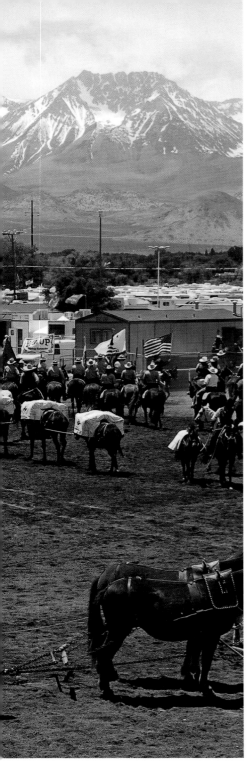

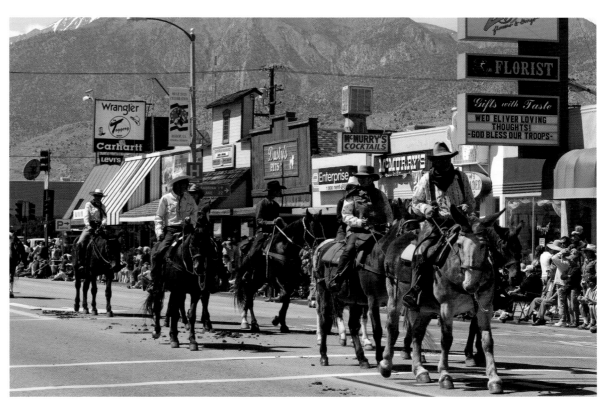

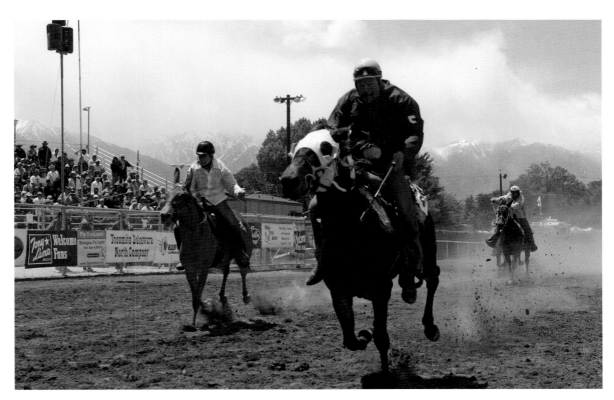

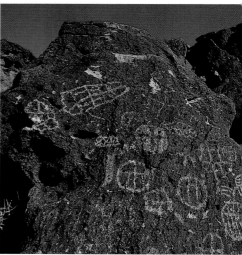

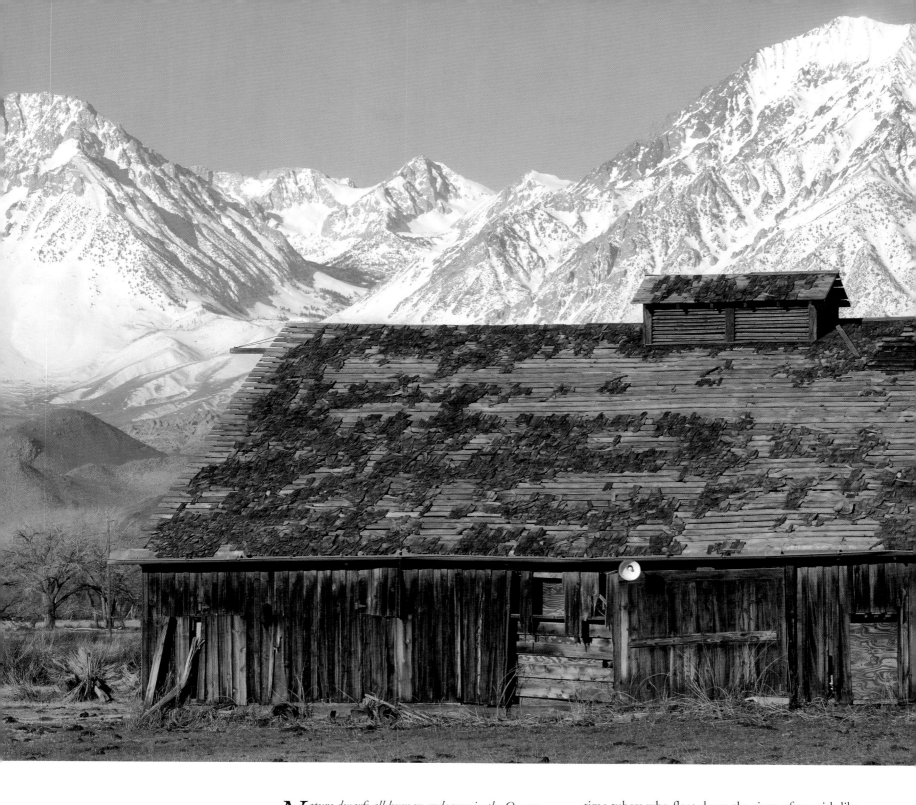

*N*ature dwarfs all human endeavor in the Owens Valley. The Sierra Nevada tower above a weather-beaten barn (above), while the White Mountains provide a stark backdrop to the Laws Railroad Museum (opposite below). Cattle graze the valley floor near the Owens River (opposite above). On the volcanic tablelands nearby, petroglyphs left by Native Americans between 500 and 2,000 years ago have survived despite the rugged environment (left).

Between Bishop and Laws, the Owens River creases the landscape below the Chalk Bluffs, twisting and turning, and flowing swiftly past hiding places for wily trout. This is also a favorite watercourse for summer-time tubers who float down the river, often with libations in tow. A bucolic setting today, the river was the object of bitter conflict early in the century, as deceptive entrepreneurs bought up land and water rights to create the Los Angeles Aqueduct. Even violent protests could not stop the project, though, which diverted valley water to thirsty Southern California when the aqueduct opened in 1913. Eventually the controversy died away. Bishop reverted to a ranch town and a recreational gateway. Today the store fronts along Main Street tout sporting gear, outdoor garb, pack trips, and guide services. And the roads out of town lead to gorgeous high-altitude lakes, remote campsites, and back-country trails.

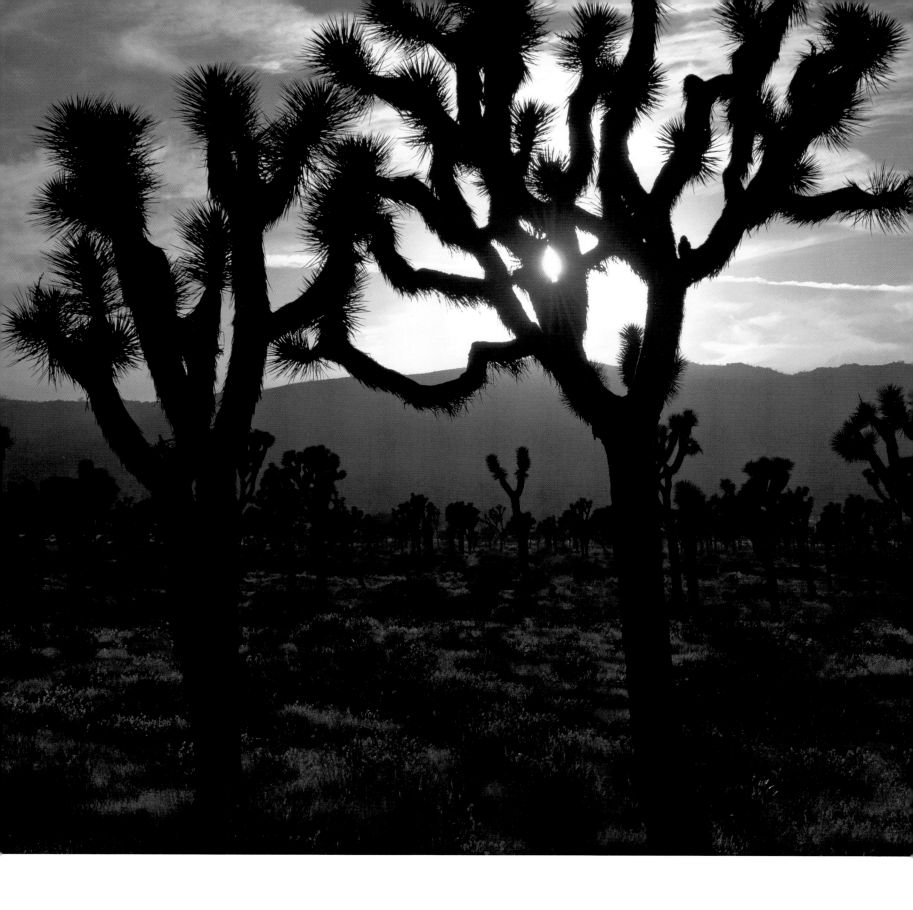

Joshua Tree

ABOUT 100 MILES east of Los Angeles, beyond the Little San Bernardino Mountains, where the Colorado and the Mojave Deserts meet, an army of Joshua trees stands sentinel in the harsh, dry terrain. The towering plants, whose branching arms end in clusters of sharp needles, are distinctive members of the yucca family, named, perhaps, by Mormon settlers reminded of the

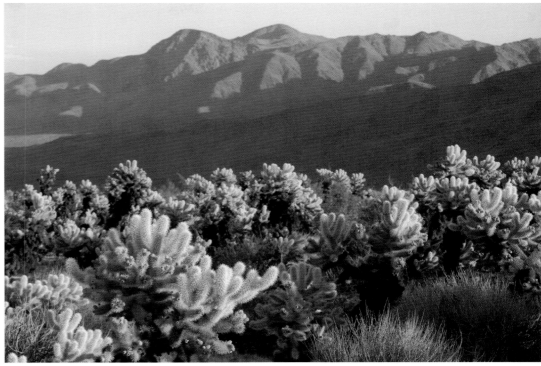

Biblical warrior, pointing the way to the promised land. Pivotal to the desert ecology, the plant harbors a rich community of living creatures, from nesting birds to animals at its base and insects that feed on its trunk.

Making a home in this unforgiving high-desert environment is difficult, and finding its beauty means looking for subtle details in a monumental landscape.

Yet there are startling outbursts of form and color – dramatic stone escarpments or carpets of wildflowers that explode into bloom overnight. Much the same is true of desert settlements, like Joshua Tree, the gateway to the national park of that name that was established in 1994. A few Western-style buildings constitute the crossroads of the unincorporated village; houses –

A landscape of unconventional beauty surrounds Joshua Tree, named for a curious species of yucca (above left). *Bristling cholla cactus* (top) *basks in golden light, joined by an eruption of wildflowers in spring* (above).

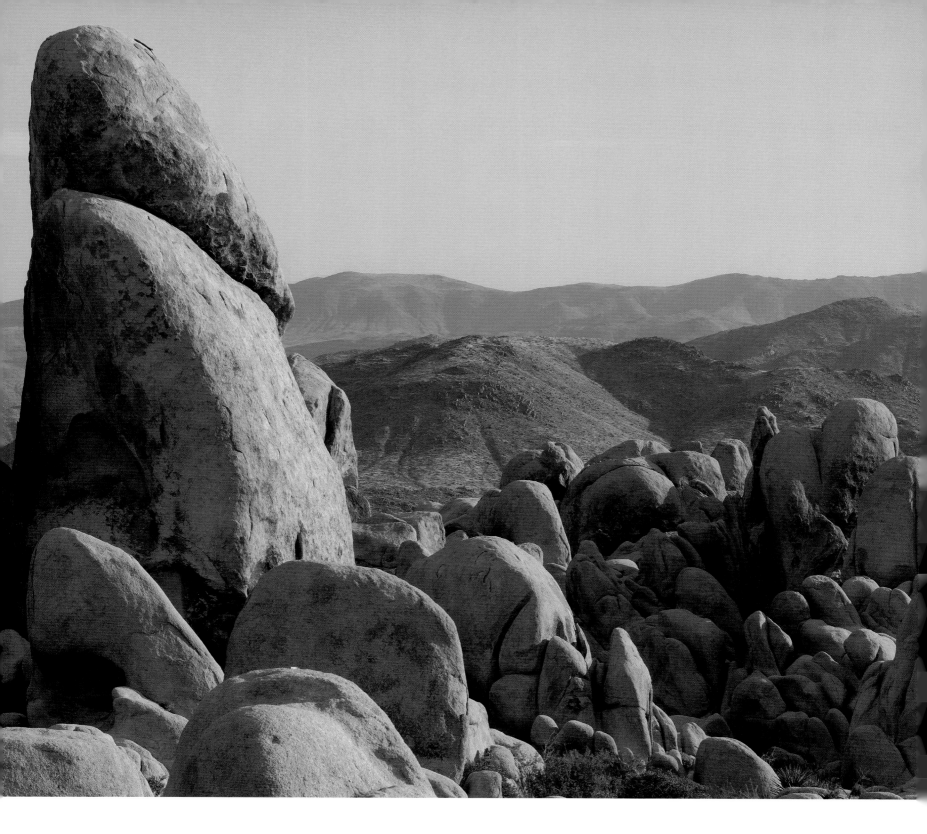

*W*ithin Joshua Tree National Park distinctive smooth boulders form a Wonderland of Rocks, where the White Tank Trail (above) leads to natural catchments that cattlemen dammed to water their animals in the dry terrain.

many barely visible against tawny rocks or dusty brush – sprawl for miles to the next town or to protected slopes of the park.

The key to life here is water, and Native Americans found it at the Oasis of Mara, just outside the visitor center of the park in nearby Twentynine Palms, where there is a refreshing grove of majestic fan palms. In the mid-1800s mountain men, miners, and homesteaders often congregated here before striking out to the unwelcoming desert. One early pioneer was Bill McHaney, who arrived in 1879 and ran a ranch with his brother, Jim. Local legend has it that they rustled their cattle,

rebranding and herding them into Hidden Valley, a secluded piñon and juniper canyon sheltered from wind – and prying eyes – by golden granite outcrops in the shapes of faces and towers. Today, this part of the park is known as the Wonderland of Rocks, for its outlandish forms. It is a world-class rock-climbing venue, and an unforgettable background for fashion photo shoots.

Not far away, the 80-acre Desert Queen Ranch, home to William Keys for more than 50 years, until his death in 1969, stands virtually unchanged from the days he lived there with his wife and children. It, too, is now part of the park, a testament to the grit, hard work,

and ingenuity needed to forge a life here. Fences made of Joshua trees define the property, and wind-powered pumps stand near the fruit trees that Frances Keys planted. Salvaging wood, metal, and other materials from abandoned mine claims and cabins, Keys built a house, garage and barns, a schoolhouse, and a store where he sold off unneeded parts to other homesteaders. He quarried stone for walls and dams, and operated a stamp-mill, crushing other miners' ore and taking his cut of the gold.

Today, the ranch evokes a desert way of life that has mostly vanished. But the old machinery also suggests found art or offbeat sculpture. It may even hint at Joshua Tree's future, as artists and musicians, attracted by the sense of space, solitude, and unearthly beauty, find their own way to a promised land.

Settlers built the Barker Dam in the 1920s for cattle and for mining. The resulting small reservoir (right) attracts birds and wildlife – and hikers – to the park. Another favorite trail takes visitors to Arch Rock (above right), named, not surprisingly, for its see-through shape.

Joshua Tree • 171

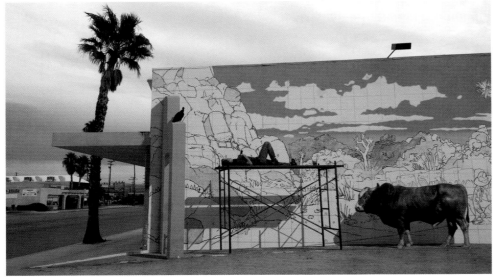

Spiky needles and evocative rock forms epitomize the dramatic but difficult environment of the high desert around Joshua Tree (opposite). A source of water at the Oasis of Mara gave birth to the town of Twentynine Palms, which remembers its heritage of people and events in murals, some still being painted, all over town (above, left and below). One building in Joshua Tree follows suit with a rowdier scene (below left).

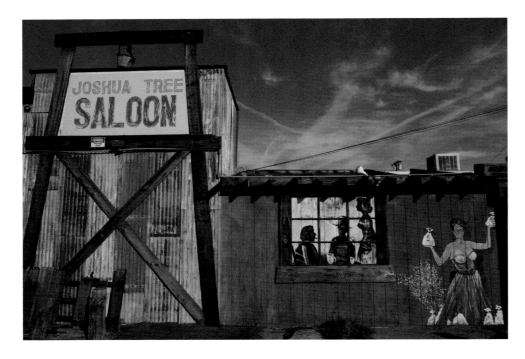

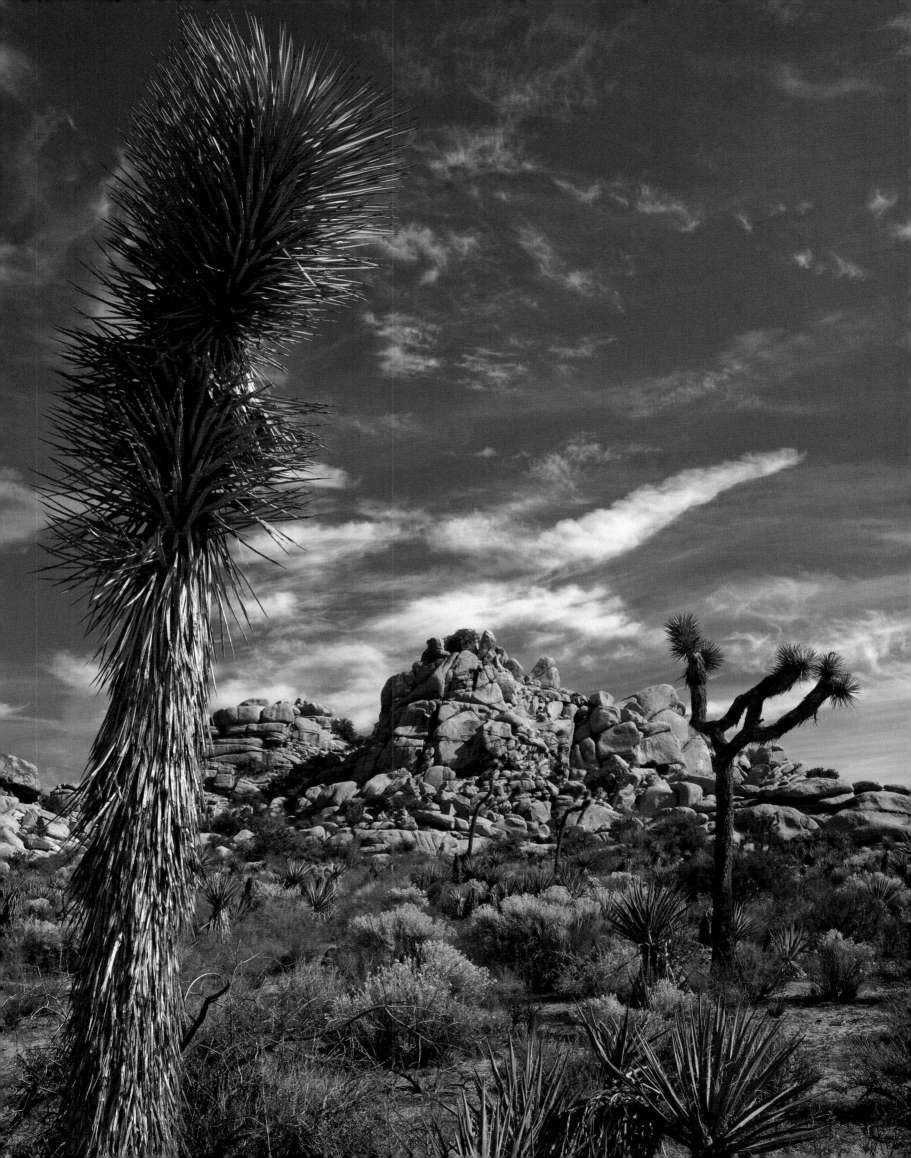

Julian

THE OAK-SHADED ROAD to Julian, about 60 miles north-east of San Diego, winds upward on ever-steeper hillsides, until just outside town the gnarled forms of apple trees appear in stately orchard rows. On Main Street, too, the Western-style façades announce cafés and pastry shops specializing in apple-pies, apple candies, and cider, interspersed with the galleries and gift shops. Julian wasn't always an apple-pie kind of town. In March 1870, this rough mining community of 300 souls consisted of around 50 tents and brush shanties, several log cabins, three or four groceries, and a dozen whiskey stills. They were the result of a Gold Rush frenzy that had begun a year earlier, when a black cattleman called Fred Coleman discovered nuggets washed into a stream.

Over the years, travelers, soldiers, and adventurers all passed through the area. In the early 1800s a mountain road linked a rancho at nearby Santa Ysabel with a mission on the coast, and after the Mexican-American War U.S. Army troops conducted Indian campaigns in the region. Later, Confederate veterans from Georgia – Drury, Frank, and James Bailey and their cousins, Mike and Webb Julian – came to start a new life in this fertile valley after the Civil War.

The school bell no longer rings at the Santa Ysabel School; it's now the headquarters of the Julian Historical Society (above). *The Pioneer Cemetery, at the edge of town* (left)*, is a park-like resting place for the mining town's early settlers. By the late 1800s residents had planted apple orchards* (above left) *whose fruit continues to bring visitors to town.*

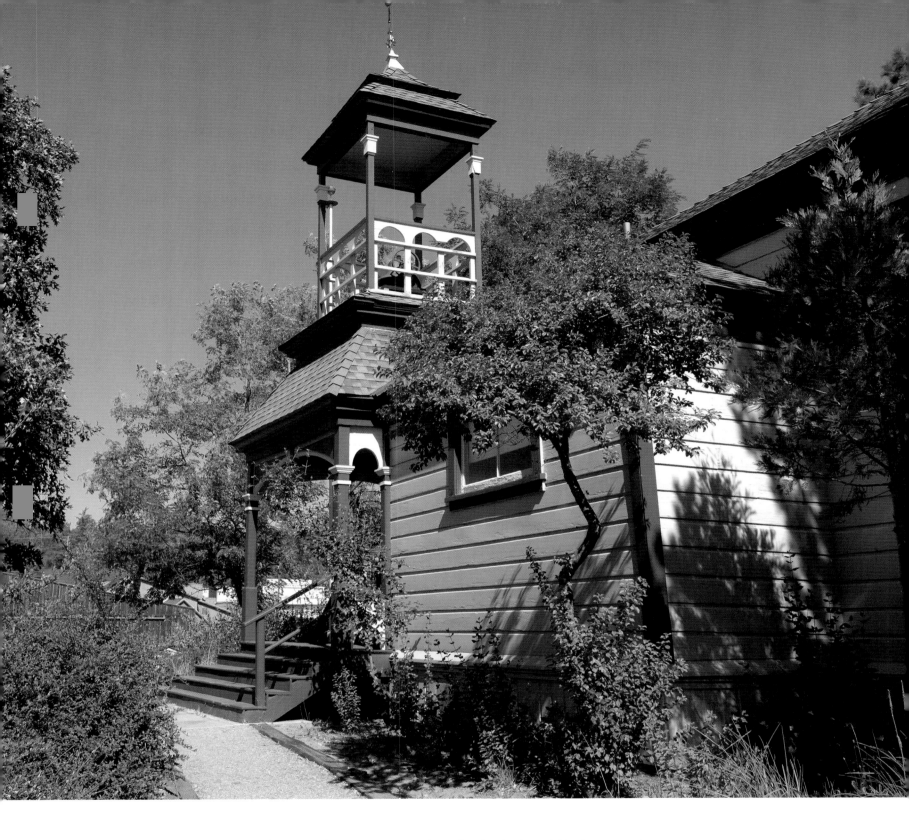

They were there when the other fortune-seekers poured in, and they soon established a new town called Julian City. The rowdier side of those early days is recalled every Sunday, with the help of re-enactors known as Julian Doves and Desperados. Their comic/historic skits – performed with great affection in accurate period dress – bring Julian residents to life, from an actual saloon-keeper and bull-whip expert who opened the first store and butcher shop to some imagined ladies of shady reputation.

The Gold Rush here lasted only a decade, though hard-rock mining continued until 1934. Julian never grew very large, but by the late 1800s there were the homes and commercial buildings that now are shops and restaurants. Drury Bailey's tidy bay-windowed cottage has stood at the edge of town since 1876. Other residences were actually built as rentals, for $6 to $12 a month, to accommodate the miners and ranchers who earned $3 for a ten-hour day. For better-heeled guests there was the Robinson Hotel – today's Victorian-style Julian Hotel, at the center of Main Street – built by former slave Albert Robinson and his wife, in 1897.

The Julian Historical Society has its offices in the pretty 1888 Santa Ysabel School, with an open bell

The Julian Hotel (opposite), founded in 1897, maintains a Victorian look both inside and out. Throughout the town, antique and collectible shops (above right) contend with apple treats (above and top) for the visitor's attention.

tower above the front porch. Its members maintain the jam-packed Pioneer Museum, which began life as a blacksmith shop around 1890. Inside, farm tools, gold pans, and Ulysses S. Grant's own bookcase share the cavernous space with shaving mugs, lace-trimmed dresses, and a wall of photographs of Julian's pioneers. Next door the Grosskopf House re-creates daily life in the 1870s; its windows reveal a table set for dinner, a small organ in the parlor, and a wrought-iron bedstead with hand-embroidered pillow-cases.

Towards the end of the 1800s Julian turned to farming, and before long its prize-winning fruit was celebrated during the autumn Apple Day (which has turned into an annual festival that lasts several weeks). More recently vineyards have staked their claim to the land, combining heritage and trendiness in bottles of apple wine.

Los Olivos, Ballard, and Santa Ynez

YOUNGSTERS STILL PLAY on a rope swing in front of Ballard's stout red schoolhouse, as they might have when it was built in 1883. Over the past 150 years the fortunes of this bucolic village, like those of neighboring Los Olivos and Santa Ynez, have risen and fallen and risen again. In part, this is due to the isolation of their valley, which is bordered on the north by the impenetrable San Rafael Mountains and on the south by the Santa Ynez range, which effectively walls it off from Santa Barbara on the coast.

In the early 19th century, life here revolved around Mission Santa Inés, which was founded in 1804. Rebuilt

Cattle graze among the oaks in the Santa Ynez Valley (left), continuing a ranching tradition that began here in the 1800s. The pastoral surroundings in the once-remote valley have attracted new residents who send their youngsters to the Ballard School (below).

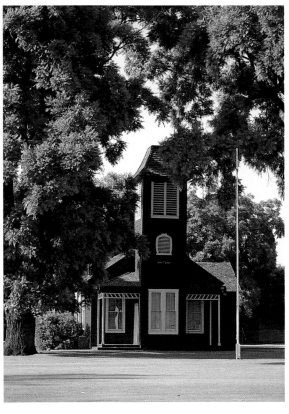

179

Spring in the Santa Ynez Mountains calls forth a burst of wild blooms, including California poppies (opposite), *the Golden State's official flower. Fields of lavender add color to the valley* (above). *Santa Ynez preserves its Western ambience* (above left), *while Los Olivos* (left) *presents a scaled-down version as a miniature pony pulls a child's carriage through town.*

after an earthquake in 1812, its stark rectangular sanctuary is enlivened by the vivid altar decoration painted by Native American craftsmen. After the missions were secularized in the 1830s, the church lands were divided into ranchos, which raised cattle for the hide and tallow trade. But a devastating drought in the 1860s decimated the herds, and the properties were broken up and sold off anew. A few enterprising men set up stations to serve the stagecoaches that in 1861 began to connect the valley with the rest of the new state. Ballard's Station – on the road through the rugged Gaviota Pass – became the town of Ballard in 1881. But the community dwindled after a new road drew traffic elsewhere.

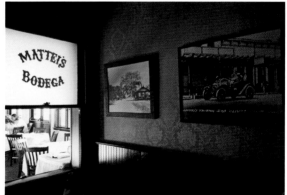

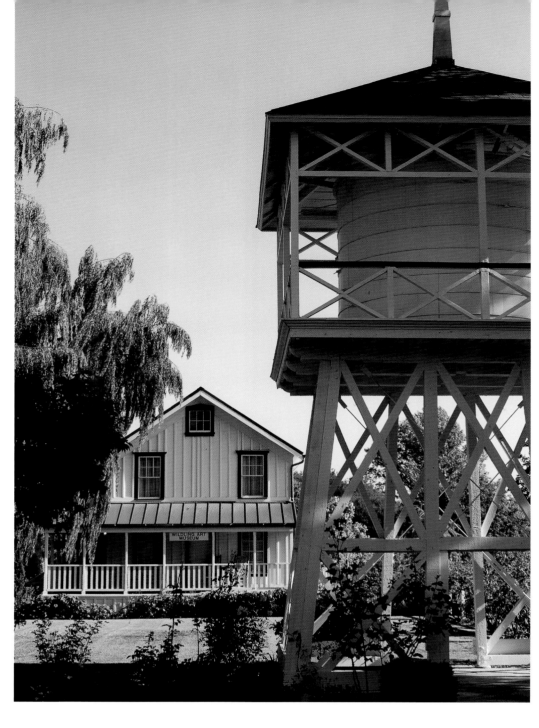

Old-time pictures line the walls of historic Mattei's Tavern (above). The Wildling Museum (above right) fills its space – an 1882 home – with contemporary paintings and sculptures that portray the natural world. Along with galleries and cafés, Los Olivos offers myriad opportunities to sample the valley's vintages (top).

Santa Ynez, a few miles south, was founded in 1882, in the hope that the Pacific Coast Railway would bring commerce to the region; five years later it had saloons, two blacksmith shops, a feed store, and a school. The Old West façades along Sagunto Street preserve the look of those days, and the Santa Ynez Valley Museum showcases the spurs, saddles, and stories of the county's *vaqueros*, or horsemen, as well as a superb collection of horse-drawn carriages.

Los Olivos, named for olive groves that were an early, but unsuccessful local crop, was formally inaugurated in 1887, but its roots really reach back two decades earlier, to a stagecoach stop for travelers who braved the nine-hour journey from Santa Barbara through the precipitous San Marcos Pass. In 1886 Swiss emigrant Felix Mattei built a hotel in Los Olivos to capitalize on the expected arrival of a narrow-gauge railway line. His hospitality has survived the generations in the old-style

steakhouse and tavern that bears his name, though the railroad eventually chose a coastal route, putting an end to the valley land boom.

After that, the village reverted to a tranquil crossroads, until, in the 1970s, its picturesque one- and two-story Victorian buildings proved congenial spots for art galleries, which soon attracted day-trippers. Five years ago the Wildling Art Museum joined the scene, exhibiting depictions of America's wilderness in the landmark Keenan-Hartley House, a residence from around 1882. Along with the artists came the vintners, who believed that the undulating landscape, bathed by cooling fog and ocean breezes, would grow world-class wines. Boutique vineyards – made famous by the movie *Sideways* – now line the arbored roads, and tasting rooms have sprung up along Grand Avenue, a new draw for visitors who enjoy the 21st-century lifestyle in the 19th-century setting.

*A*ll roads lead to wineries, it seems, in the Santa Ynez Valley (below), *bringing tasters and tourists as well as grape pickers* (right) *to the autumn-tinted vineyards* (above).

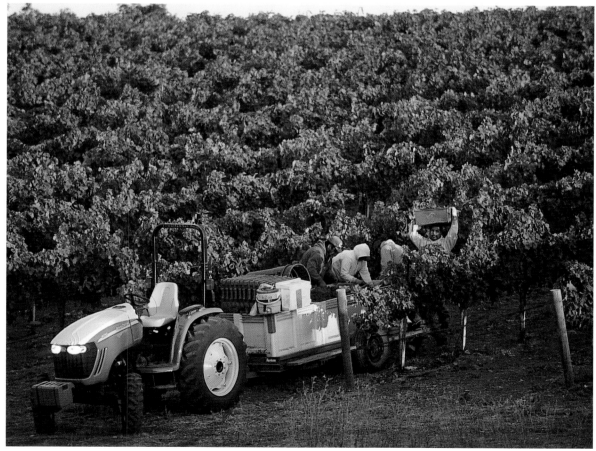

The rolling hills around Los Olivos are punctuated by palms, oaks, and the occasional old water tower (left). As the roads rise into Foxen Canyon (below), the straight lines of grape-vines add order to the panorama.

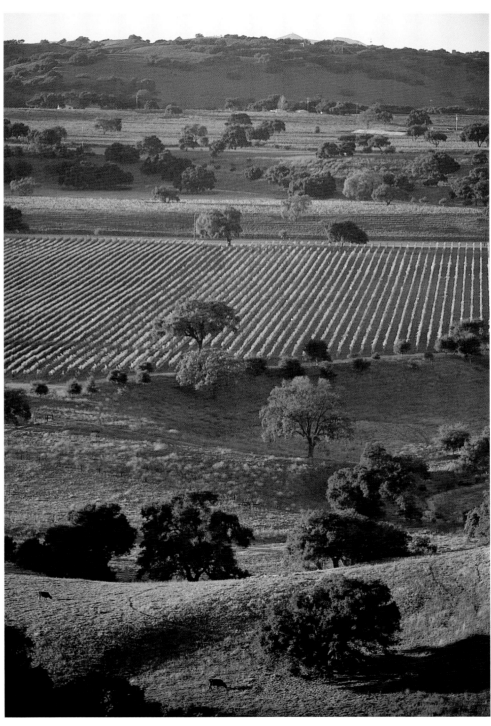

Ojai

IN 1937 FRANK CAPRA'S *Lost Horizon* brought to the screen the romantic story of a planeload of passengers hijacked to Shangri-La, a Himalayan paradise where strife was unknown and the inhabitants never aged. Scenes from that movie were filmed in Ojai – though no one agrees where – and some of its aura still hovers over this valley, which is cradled by rippled mountains with names like Topa Topa and Chief Peak. Because of Ojai's bowl-like setting, locals claimed for years that the word meant 'nest' to the native Chumash inhabitants. But scholars now believe it stands for 'moon,' which may be just as apt, since New Age residents hold full-moon gatherings on panoramic Meditation Mount.

The first European to settle here was Fernando Tico, who built Rancho Viejo in the valley in 1831. By 1853

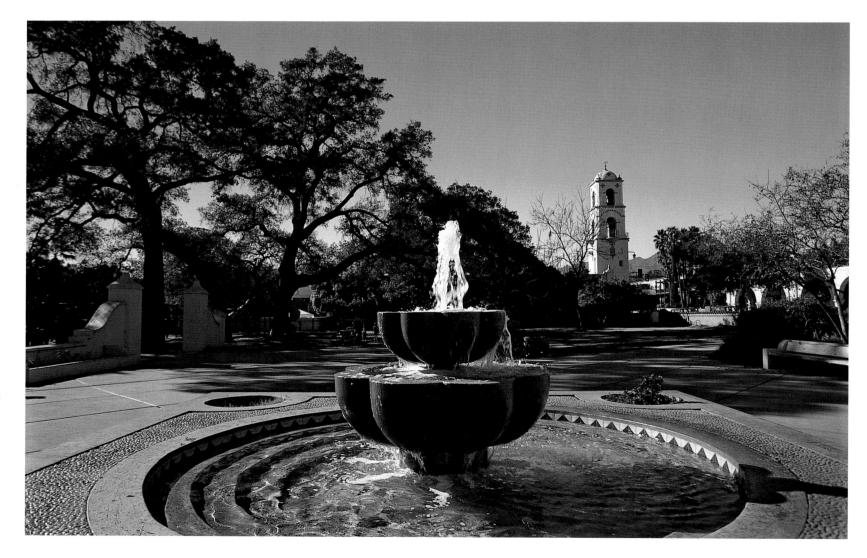

he had sold off his land, which changed hands several more times over the next two decades. Initially developers came to drill for oil, but by 1873 Ojai was being touted to Easterners for its health-enhancing qualities. Among the loudest promoters was Charles Nordhoff, who wrote of the town's beauty before he had even seen it.

One drawback was the lack of a place to stay. An enterprising lawyer named Abram Blumberg remedied that when he built the Nordhoff Hotel in 1874, and the burgeoning community was named for the writer, too. Wheat, beans, barley, and potatoes filled the fields around the oak-studded village. By the 1880s, however, a few experimental citrus trees had turned into extensive groves of oranges and lemons. In 1898, when the railroad connected the town to Ventura, crates of fruit were being shipped out, and a new crop of tourists was riding in.

Ohio glass manufacturer Edward Libbey and his wife, Florence, were enchanted by their first visit in 1908. The couple returned frequently, buying land and eventually shaping the area's destiny. To replace 'ordinary' Western false-front façades, Libbey hired San Diego architects Frank Mead and Richard Requa, and in 1917 their mission-style shopping Arcade and Pergola lined Ojai Avenue, a bell tower crowned the post-office, and St. Thomas Aquinas church, now the Ojai Museum, opened its doors. To match the new look there was a new name – Ojai.

Attracted by the valley's growing reputation for spirituality, the Theosophical Society set up a center and library amid serene gardens in the 1920s and pursued its

Arches and other rounded details are some of the hallmarks of the mission-revival architecture (opposite) *devised by Frank Mead and Richard Requa for Ojai in the early 20th century. Shoppers continue to benefit from the shady Arcade* (below), *which frames the bell tower of the post-office that was modeled on a Havana campanile.*

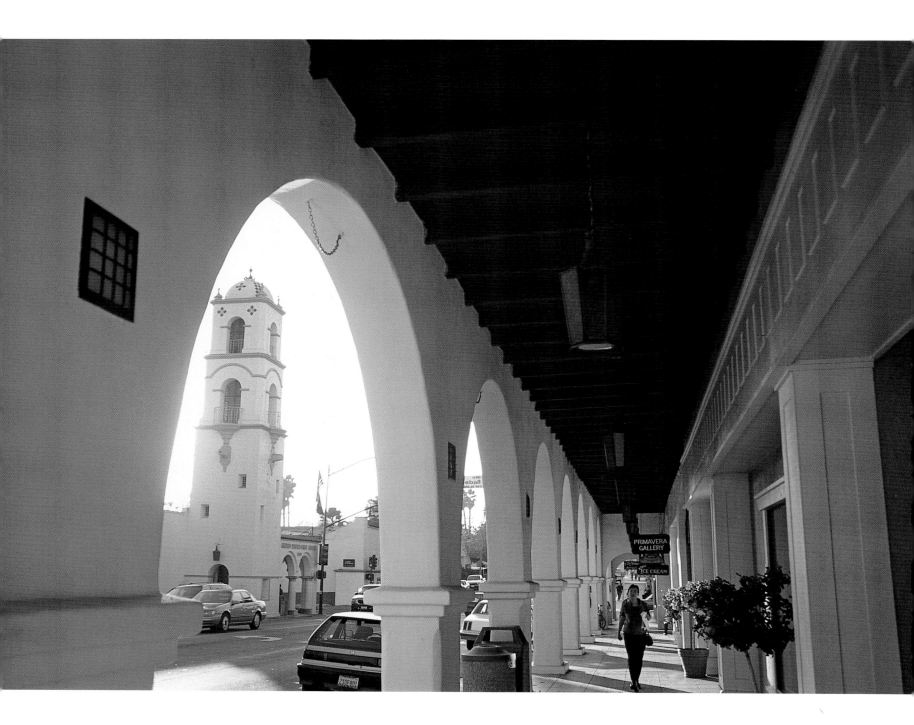

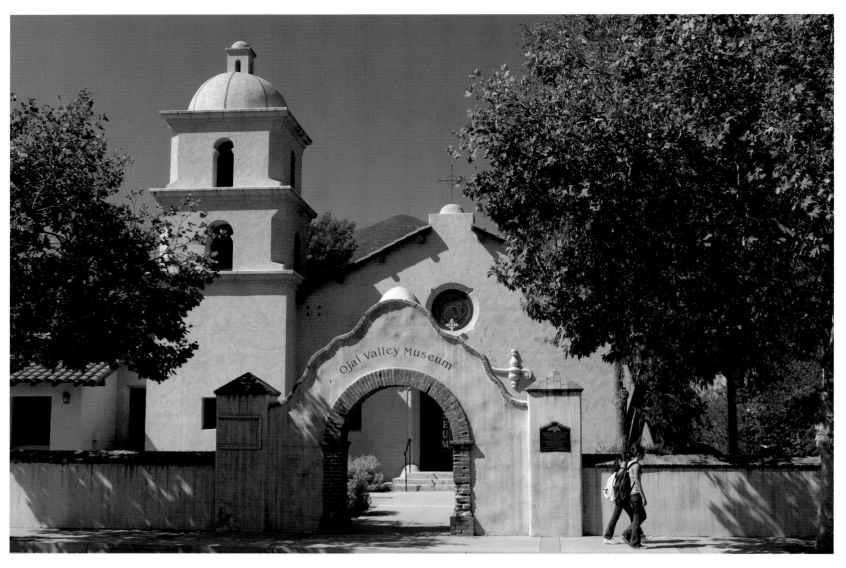

goals of harmony among all people and the comparative study of religion, philosophy, and science. One of the leaders, Annie Besant, took a young Indian named Jiddu Krishnamurti under her wing. He, too, fell under Ojai's spell, lecturing around the world but always returning to his white frame house at the edge of the orange groves. Harmony didn't last. Krishnamurti broke with his mentors, famously insisting, 'Truth is a pathless land.' But his students – including Beatrice Wood, a ceramic artist known for metallic-glazed lustreware as well as her romantic liaisons – nevertheless followed the road to Ojai. Soon other potters, painters, and sculptors had built studios nearby. Wood, the doyenne of the colony, died in 2000 at the age of 105, but her hillside workshop is at the heart of a new arts center and gallery.

And the feeling of well-being continues to work its magic, especially at the end of day, when, just as the sun is about to go down, its long rays flash on the mountains to the east, bathing the scene in a perfect 'pink moment.'

Local history is embodied in the walls of the Ojai Valley Museum (above), *originally the St. Thomas Aquinas church built by Mead and Requa in 1919. Another cherished landmark is Bart's Books* (left), *where thousands of used volumes are displayed on tree-shaded patios. The Ojai Valley Inn and Spa* (opposite below) *got its start in 1923, when glass manufacturer Edward Libbey commissioned a clubhouse for his private golf course. Today, its rolling greens challenge both hotel guests and day visitors* (opposite above).

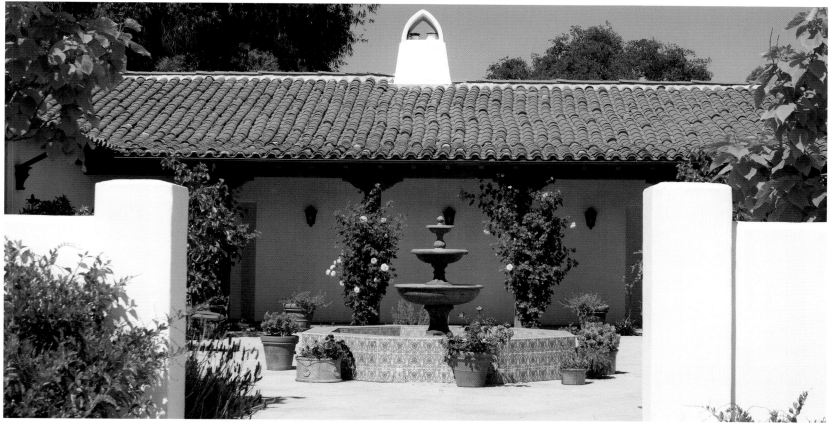

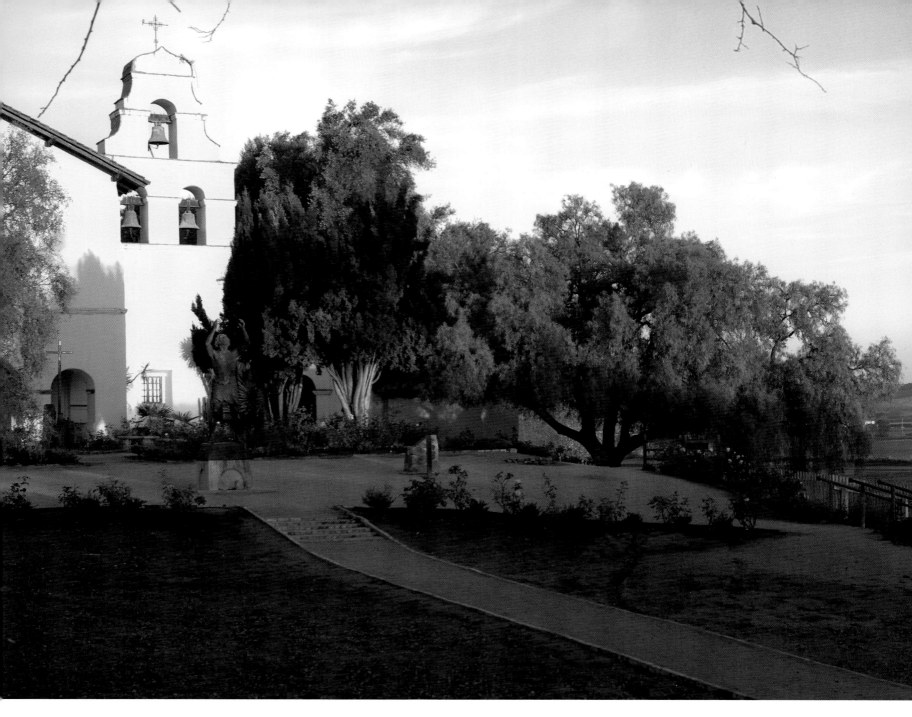

*M*orning sunlight casts a golden sheen on the flat-front bell tower of Mission San Juan Bautista (above). The stairs at the side lead down to the original track of El Camino Real, the king's highway that connected California's 23 missions. The sculpture of St. John the Baptist (left) is the work of Thomas Marsh. Erected in 2001 in front of the sanctuary, it depicts the mission's namesake saint acknowledging an unseen spirit. Edging the Plaza, the mission's arched monastery wing (opposite) is all that remains of a quadrangle that once enclosed gardens and other work areas.

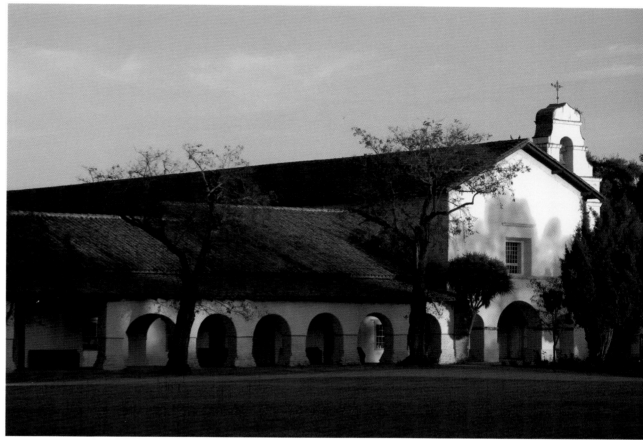

San Juan Bautista

IT IS HARD to believe today, when San Juan Bautista is a quaint, quiet town a few miles off the highway, that a century and a half ago this was a crossroads of California. From the historic plaza – which had a movie moment in Alfred Hitchcock's *Vertigo* – the view takes in a panorama of green fields. Originally this was a marsh that edged into a flat grassy plain, part of a landscape that nurtured thousands of Ohlone Indians before the Europeans settled here.

The old Mission San Juan Bautista, founded in 1797, has been in continuous use here since it was completed in 1812. Inside, the decoratively painted walls extend down the extraordinarily wide nave, whose two aisles are defined by arch-topped columns under a flat wood ceiling. A strikingly pretty church, it is graced by half a dozen statues of saints in the reredos behind the altar, painted in 1817 in *trompe-l'œil* style by an American sailor who jumped ship and did the work in exchange for room and board. When California's missions were secularized in the 1830s, the church lands were distributed among a number of ranches. Other buildings soon rose around this plaza, including an adobe residence for Jose Castro, who tried to lead a rebellion against the Mexican authorities in 1843, then later commanded Mexican troops during the Mexican-American War.

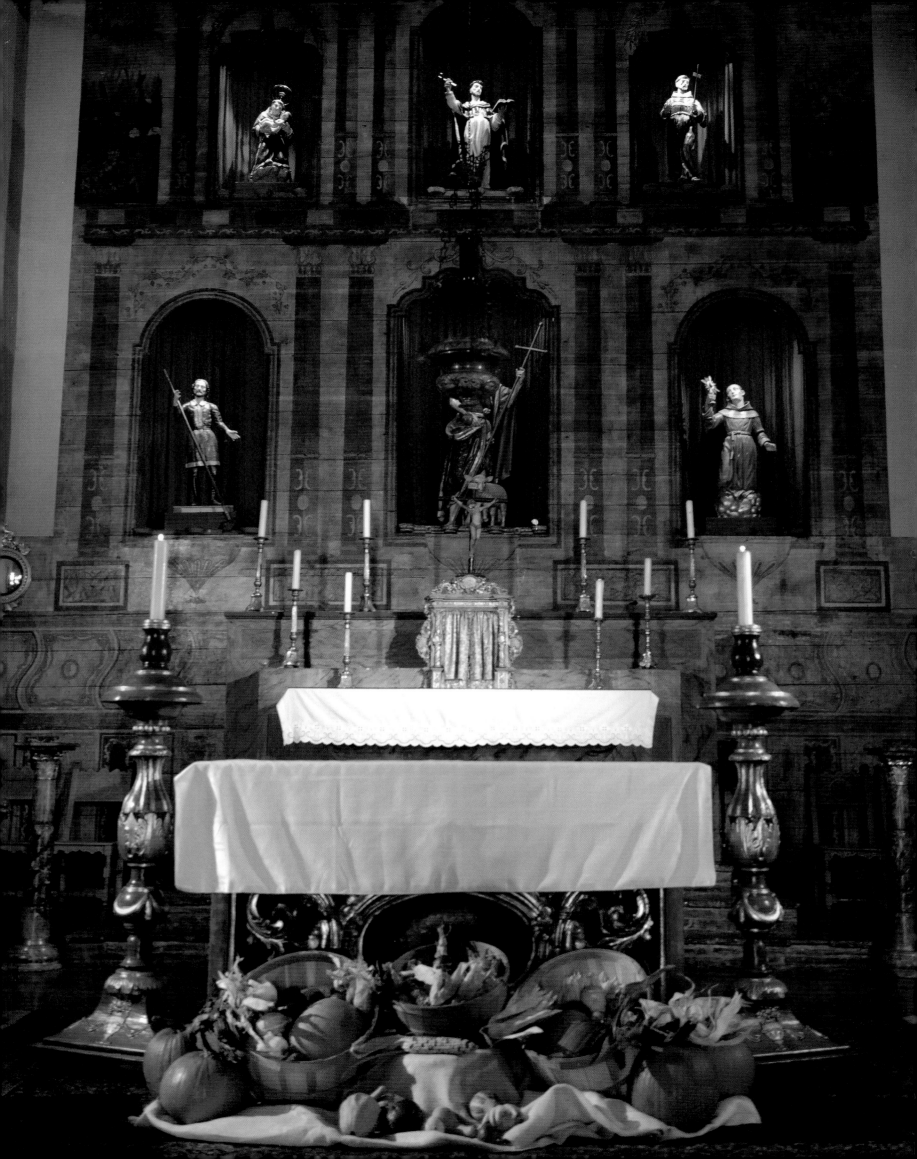

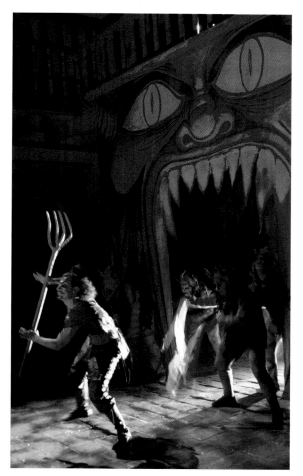

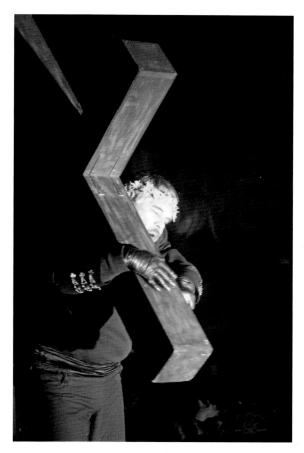

*N*ature's bounty is heaped upon the church altar (opposite) at harvest time. During Yule the spacious interior becomes a stage for El Teatro Campesino, which performs Mexican folk plays like La Pastorela (all above *and* right), in which the Devil tries to tempt and waylay shepherds on their way to worship the Christ Child.

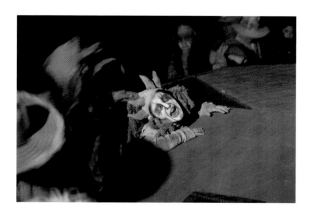

San Juan Bautista prospered during the Gold Rush days, as prospectors streamed into the state. In 1858 Angelo Zanetta, a chef and hotelier from New Orleans, bought an old adobe barracks and transformed it into the Plaza Hotel, which soon became known for its food and accommodation for travelers on the busy north-south stage route. Today, with its antique furnishings, the building is the visitors' center of the San Juan Bautista State Historic Park and a showcase for the lifestyle of the times. Clothes are laid out on the beds in several bedrooms, and the dining-room is set for hungry customers. There are several outbuildings – a wash-house (for people, not clothes), a privy, and a chicken coop – as well as the huge Plaza Stable, which serviced several stage lines. Dozens of coaches and carts are also on display, from a buck-board and a chuck wagon to a sturdy beer wagon.

Steps away is Plaza Hall, once a dormitory for the mission's Indian women. Zanetta and a partner expanded it to a two-story building that they hoped would become the court-house of San Benito County, which was created in 1870. But the county seat went to nearby Hollister, and by the end of the century San Juan Bautista was fading, the victim of catastrophes that ranged from fire to a smallpox epidemic. The railroad bypassed the town, and the mission, which had been built virtually atop the San Andreas Fault, was damaged by the same 1906 earthquake that leveled San Francisco. Still, the town survived, with Victorian cottages and late-19th-century buildings – particularly along Third Street – that have been converted to shops inviting visitors to browse for collectibles and antiques that evoke San Juan Bautista's heyday.

G̶reen shutters set off the rosy tones of a 19th-century building (above), one of many on Third Street (opposite above).

T̶he Plaza is the centerpiece of San Juan Bautista State Historic Park, which has its visitors' center in the Plaza Hotel (below). Angelo Zanetta, an accomplished chef, opened the inn in 1858 and made it a success. A decade later he bought Plaza Hall (opposite below, in the background) for his private residence. The stable with its fine collection of wagons stands next door.

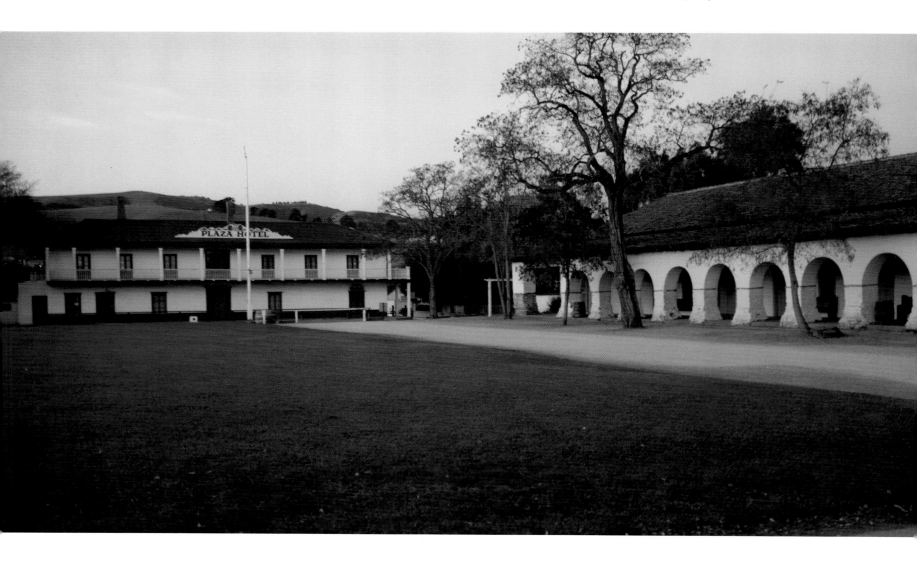

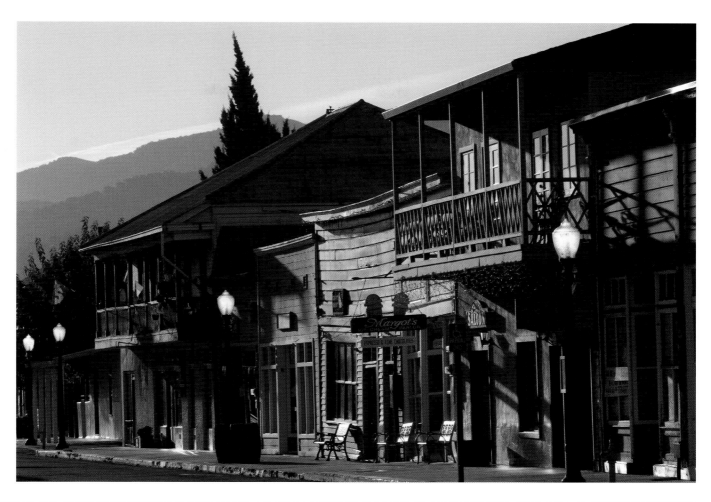

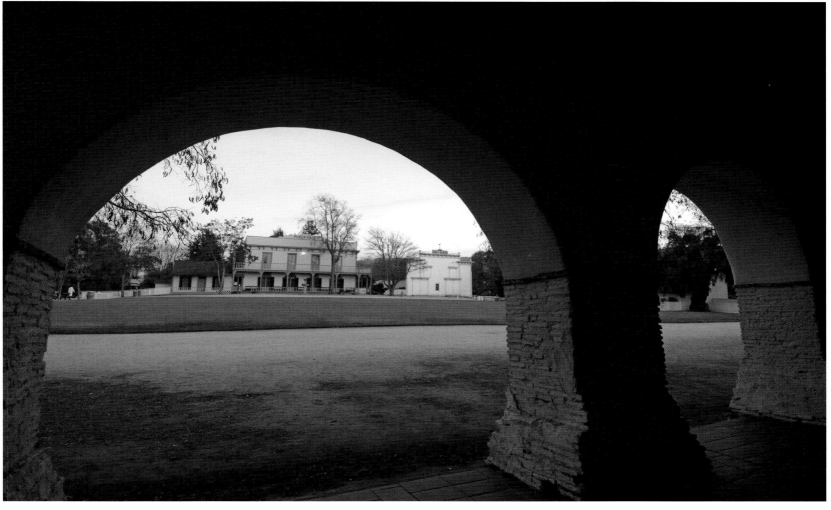

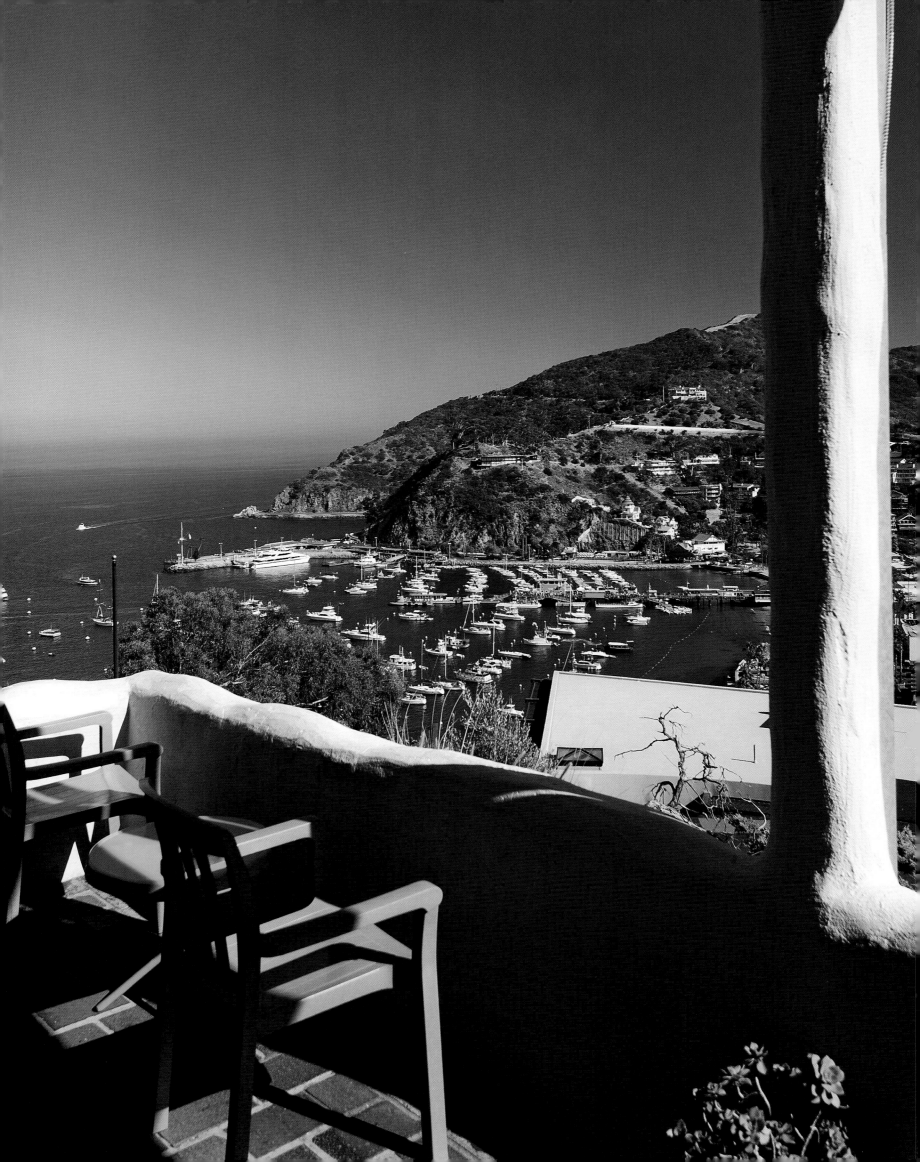

Places to Stay and Eat

Avalon

For more information: Catalina Island Chamber of Commerce & Visitors Bureau, P. O. Box 217, Avalon, CA 90704, 310-510-1520, www.CatalinaChamber.com.

Hotels

HOTEL METROPOLE, 310-510-1884, 800-541-8528, www.hotel-metropole.com. Casually elegant accommodations across the street from the beach.

THE INN ON MT. ADA, 310-510-2030, 800-608-7669, www.innonmtada.com. Exquisitely renovated luxury bed-and-breakfast in the hillside mansion built by William Wrigley.

PAVILION LODGE, 310-510-2500, 800-626-5440, www.scico.com. Comfortable accommodations around a courtyard, across the street from the beach.

ZANE GREY PUEBLO, 310-510-0966, 800-3-PUEBLO, www.zanegreypueblo.com. Simple accommodations with an ocean view in the former home of writer Zane Grey.

Restaurants

ARMSTRONG'S SEAFOOD RESTAURANT, 310-510-0113. Fresh fish and seafood specialties, overlooking the water.

CATALINA COUNTRY CLUB, 310-510-7404. Elegant dining in a historic building that was once the Chicago Cubs' spring training camp.

ERIC'S ON THE PIER, 310-510-0894. Mexican-American dishes in an informal setting on Avalon's wharf.

MI CASITA MEXICAN FOOD, 310-510-1772. Mexican specialties and seafood, with an upstairs patio.

RISTORANTE VILLA PORTOFINO, 310-510-2009. Italian cuisine at the edge of Avalon's main street.

Bishop

For more information: Bishop Area Chamber of Commerce and Visitors Bureau, 690 N. Main Street, Bishop, CA 93514, 760-873-8405, 888-395-3952, www.bishopvisitor.com.

Hotels

BEST WESTERN CREEKSIDE INN, 760-872-3044, 800-273-3550, www.BishopCreekside.com. Comfortable, up-to-date motel-style accommodations beside a creek.

CHALFANT HOUSE BED & BREAKFAST, 760-872-1790, 800-641-2996, www.chalfanthouse.com. Victorian-style rooms in an 1898 house.

Restaurants

JACK'S RESTAURANT, 760-872-7971. Casual dining in a longtime locals' favorite.

WHISKEY CREEK, 760-873-7174. Steaks and country cooking in a former inn.

YAMATANI, 760-872-4801. Sushi and Japanese cuisine in a spacious dining-room.

Cambria

For more information: Cambria Chamber of Commerce, 767 Main Street, Cambria, CA 93428, 805-927-3624, www.cambriachamber.org ; San Luis Obispo County Visitors & Conference Bureau, 811 El Capitan Way, Suite 200, San Luis Obispo, CA 93401, 805-541-8000, 800-634-1414, www.SanLuisObispoCounty.com.

Hotels

CAMBRIA PINES LODGE, 805-927-4200, 800-445-6868, www.moonstonehotels.com. Rustic cabins and luxury suites among the pines overlooking the village.

PELICAN COVE INN, 805-927-1500, 800-222-9160, www.moonstonehotels.com. Upscale rooms and suites on the beach.

THE SQUIBB HOUSE, 805-927-9600, 866-927-9600, www.squibbhouse.net. Bed-and-breakfast in a late 19th-century home in the center of the village.

Restaurants

MAIN STREET GRILL, 805-927-3194. Barbecue ribs and other grilled specialties.

MOONSTONE BEACH BAR AND GRILL, 805-927-3859. Sandwiches, salads, and café fare with a view of the ocean.

The balcony of the Zane Grey Pueblo hotel looks out over Avalon (opposite).

ROBIN'S, 805-927-5007. International dishes in a cozy house in the center of town.

THE SEA CHEST, 805-927-4514. Oyster bar and seafood by the beach.

THE SOW'S EAR, 805-927-4865. California cuisine in a casually elegant dining-room.

Carmel-by-the-Sea

For more information: Carmel Chamber of Commerce, P. O. Box 4444, Carmel, CA 93921, 831-624-2522, 800-550-4333, www.carmelcalifornia.org. Or Monterey County Convention & Visitors Bureau, 150 Olivier Street, Monterey, CA 93940, 831-649-1770, 888-221-1010, www.montereyinfo.org.

Hotels

CYPRESS INN, 831-624-3871, 800-443-7443, www.cypress-inn.com. Historic small hotel in the center of town.

L'AUBERGE CARMEL, 831-624-8578, www.laubergecarmel.com. Luxurious European-style inn in the heart of Carmel.

LODGE AT PEBBLE BEACH, 831-647-7500, 800-654-9300, www.pebblebeach.com. Luxury accommodations at a legendary golf resort along Seventeen-Mile Drive.

TRADEWINDS INN, 831-624-2776, 800-624-6665, www.tradewindscarmel.com. Upscale accommodations with Asian-tropical style.

Restaurants

CARMEL BISTRO, 831-626-6003. Casually elegant California cuisine.

CASANOVA, 831-625-0501. Italian and French cuisine in a romantic setting.

FLYING FISH GRILL, 831-625-1962. Asian-style seafood in an intimate space.

HOG'S BREATH INN, 831-625-1044. Clint Eastwood's restaurant, serving steaks, seafood, and pasta in an open-air courtyard or dining-room.

RIO GRILL, 831-625-5436. Creative American cuisine with Southwestern flavors.

Downieville

For more information: Sierra County Chamber of Commerce, P. O. Box 436, Sierra City, CA 96125, 800-200-4949, www.sierracounty.org.

Hotels

CARRIAGE HOUSE INN, 530-289-3573, 800-296-2289, www.downievillecarriagehouse.com. Comfortable 9-room inn overlooking the river, in the center of town.

RIVERSIDE INN, 530-289-1000, 888-883-5100, www.riversideinndv.com. Pleasant motel-style inn at the river's edge.

Restaurants

GRUBSTAKE SALOON, 530-289-0289. Steaks, fish, and local specialties in a casual Downieville favorite.

Eureka and Arcata

For more information: Humboldt County Convention & Visitors Bureau, 1034 Second Street, Eureka, CA 95501, 707-443-5097, 800-346-3482, www.redwoodvisitor.org.

Hotels

CARTER HOUSE INNS, 707-444-8062, 800-404-1390, www.carterhouse.com. Luxe accommodations in a replica Victorian mansion or an antique-filled inn in the historic district of Eureka.

EAGLE HOUSE INN, 707-444-3344, www.eaglehouseinn.com. Twenty-four renovated Victorian rooms in a landmark Eureka hotel built in 1886.

HOTEL ARCATA, 707-826-0217, 800-344-1221, www.hotelarcata.com. Historic Beaux-Arts hotel on the Old Town plaza in Arcata.

Restaurants

ABRUZZI, 707-826-2345. Italian specialties in a historic building on Arcata's Old Town plaza.

CAFÉ WATERFRONT, 707-443-9190. Oyster bar and seafood bistro on the promenade facing the bay in Eureka.

HURRICANE KATE'S, 707-444-1405. Innovative fusion dishes and pizza in a lively, art-filled space on Eureka's Second Street.

RESTAURANT 301, 707-444-8062. Gourmet California cuisine at Eureka's Carter House Inns.

RITZ TEPPANYAKI AND SUSHI BAR, 707-443-7489. Japanese cuisine in an elegant Art Deco setting on Eureka's F Street.

Ferndale

For more information: Humboldt County Convention & Visitors Bureau, 1034 Second Street, Eureka, CA 95501, 707-443-5097, 800-346-3482, www.redwoodvisitor.org.

Hotels

HOTEL IVANHOE, 707-786-9000, www.ivanhoe-hotel.com. Four antique-filled rooms in one of Ferndale's earliest hotels.

GINGERBREAD MANSION, 707-786-4000, 800-952-4136, www.gingerbread-mansion.com. Victorian-style accommodations in an ornate, 11-room bed-and-breakfast built in 1899.

SHAW HOUSE INN, 707-786-9958, 800-557-SHAW, www.shawhouse.com. Restored Victorian rooms and suites in the Carpenter Gothic mansion of Ferndale's founder.

VICTORIAN HOUSE INN, 707-786-4949, 888-589-1808, www.a-victorian-inn.com. Twelve turn-of-the-century-style guest rooms in a historic hotel.

Restaurants

CURLEY'S GRILL, 707-786-9696. Steaks, seafood, and Italian specialties.

FERNDALE MEAT COMPANY, 707-786-4501. Fresh deli sandwiches in a longtime butcher shop.

HOTEL IVANHOE, 707-786-9000. Family-run dining-room, emphasizing steaks and Italian dishes.

Joshua Tree

For more information: Joshua Tree Chamber of Commerce, P. O. Box 600, 61325 29 Palms Hwy #F, Joshua Tree, CA 92252, 760-366-3723, www.joshuatreechamber.org; Joshua Tree National Park, 74485 National Park Drive, Twentynine Palms, CA 92277, 760-367-5500, www.nps.gov/jotr.

Hotels

SPIN AND MARGIE'S DESERT HIDE-A-WAY, 760-366-9124, www.deserthideaway.com. Retro-chic rooms in a desert garden setting at the edge of Joshua Tree with a view of the mountains.

29 PALMS INN, 760-367-3505, www.29palmsinn.com. Adobe bungalow and cottage resort, dating to 1928, built on a California fan palm oasis in Twentynine Palms.

Restaurants

CROSSROADS CAFÉ, 760-366-5414. A locals' favorite for breakfasts, sandwiches, and salads in a casual setting in the center of Joshua Tree.

PARK ROCK CAFÉ, 760-366-3622. Café-deli a block from the Joshua Tree central crossroads.

YOKOZUNA, 760-365-2521. Japanese dishes in Yucca Valley.

29 PALMS INN, 760-367-3505. Longtime popular restaurant for steaks and seafood in Twentynine Palms.

Julian

For more information: Julian Chamber of Commerce, 2129 Main Street, Julian, CA 92036, 760-765-1857, www.julianca.com.

Hotels

EAGLENEST BED & BREAKFAST, 760-765-1252, 888-345-6378, www.eaglenestbnb.com. Four Victorian-style rooms in a hillside home with a swimming-pool.

JULIAN HOTEL, 760-865-0201, 800-734-5854, www.julianhotel.com. Old-style accommodations in a 100-year-old hotel on Main Street.

Restaurants

BOAR'S HEAD SALOON, 760-765-2265. Country & Western bar behind a family-oriented burgers-and-barbecue restaurant.

MINER'S DINER & SODA FOUNTAIN, 760-765-3753. Sandwiches and ice-cream in an old-fashioned soda fountain.

ROMANO'S DODGE HOUSE, 760-765-1003. Hearty Italian specialties.

THE JULIAN GRILLE, 760-765-0173. Seafood, beef, and pasta in a historic cottage setting.

Los Olivos, Ballard, and Santa Ynez

For more information: Santa Ynez Valley Visitors Association, P. O. Box 1918, Santa Ynez, CA 93460, 800-742-2843, www.syvva.com.

Hotels

BALLARD INN, 805-688-7770, 800-638-2466, www.ballardinn.com. Fifteen-room country-style bed-and-breakfast inn in the center of Ballard.

FESS PARKER'S WINE COUNTRY INN & SPA, 805-688-7788, 800-446-2455, www.fessparker.com. Upscale accommodations on Grand Avenue in Los Olivos.

SANTA YNEZ INN, 805-688-5588, 800-643-5774, www.santaynezinn.com. New Victorian-style luxury inn on the main thoroughfare in Santa Ynez.

Restaurants

BALLARD INN RESTAURANT, 805-688-7770. Innovative fusion cuisine in a well-appointed dining-room.

BROTHERS RESTAURANT AT MATTEI'S TAVERN, 805-688-4820. Steaks and hearty fare at a historic stagecoach inn in Los Olivos.

LOS OLIVOS CAFÉ, 805-688-7265. Mediterranean/California dishes in a casual setting.

PATRICK'S SIDE STREET CAFÉ, 805-686-4004. Stylish wine-country café in Los Olivos.

RED BARN RESTAURANT, 805-688-4142. Locals' favorite steakhouse in Santa Ynez.

VINEYARD HOUSE RESTAURANT, 805-688-2886. California cuisine in a Victorian house and garden in Santa Ynez.

WINE CASK, 805-688-7788. Gourmet dinners and wine pairings in Los Olivos.

Mendocino

For more information: Mendocino County Alliance, 866-466-3636, www.gomendo.com; Ford House Museum and Visitor Center, Mendocino Headlands State Park, 735 Main Street, Mendocino, CA 95460, 707-937-5397.

Hotels
BREWERY GULCH INN, 707-937-4752, 800-578-4454, www.brewerygulchinn.com. Elegant water-view accommodations in a bed-and-breakfast inn built from salvaged old-growth redwood.

MENDOCINO HOTEL AND GARDEN SUITES, 707-937-0511, 800-548-0513, www.mendocinohotel.com. Classic 1878 hotel in the heart of Main Street opposite the water.

SEA ROCK INN, 707-937-0926, 800-906-0926, www.searock.com. Cozy suites and cottages with an ocean view.

Restaurants
LITTLE RIVER INN, 707-937-5942. Longtime locals' favorite restaurant and bar in an inn that dates from 1853, just outside the town of Mendocino.

MACCALLUM HOUSE, 707-937-0289. Fine dining in a beautifully renovated historic mansion in town.

955 UKIAH, 707-937-1955. Seafood and California cuisine in a cottage setting.

Montecito and Summerland

For more information: Santa Barbara Conference and Visitors Bureau, 1601 Anacapa Street, Santa Barbara, CA 93101, 805-966-9222, www.santabarbaraCA.com.

Hotels
FOUR SEASONS RESORT THE BILTMORE SANTA BARBARA, 805-969-2261, www.fourseasons.com/santabarbara. Elegant Spanish-colonial-style accommodations across from Butterfly Beach in Montecito.

MONTECITO INN, 805-969-7854, 800-843-2017, www.montecitoinn.com. Classic upscale hotel, once owned by Charlie Chaplin, on Montecito's Coast Village Road.

SAN YSIDRO RANCH, 805-565-1700, 800-368-6788, www.sanysidroranch.com. Luxurious bungalow-style resort in the Montecito foothills.

Restaurants
CAVA, 805-969-8500. Tapas and Mexican cuisine in downtown Montecito.

LUCKY'S, 805-565-7540. New York-style steakhouse in the heart of Montecito.

SAKANA, 805-565-2014. Superb sushi in a cozy Montecito setting.

SUMMERLAND BEACH CAFÉ, 805-969-1019. Burgers, salads, and breakfasts in an 1893 Victorian house.

TRATTORIA MOLLIE, 805-565-9381. Homemade pasta and Italian dishes on Montecito's Coast Village Road.

VIA VAI, 805-565-9393. Upscale pizzas and Italian cuisine in Montecito's upper village.

Monterey

For more information: Monterey County Convention & Visitors Bureau, 150 Olivier Street, Monterey, CA 93940, 831-649-1770, 888-221-1010, www.montereyinfo.org.

Hotels
HOTEL PACIFIC, 831-373-5700, 800-554-5542, www.hotelpacific.com. An all-suite, Spanish-colonial-style hotel in the historic downtown district.

MONTEREY PLAZA RESORT & SPA, 831-646-1700, 800-334-3999, www.montereyplazahotel.com. A luxury hotel and spa on the bay at the edge of Cannery Row.

OLD MONTEREY INN, 831-375-8284, 800-350-2344, www.oldmontereyinn.com. Tudor-style country bed-and-breakfast in a garden setting.

SPINDRIFT INN, 831-646-8900, 800-841-1879, www.spindriftinn.com. Small, comfortable water-view hotel on Cannery Row.

Restaurants
CAFÉ FINA, 831-372-5200. Fresh seafood on Old Fisherman's Wharf #1.

CANNERY ROW DELICATESSEN, 831-645-9549. Great breakfasts and lunches in a convenient location.

JUGEM, 831-373-6463. Hip sushi restaurant near the historic area.

MONTRIO, 831-648-8880. Innovative American cooking in downtown Monterey.

WHALING STATION, 831-373-3778. Steaks and seafood in a bistro setting near the Aquarium.

Nevada City

For more information: Nevada City Chamber of Commerce, 132 Main Street, Nevada City, CA 95959, 530-265-2692, 800-655-6569, www.nevadacitychamber.com.

Hotels
FLUME'S END, 530-265-9665, 800-991-8118, www.flumesend.com. Bed-and-breakfast built over an old gold-stamp-mill in a scenic creekside spot.

NATIONAL HOTEL, 530-265-4551, www.thenationalhotel.com. Historic hotel, built in 1856 at the end of Broad Street.

EMMA NEVADA HOUSE, 530-265-4415, 800-916-EMMA, www.emmanevadahouse.com. Elegantly renovated 6-room inn that was the family home of a 19th-century opera singer.

Restaurants
CITRONEE BISTRO AND WINE BAR, 530-265-5697. American regional cuisine with Mediterranean touches in a casually elegant setting on the main street.

NATIONAL HOTEL, 530-265-4551. Atmospheric 19th-century bar and dining-room.

FRIAR TUCK, 530-265-9093. Steaks and seafood in several inviting brick-walled rooms, with nightly music.

IKE'S QUARTER CAFÉ, 530-265-6138. Informal New Orleans-style café.

Ojai

For more information: Ojai Valley Chamber of Commerce, 201 S. Signal Street, Ojai, CA, 805-646-8126, www.ojaichamber.org.

Hotels
LAVENDER INN, 805-646-6635, www.lavenderinn.com. Charming 7-room bed-and-breakfast, plus a cottage, built around Ojai's original brick schoolhouse.

OJAI VALLEY INN AND SPA, 805-646-1111, 888-697-8780, www.ojairesortcom. Luxurious and historic Mediterranean-style golf resort, plus a spacious spa, on an expansive property in the heart of the valley.

Restaurants
AZU, 805-640-7987. Trendy tapas on Ojai's main street.

BOCCALLI'S, 805-646-6116. Longtime pizza and pasta restaurant at the east end of town.

BONNIE LU'S, 805-646-0207. Comfort food in a locals' favorite in the Arcade.

SUZANNE'S CUISINE, 805-640-1961. Fine dining in a garden setting.

THE RANCH HOUSE, 805-646-2360. Classic California restaurant at the edge of Ojai.

Point Reyes Station

For more information: Point Reyes Lodging Association, 415-663-1872, 800-539-1872, www.ptreyes.com; Point Reyes National Seashore, Point Reyes Station, CA 94956-9799, 415-464-5100, www.nps.gov/pore.

Hotels
POINT REYES STATION INN, 415-663-9372, www.pointreyesstationinn.com.

Spacious individually decorated rooms in a well-appointed, antique-filled inn.

POINT REYES VINEYARD INN, 415-663-1011, 800-516-1011, www.ptreyesvineyardinn.com. Comfortable accommodations in the middle of a champagne vineyard.

Restaurants
OLEMA FARM HOUSE RESTAURANT, 415-663-1264. Dining-room and bar in a house that goes back to 1865 in neighboring Olema.

STATION HOUSE CAFÉ, 415-663-1515. California cuisine with an emphasis on organic ingredients on the main street in Point Reyes.

TONY'S SEAFOOD, 415-663-1107. Fish dishes overlooking Tomales Bay in Marshall.

St. Helena

For more information: St. Helena Chamber of Commerce, 1010 Main Street, Suite A, St. Helena, CA 94574, 707-963-4456, 800-799-6456, www.sthelena.com; and Napa Valley Convention and Visitors Bureau, 1310 Napa Town Center, Napa, CA 94559, 707-226-7459, www.napavalley.org.

Hotels
AMBROSE BIERCE HOUSE, 707-963-3003, www.ambrosebiercehouse.com. Four-room bed-and-breakfast in the 19th-century writer's home, built in 1872, in downtown St. Helena.

AUBERGE DU SOLEIL, 707-963-1211, 800-348-5406, www.aubergedusoleil.com. Exquisite Mediterranean-inspired resort and spa on expansive grounds in Rutherford.

CALISTOGA RANCH, 707-254-2800, 800-942-4220, www.calistogaranch.com. Luxurious cedar-shingle-style cottages and resort in a rustic setting at the edge of Calistoga.

MAISON FLEURIE, 707-944-2056, 800-788-0369, www.foursisters.com. Small French-style country inn in a historic stone building in Yountville.

MEADOWOOD NAPA VALLEY, 707-963-3646, 800-458-8080, www.meadowood.com. Luxe inn and spa in a country setting in St. Helena.

Restaurants
CINDY'S BACKSTREET KITCHEN, 707-963-1200. Locals' favorite for stylish comfort food in St. Helena.

COOK, 707-963-7088. Upscale Italian cuisine on Main Street in St. Helena.

MARKET, 707-963-3799. American classics in a St. Helena neighborhood restaurant.

REDD, 707-944-2222. Innovative cooking in a sleek, see-and-be-seen setting in Yountville.

TAYLOR'S REFRESHER, 707-963-3486. Great burgers for locals and visitors alike in St. Helena.

TERRA, 707-963-8931. New American cooking in a century-old stone building in St. Helena.

THE FRENCH LAUNDRY, 707-944-2380. Thomas Keller's internationally famous California-French gourmet restaurant in Yountville.

San Juan Bautista

For more information: San Juan Bautista Chamber of Commerce, 33 Washington Street/203 Third Street, Suite D, San Juan Bautista, CA 95045, 831-623-2454, www.san-juan-bautista.ca.us; San Juan Bautista State Historic Park, P.O. Box 787, San Juan Bautista, CA 95045, 831-623-4881, www.parks.ca.gov.

Hotels
POSADA DE SAN JUAN, 831-623-4030. Comfortable rooms in a Spanish-style inn, one block from the historic park.

Restaurants
DOÑA ESTHER, 831-623-2518. Locals' favorite for Mexican specialties.
JARDINES DE SAN JUAN, 831-623-4466. Classic Mexican cuisine in a lush garden, with music on weekends.
MATXAIN ETXEA, 831-623-4472. Basque specialties in a country-style restaurant.
SAN JUAN BAKERY, 831-623-4570. Sandwiches and fresh-baked pastries.
THE CUTTING HORSE, 831-623-4549. Steakhouse in the heart of town.

San Juan Capistrano

For more information: Anaheim/Orange County Visitor & Convention Bureau, 800 W. Katella Ave, P.O. Box 4270, Anaheim, CA 92803, 714-765-8888, 888-598-3200, www.anaheimoc.org.

Hotels
LAGUNA CLIFFS MARRIOTT RESORT & SPA, 949-661-5000, www.lagunacliffs.com. A gracious 475-room resort on a panoramic ocean-view bluff in Dana Point, ten minutes from the heart of San Juan Capistrano.
MISSION INN, 949-234-0249, 866-234-0249, www.missioninnsjc.com. Twenty-room hacienda-style hotel in an orange grove near the mission.

Restaurants
EL ADOBE, 949-493-1163. Mexican steakhouse in two historic adobes from the 1830s.
L'HIRONDELLE, 949-661-0425. Belgian and French cuisine in a romantic setting across from the mission.
RAMOS HOUSE CAFÉ, 949-443-1342. Breakfast and lunch in an 1881 cottage on historic Los Rios Street.

Sausalito

For more information: Sausalito Visitors Center, 780 Bridgeway, Sausalito, CA 94965, 415-332-0505, www.sausalito.org.

Hotels
CASA MADRONA HOTEL AND SPA, 415-332-0502, 800-288-0502, www.casamadrona.com. Sophisticated hotel in the heart of Sausalito.
HOTEL SAUSALITO, 415-332-0700, 888-442-0700, www.hotelsausalito.com. Sixteen rooms and suites with sunny Old World décor.
THE INN ABOVE TIDE, 415-332-9535, 800-893-8433, www.innabovetide.com. Sophisticated and elegant contemporary accommodations over the water, with a panoramic view of San Francisco.

Restaurants
ANGELINO RESTAURANT, 415-331-5225. Italian cuisine in an easy-going setting.
POGGIO, 415-331-7771. Upscale Tuscan trattoria.
SUSHI RAN, 415-332-3620. Popular sushi restaurant in the Caledonia Street neighborhood.

Sonoma

For more information: Sonoma Valley Visitors Bureau, 453 First Street East, Sonoma, CA 95476, 707-996-1090, 866-996-1090, www.sonomavalley.com; the Sonoma County Tourism Bureau, www.sonomacounty.com.

Hotels
FAIRMONT SONOMA MISSION INN & SPA, 707-938-9000, 866-540-4499, www.fairmont.com/sonoma. Upscale, historic resort with a golf course and spa.
GAIGE HOUSE INN, 707-935-0237, 800-935-0237, www.gaige.com. Luxurious Asian-fusion style in a 19th-century Queen Anne house and contemporary spa suites, in Glen Ellen.
THE INN AT SONOMA, 707-939-1340, 800-568-9818, www.foursisters.com. Small, graciously appointed inn two blocks from the Plaza in Sonoma.
THE SWISS HOTEL, 707-938-2884, www.swisshotelsonoma.com. Five-room historic hotel on the Plaza in Sonoma.
TROJAN HORSE INN, 707-996-2430, 800-899-1925, www.TrojanHorseInn.com. Six-room bed-and-breakfast in a 19th-century house at the edge of Sonoma.

Restaurants
CAFÉ CITTI, 707-833-2690. Casual trattoria in Kenwood.
EL DORADO KITCHEN, 707-996-3030. Contemporary California cuisine in a newly renovated hotel on the Plaza.
HARMONY CLUB, 707-996-9779. Wine-country cooking in the boutique Ledson Hotel on the Plaza.

MAYA RESTAURANT, 707-935-3500. Yucatan cuisine in a festive setting on the Plaza.

MERITAGE MARTINI OYSTER BAR & GRILL, 707-938-9430. Southern French and Northern Italian cuisine in a stylish setting.

MURPHY'S IRISH PUB, 707-935-0660. Cozy pub in the heart of Sonoma.

THE GIRL & THE FIG, 707-938-3634. Seasonal, Provençal-inspired cuisine, in the Sonoma Hotel.

THE RED GRAPE, 707-996-4103. Upscale pizzas and salads.

Sonora, Columbia, and Jamestown

For more information: Tuolumne County Visitors Bureau, P. O. Box 4020, Sonora, CA 95370, 209-533-4420, 800-446-1333, www.thegreatunfenced.com.

Hotels

GUNN HOUSE HOTEL, 209-532-3421, www.gunnhousehotel.com. Antique-filled rooms in a hotel built around a 19th-century adobe home in Sonora.

BRADFORD PLACE INN, 209-536-6075, 800-209-2315, www.bradfordplaceinn.com. Lodging in an 1899 Victorian home in Sonora.

COLUMBIA CITY HOTEL, 209-532-1479, 800-532-1479, www.cityhotel.com. Ten-room bed-and-breakfast in a 19th-century building in Columbia State Historical Park.

HISTORIC NATIONAL HOTEL, 209-984-3446, 800-894-3446, www.national-hotel.com. Restored Gold Rush hotel from 1859 in Jamestown.

JAMESTOWN HOTEL, 209-984-3902, 800-205-4901, www.jamestownhotel.com. Victorian-style bed-and-breakfast on the main street in Jamestown.

Restaurants

BACKSTREET BAR AND GRILL, 209-533-0996. Gourmet pizzas, sandwiches, and pasta in Sonora.

BANNY'S CAFÉ AND WINE BAR, 209-533-4709. Contemporary cooking in a sophisticated setting in Sonora.

LEGENDS, 209-532-8120. Old-fashioned ice-cream parlor-cum-bookstore on Sonora's main street.

SEVEN SISTERS, 209-928-9363. Exceptional gourmet cuisine at the Black Oak Casino, on the outskirts of Sonora.

WILLOW STEAKHOUSE AND SALOON, 209-984-3998. Locals' favorite for steaks and burgers in Jamestown.

Sutter Creek

For more information: Amador Council of Tourism, P.O. Box 40, Sutter Creek, CA 95685, 877-868-7262, www.touramador.com.

Hotels

DAY'S INN, SUTTER CREEK, 209-267-9177, www.goldcountryhotel.com. Spacious, convenient motel-style accommodations at the edge of the historic district.

HANFORD HOUSE, 209-267-0747, 800-871-5839, www.hanfordhouse.com. A brick, manor-style bed-and-breakfast with 9 individually decorated rooms.

SUTTER CREEK INN, 209-267-5606, www.suttercreekinn.com. The first bed-and-breakfast in the area, with 17 picturesque rooms in a house dating back to about 1859.

Restaurants

BACK ROADS COFFEE HOUSE, 209-267-0440. Salads and sandwiches on Main Street.

SUSAN'S WINE BAR AND EATERY, 209-267-0945. Mediterranean cuisine in a garden setting a half-block off Main Street.

SUTTER CREEK PALACE, 209-267-1300. American cuisine in a pretty Victorian bar and dining-room.

Truckee

For more information: Truckee Donner Chamber of Commerce, 10065 Donner Pass Road, Truckee, CA 96161, 530-587-2757, 866-443-2027, www.truckee.com.

Hotels

HAMPTON INN & SUITES, 530-587-1197, 800-648-7751, www.hamptoninntruckee.com. Comfortable, new lodgings near the Truckee Airport.

THE TRUCKEE HOTEL, 530-587-4444, 800-659-6921, www.thetruckeehotel.com. A historic inn, built in 1873 and renovated with an eye toward preservation.

Restaurants

BAR OF AMERICA & PACIFIC CREST, 530-587-2626. Hip bistro with music on weekends.

COTTONWOOD, 530-587-5711. Fine dining overlooking Truckee from a longtime ski lodge.

MOODY'S BISTRO & LOUNGE, 530-587-8688. Contemporary California cuisine with Art Deco ambience, in the historic Truckee Hotel.

SQUEEZE IN, 530-587-9814. Popular breakfast place.

TRUCKEE DINER, 530-582-5235. Breakfast, burgers, and shakes in an authentic diner.

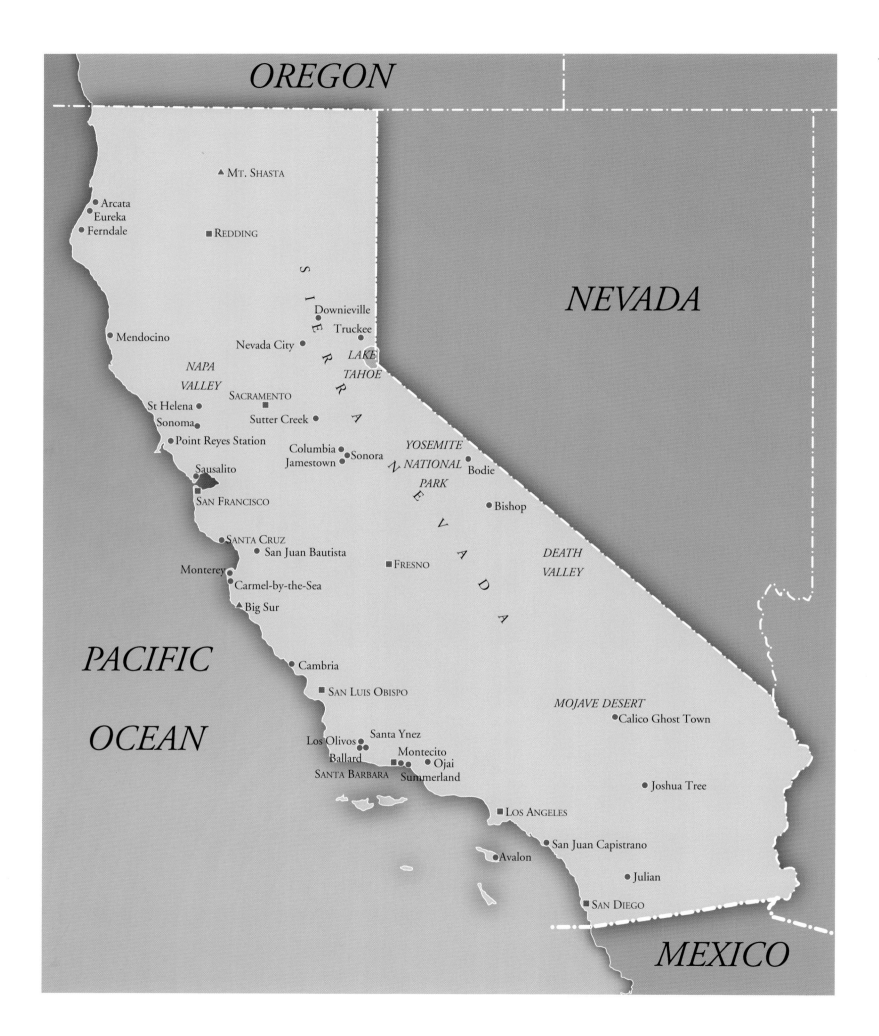

OREGON

NEVADA

▲ Mt. Shasta

● Arcata
Eureka
● Ferndale

■ Redding

● Mendocino

Downieville ●
Truckee ●

Nevada City ●

LAKE TAHOE

NAPA VALLEY

St Helena ●
Sonoma ●

Sacramento ■

Sutter Creek ●

● Point Reyes Station

Columbia ●
Jamestown ● ● Sonora

YOSEMITE NATIONAL PARK

Sausalito

● Bodie

San Francisco

● Bishop

● Santa Cruz
● San Juan Bautista

DEATH VALLEY

Monterey ●
● Carmel-by-the-Sea

■ Fresno

▲ Big Sur

PACIFIC

● Cambria

OCEAN

■ San Luis Obispo

MOJAVE DESERT
● Calico Ghost Town

Santa Ynez
Los Olivos ●
Ballard ●
■ Montecito
● ■ ● Ojai
Santa Barbara Summerland

● Joshua Tree

■ Los Angeles

● San Juan Capistrano

● Avalon

● Julian

■ San Diego

MEXICO

S
I
E
R
R
A

N
E
V
A
D
A

Selected Reading

General books about California and broad California topics

Calfant, W. A., *Gold, Guns & Ghost Towns*, 1947.

Graham, Otis L., Jr., and Sarah Harper Case, Victor W. Gerci, Susan Goldstein, Richard P. Ryba, and Beverly J. Schwartzberg. *Aged in Oak: the Story of the Santa Barbara County Wine Industry*, 1998.

Lavender, David. *California: Land of New Beginnings*, with a new Afterword, 1987 (paper).

Leffingwell, Randy. *California Missions and Presidios*, 2005.

Miller, Donald C. *Ghost Towns of California*, 1978.

Starr, Kevin. *California, A History*, 2005.

—. Americans and the California Dream Series:
Americans and the California Dream, 1850–1915, 1986 (paper).
Inventing the Dream: California Through the Progressive Era, 1986 (paper).
Material Dreams: Southern California Through the 1920s, 1991 (paper).
Endangered Dreams: The Great Depression in California, 1997 (paper).
The Dream Endures: California Enters the 1940s, 2002 (paper).
Embattled Dreams: California in War and Peace, 1940–1950, 2003 (paper).

Sunset Editors. *The California Missions: A Pictorial History*, 1997.

Verardo, Denzil and Jennie. *Napa Valley: From Golden Fields to Purple Harvest*, 1986.

Books about specific towns

Abrahamson, Eric. *Historic Monterey: California's Forgotton First Capital*, 1989.

Baker, Gayle. *Point Reyes*, 2004.

Cates, Robert B. *Joshua Tree National Park; A Visitor's Guide*, 1995.

Davis, Myrna, and Mary Hozhauer. *Almost Heaven: A Walk Through Old Summerland*, 1997.

Fry, Patricia L. *The Ojai Valley: An Illustrated Guide*, 1999.

Griscom, Elane. *Behind the Hedges of Montecito*, 2000.

McKinney, Mel. *The Finn, the Twin and the Inn*, 1994.

Myrick, David F. *Montecito and Santa Barbara*, Vol. I, 1987.

Norris, Jim. *Los Olivos*, 1987.

Vogt, Elizabeth. *Montecito: California's Garden Paradise*, 1993.

Arcadia Publishing Company is publishing an ever-lengthening series of books about many of the small towns and villages in California.

For a complete, current list, consult: www.arcadiapublishing.com.

Acknowledgments

The author, photographer, and the publisher wish to thank the following organizations for their help in the preparation of this book.

Avalon
Catalina Island Chamber of Commerce &
 Visitors Bureau
Santa Catalina Island Company
The Inn on Mount Ada
Pavilion Lodge
Zane Grey Pueblo
Catalina Express

Bishop
Bishop Area Chamber of Commerce and
 Visitors Bureau

Cambria
San Luis Obispo County Visitors & Conference
 Bureau
Moonstone Hotel Properties
Hearst San Simeon State Historical Monument

Carmel-by-the-Sea
Monterey County Convention & Visitors
 Bureau
Los Laureles Lodge
Tradewinds Inn

Downieville
Sierra County Chamber of Commerce
Carriage House Inn

Eureka and Arcata
Humboldt County Convention and Visitors
 Bureau
Eagle House Inn

Ferndale
Humboldt County Convention and Visitors
 Bureau
Shaw House Inn

Joshua Tree
Joshua Tree Chamber of Commerce

Julian
Julian Chamber of Commerce
Eaglenest Bed & Breakfast

Mendocino
Mendocino County Alliance
Brewery Gulch Inn
Mendocino Hotel
Kelley House Museum

Montecito and Summerland
Casa del Herrero
Ganna Walska Lotusland

Monterey
Monterey County Convention &
 Visitors Bureau
Hotel Pacific
Woodside Hotels & Resorts
California Legacy Tours

Nevada City
Nevada City Chamber of Commerce
Flumes End

Ojai
Ojai Valley Inn and Spa

Point Reyes Station
Point Reyes Lodging Association
Point Reyes Station Inn
Point Reyes Vineyard Inn

St. Helena
Calistoga Ranch

San Juan Capistrano
Anaheim/Orange County Visitor &
 Convention Bureau
Laguna Cliffs Marriott Resort & Spa

Sausalito
The Inn Above Tide

Sonoma
Sonoma County Tourism Bureau
Gaige House Inn
Sonoma Creek Inn

Sonora, Columbia, and Jamestown
Tuolumne County Visitors Bureau
Gunn House Hotel

Sutter Creek
Amador Council of Tourism
Days Inn, Sutter Creek

Truckee
Truckee Donner Chamber of Commerce

Thanks also to the following people who were
particularly helpful in obtaining
accommodations and other assistance as we
researched this book: Doug and Claire Barr,
Elaine Cali, Nyna Cox, Ray Hillman, Karen
Pingitore, Sharon Rooney, Fred Sater, Maris
Somerville.